been in the city of Jerusalem (see Josephus, *War*, 6.423–37) and there would have been the serious threat of a riot (see Mark 14:2). (2) On occasion Pilate did "bow to Jewish demands" when there was enough Jewish crowd pressure (see Josephus, *Antiquities*, 18.3.1). Therefore, it does not strain credulity to imagine Pilate giving the body of Jesus to a Jewish leader like Joseph of Arimathea in order to avoid the violence that may have ensued when several hundred thousand Jews discovered that their "land" had been "defiled" by an explicit violation of the Torah during the most solemn festival of the liturgical year (see Deuteronomy 21:22–23; 11QTemple 64:6–13). See David W. Chapman, *Ancient Jewish and Christian Perceptions of Crucifixion* (Grand Rapids, MI: Baker Academic, 2008), 117–47.

20 Allison, *Resurrecting Jesus*, 332.

21 See Josephus, *Antiquities*, 4.219: "Put not trust in a single witness, but let there be three or at the least two, whose evidence shall be accredited by their past lives. From women let no evidence be accepted, because of the levity and temerity of their sex." See Licona, *The Resurrection of Jesus*, 349–58; Byrskog, *Story as History*, 73–82; Richard Bauckham, *Gospel Women: Studies of the Named Women in the Gospels* (Grand Rapids, MI: Eerdmans, 2002), 259; Claudia Setzer, "Excellent Women: Female Witnesses to the Resurrection," *Journal of Biblical Literature* 116 (1997): 259–72. Bart Ehrman admits the "force" of the argument that no one in an ancient Jewish context would invent the discovery of the tomb by women if they wanted their story to be believed. He nevertheless goes to great lengths to imagine various literary and other reasons it would have been invented, none of which is very convincing. The problem with such a response is that any scholar can use their imagination to come up with all kinds of *possible* scenarios. But historical investigation is supposed to rely on actual *evidence*. In this case, Ehrman can produce no evidence that the multiply attested stories of the women discovering the tomb were invented and therefore should be discarded. See Ehrman, *How Jesus Became God*, 166–68. For a serious critique of Ehrman's attempt to make the empty tomb disappear, see Craig A. Evans, "Getting the Burial Traditions and Evidences Right," in Michael F. Bird et al., *How God Became Jesus: The Real Origins of Belief in Jesus' Divine Nature: A Response to Bart D. Ehrman* (Grand Rapids, MI: Zondervan, 2014), 71–93 (though Evans misidentifies the Idumeans as Romans on p. 79).

22 Ratzinger, *Jesus of Nazareth*, 2.254: "The empty tomb is no proof of the Resurrection, that much is undeniable."

23 The historical truth of this penalty for soldiers is corroborated by literally dozens of ancient Roman sources. Luke is not making it up. See Keener, *Acts*, 2:1954–56.

24 For full discussions with an eye for the historical issues involved, see Keener, *The Historical Jesus of the Gospels*, 342–44; Licona, *The Resurrection of Jesus*, 318–71; Wright, *The Resurrection of the Son of God*, 585–682.

confession of Jesus' deity is unmistakable. It cannot simply represent an accla-
mation to the Father, since John explicitly claims that the words are addressed to
Jesus (*autō*)."

15 Ratzinger, *Jesus of Nazareth*, 2.274–77.

16 See Meier, *A Marginal Jew*, 2:520, on the "academic sneer factor" and the
widespread assumption, "especially in religion departments," that "Modern
man cannot believe in miracles"—a view which he associates above all with Ru-
dolf Bultmann's famous claim that "It is impossible to use electric light and the
wireless and to avail ourselves of modern medical and surgical discoveries, and
at the same time to believe in the New Testament world of . . . miracles." See
Rudolf Bultmann, "The New Testament and Mythology," in *New Testament and
Mythology and Other Basic Writings*, ed. Schubert Ogden (Philadelphia: Fortress,
1984), 5. On miracles in modern and ancient minds see Meier, *A Marginal Jew*,
2.509–616. The definitive work for some time to come on the subject of ancient
and modern views of miracles is the massive study by Craig S. Keener, *Miracles:
The Credibility of the New Testament Accounts*, 2 vols. (Grand Rapids, MI: Baker
Academic, 2011).

17 Cf. N. T. Wright, *Surprised by Scripture* (San Francisco: HarperOne, 2014),
41–63.

18 Licona, *The Resurrection of Jesus*, 333–34, 461–63, 629–32.

19 Ehrman, *Jesus: Apocalyptic Prophet*, 228. Unfortunately, in his more recent
work, Ehrman does not follow his own criterion of multiple attestation when it
comes to the burial of Jesus by Joseph of Arimathea or the discovery of the empty
tomb. Instead, he makes the claim—for which he can produce no positive histori-
cal evidence—that Jesus's body was not buried by Joseph. Instead, Ehrman as-
serts that Jesus's body was either left to decompose on the cross, eaten by dogs
and birds, or thrown into a common grave for criminals. See Ehrman, *How Jesus
Became God*, 151–67. In keeping with his tendency to ignore widely known recent
works by major scholars who disagree with him (e.g., R. Bauckham, R. Burridge,
M. Hengel), Ehrman never engages the extensive arguments for Jesus's burial by
Joseph of Arimathea by Dale Allison in Allison, *Resurrecting Jesus*, 352–63. More
important, Ehrman ignores the evidence from Josephus that Jews were noted for
their concern for burying the victims of crucifixion: "They [the Idumeans] actu-
ally went so far in their impiety as to cast out the corpses without burial, although
the Jews are so careful about funeral rites that even malefactors who have been
sentenced to crucifixion are taken down and buried before sunset" (Josephus,
War, 4.317). Trans. H. St. J. Thackeray, *Josephus: The Jewish War*, books 3–4, Loeb
Classical Library 487 (Cambridge, MA: Harvard University Press, 1927), 249. Ehr-
man's argument that Pilate did not bow to Jewish custom and that "it was not
Jews who killed Jesus, so they had no say about when he would be taken down
from the cross" (*How Jesus Became God*, 157) also ignores two other facts: (1) Jesus
was crucified during Passover, when hundreds of thousands of Jews would have

3 See Wright, *The Resurrection of the Son of God*, 7, 276, 342.

4 This is particularly clear in the case of Lazarus, who, as a result of his being raised, was the subject of a plot by the chief priest "to put Lazarus also to death" (John 12:10)!

5 Cf. Luke Timothy Johnson, *The Real Jesus: The Misguided Quest for the Historical Jesus and the Truth of the Traditional Gospels* (San Francisco: HarperCollins, 1995), 134–36, who downplays the importance of the empty tomb and claims instead that "resurrection" meant that "after his crucifixion . . . Jesus entered into the powerful life of God" or "the passage of the human Jesus into the power of God." For a critique, see Wright, *The Resurrection of the Son of God*, 204. See also Marcus Borg's affirmation that Jesus is somehow "alive" in a way that does not involve an empty tomb. Marcus Borg and N. T. Wright, *The Meaning of Jesus: Two Visions* (San Francisco: HarperCollins, 1999), 129–44.

6 See George W. E. Nickelsburg, *Resurrection, Immortality, and Eternal Life in Intertestamental Judaism and Early Christianity*, 2nd ed. (Cambridge, MA: Harvard University Press, 2006), for the range of views.

7 See Acts 1:21-22; 2:31; 4:33; 17:18; Romans 1:4; 1 Corinthians 15:35-45; Philippians 3:20-21; 1 Peter 1:3; 3:21. Wright, *The Resurrection of the Son of God*, 31, puts it well: "Here there is no difference between pagans, Jews, and Christians. They all understood the Greek word *anastasis* and its cognates . . . to mean . . . new life after a period of being dead. . . . All of them were speaking of a new life after 'life after death' in the popular sense, a fresh living embodiment following a period of death as a state."

8 Allison, *Resurrecting Jesus*, 625, notes that there is no evidence for early Christian belief in a "non-physical resurrection."

9 Compare Rudolf Bultmann, *History of the Synoptic Tradition*, 290: "Originally there was no difference between the Resurrection of Jesus and his Ascension; this distinction first arose as a consequence of the Easter legends."

10 For a fuller discussion of the ascension, see Keener, *Acts*, 1.711–31; Ratzinger, *Jesus of Nazareth*, 2.278–93. See also Douglas Farrow, *Ascension Theology* (London: Bloomsbury T. & T. Clark, 2011); Gerritt Dawson, *Jesus Ascended: The Meaning of Christ's Continuing Incarnation* (London: Bloomsbury T. & T. Clark, 2004).

11 See Ratzinger, *Jesus of Nazareth*, 2.244.

12 See Ratzinger, *Jesus of Nazareth*, 2.268; Wright, *The Resurrection of the Son of God*, 657–58.

13 See Wright, *The Resurrection of the Son of God*, 655–56.

14 Keener, *The Gospel of John*, 2:1211: "In this case, as in the prologue, the

Programme in the Book of Psalms, Journal for the Study of the Old Testament Supplement Series 252 (Sheffield, UK: Sheffield Academic Press, 1997).

31 Pietersma and Wright, *A New English Translation of the Septuagint,* 557. The Greek reads *ōryxan cheiras mou kai podas* (Psalm 21:17 LXX).

32 Newman, "Psalms," 1107.

33 Keener, *The Historical Jesus of the Gospels,* 576: "Jesus had to know that Psalm 22 went on to declare the psalmist's vindication."

34 For what follows, see Brant Pitre, "Jesus, the New Temple, and the New Priesthood," *Letter & Spirit* 4 (2008): 47–83. See also Nicholas Perrin, *Jesus the Temple* (Grand Rapids, MI: Baker Academic, 2010).

35 See Ratzinger, *Jesus of Nazareth,* 224–26; Brown, *The Death of the Messiah,* 2.1176–88.

36 On Passover, see Daniel K. Falk, "Festivals and Holy Days," in *The Eerdmans Dictionary of Early Judaism,* ed. John J. Collins and Daniel C. Harlow (Grand Rapids, MI: Eerdmans, 2010), 636–45; James C. VanderKam, "Passover," in *Encyclopedia of the Dead Sea Scrolls,* ed. Lawrence H. Schiffman and James C. VanderKam, 2 vols. (Oxford: Oxford University Press, 2000), 2.637–38; Sanders, *Judaism: Practice and Belief,* 132–38.

37 See Sanders, *Judaism: Practice and Belief,* 47–54.

38 Trans. William H. Whiston, *Josephus: Complete Works* (repr., Peabody, MA: Hendrickson, 1994), 749.

39 Trans. Herbert Danby, *The Mishnah* (Oxford: Oxford University Press, 1933), 594.

40 Sanders, *Judaism: Practice and Belief,* 70–71.

41 See Keener, *The Gospel of Matthew,* 356: "Jesus' self-claim is veiled enough to prevent accusations of blasphemy—especially since his opponents would not expect him to claim what he is claiming—but obvious enough to enrage them."

Chapter 12: The Resurrection

1 For full-length studies, see Michael Licona, *The Resurrection of Jesus: A Historiographical Approach* (Downers Grove, IL: InterVarsity Press, 2010); Dale C. Allison, Jr., *Resurrecting Jesus* (London: T. & T. Clark, 2005), 198–376; N. T. Wright, *The Resurrection of the Son of God,* Christian Origins and the Question of God 3 (Minneapolis: Fortress, 2003).

2 Ratzinger, *Jesus of Nazareth,* 243.

THE DEVIL

The Archfiend in Art
From the Sixth to the Sixteenth Century

LUTHER LINK

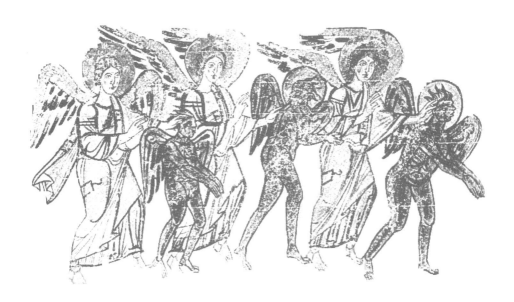

HARRY N. ABRAMS, INC., PUBLISHERS

Dedicated to Kurt

Library of Congress Cataloging-in-Publication Data
Link, Luther.
 The Devil : the archfiend in art / Luther Link.
 p. cm.
 Includes bibliographical references.
 ISBN 0–8109–3226–1
 1. Devil in art. I. Title.
N8140.L56 1995
704.9'487—dc20 95–30181

First published in Great Britain in 1995 by Reaktion Books Ltd., London

Published in 1996 by Harry N. Abrams, Incorporated, New York
A Times Mirror Company

Printed and bound in Great Britain

Contents

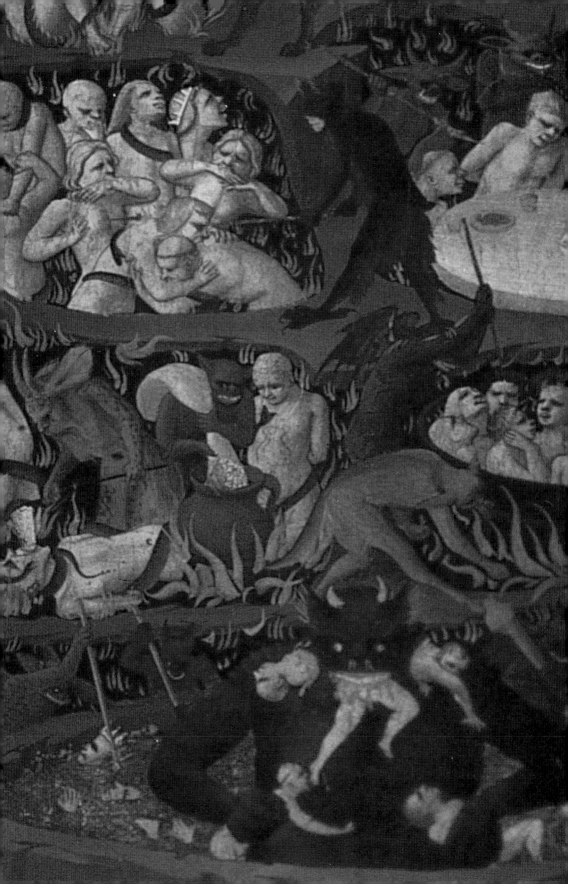

Preface

No one can know the origin of evil who has not grasped the truth
about the so-called Devil and his angels, and who he was before
he became a Devil and how he became a Devil . . .

ORIGEN

'Art-speech is the only truth. An artist is usually a damned liar, but his
art, if it be art, will tell you the truth of his day. And that is all that
matters. Away with eternal truth.' 'The artist', D. H. Lawrence
continues in his *Studies in Classic American Literature*, 'usually sets out –
or used to – to point a moral and adorn a tale. The tale, however, points
the other way, as a rule. Two blankly opposing morals, the artist's and
the tale's. Never trust the artist. Trust the tale.' How well Lawrence's
strictures apply to Leonardo or to Michelangelo, readers can judge for
themselves. The awkward phrase 'art-speech' speaks for itself: what,
exactly, Lawrence's 'only truth' means, perhaps only Lawrence knew.
Particularly with medieval art, Lawrence's comments create difficult-
ies: eliminate the historical context, and some strange interpretations
will follow. Nevertheless, I do not want to ignore what Lawrence was
getting at; in fact, parts of this book show that many medieval and
Renaissance artists were, in his sense, 'damned liars'.

Perhaps I should explain two assumptions I make when writing
about paintings and sculptures. The first is that respect for certain
historical conventions need not result in the abdication of judgement
nor in the acceptance that all conventions are equally effective. The
second is that the immediate impact of a work, regardless of extrinsic
considerations, is perfectly relevant. The first assumption relates to
evaluating the success, or failure, of the Devil's representation (or that
of Jesus). One aspect of artistic evaluation is clearly that of distinguish-
ing between a sign and a symbol, between a label and what is shown and
felt. For example, if I draw a square and a circle and I label the square

1 Detail of Fra Angelico's *The Last Judgment* (illus. 32).

'Jesus' and the circle 'Devil', we have a representation. However, without the label, you cannot guess the drawing's content. Your understanding depends on information that is extrinsic to the painting and cannot be inferred. Mark Twain, writing about Guido Reni's famous painting of Beatrice Cenci (*Life on the Mississippi*, ch. 44), observed that

A good legible label is usually worth, for information, a ton of significant attitude and expression in a historical picture. In Rome, people with fine sympathetic natures stand up and weep in front of the celebrated 'Beatrice Cenci the Day Before Her Execution.' It shows what a label can do. If they did not know the picture, they would inspect it unmoved, and say, 'Young Girl with Hay Fever; Young Girl with her Head in a Bag.'

Perhaps a more apposite example is Christ suffering on the Cross. Just because Christ is on the Cross does not mean the painter has shown that Christ is suffering. A complex of culturally defined features lets us know that this is Christ on the Cross and remind us that we know he suffered: these are what the painting *says*; it does not mean that the artist has *shown* that Christ is suffering. That depends on how effectively he, or she, has made us feel, through technique, feeling and imagination, that Christ is in pain. Perspective is one important technique, though in early medieval painting there was neither linear perspective nor optical foreshortening: the more important subjects were shown larger, even if they were farther away. We have to *interpret* a subject's large size as a sign of its importance. This remains only a *sign* unless we, too, feel or sense the importance of the scene depicted. The degree to which that importance depends on the established convention alone, to that degree the painting, as a painting, is a failure.

Paintings are normally representations of solids on a planar surface; conventions, therefore, have to be used. Perspective shows spatial relations through volume, line and tone. Without some kind of perspective, certain relations between people and between people and objects, can hardly be imitated. This does not mean that the linear perspective established in the Renaissance ensured that pictures superior to those of the Romanesque period could be painted, but it does explain why the figures in Byzantine and Romanesque works often seem isolated from one another, seem unrelated, though the recognizable situations they are in allow us to interpret or translate certain conventions into such relations. The Byzantine convention that makes figures appear to be standing on tiptoe must also be understood as a particular convention at that time, although we are not obliged to follow historical relativists and assume that this convention was necessarily a success. My second assumption is that the immediate

impact of a work is of considerable importance. I see no reason to admire a work that is inert. Too much has been made of the requirement that we adjust our responses to fit with those of, say, high-placed clerics when examining Last Judgment tympana. In the first place, though we can try, we cannot respond to a work exactly as did people of the eleventh century. In the second, the response was far more varied than some studies suppose: the 'response of the medieval audience' is an artificial construct. In the third, and I should like to stress this, complex anagogical interpretations of medieval works are often based on serious misunderstanding. I will mention some examples later, but for the moment one instance from the Renaissance is instructive: the Moses/Christ cycles in the Sistine Chapel. The twelve frescoes for the second tier of the south and north walls of the Chapel were contracted out to various famous artists, and the work was finished by 1483. Episodes from the Old Testament (the Life of Moses) were matched with frescoes of New Testament scenes (the Life of Christ). The Moses scenes prefigured, pointed to and were fulfilled by the Christ scenes. This kind of iconography had been a defining, popular feature of Christian art since early medieval times. Yet, in this case, the programme was so elaborate and learned that no scholar could explain the correlations, not even the sequential order of the episodes depicted. Only with the recent reconstruction of the fresco captions (*tituli*) and the discovery of an informative sixteenth-century document are the correlations finally recovered. Even so, as André Chastel noted in his study of Renaissance art:

The most astonishing aspect is the frequent disagreement between the meaning and what actually appears in the picture. More precisely, the element which dominates the painted composition, the image, does not necessarily agree with the meaning given to it. [1]

For example, the overpowering main subject of the painting with the caption 'Temptations of Christ' is the 'Purification of the Leper'. If the 'label', even in the consciously learned context of Papal patronage and direction, does not always match that which the painting actually shows, then a specialist knowledge of iconography, although it may well be interesting, is *not* essential for the evaluation of a painting. It cannot replace our own response to a work carefully looked at in its social, historical and aesthetic context. The importance of such iconography is often exaggerated, often of dubious relevance, and sometimes the iconography is, in fact, non-existent. Yet some scholars use such data, slyly substituting explications for evaluations.

For most medieval works another, crucially underrated, factor is

decisive: ignorance. Though the Church could argue over subtleties in, for example, formulations of the Trinity, how could the average person follow? He could not. Even today, how many people can precisely distinguish between a molecule and an element, or between viruses and bacteria? Scholars ought more to consider the full implications of statistics derived from the Spanish Inquisition. In the fifteenth century a major source of heresy was ignorance. It is true that numerous heretical sects had their own particular doctrines, but when inquisitors questioned suspects, they found the answers they received were often heretical simply because the person under interrogation did not clearly understand Church doctrine.[2] Of course, the situation was much worse in the early medieval period. This is one reason why the writings of Scholastics and theologians, the main focus of many medievalists, are largely irrelevant to the concerns of this book.

Specialists may be appalled to find themselves reading a book that covers seven centuries. Yet, because monographs are often so narrowly focused, for example the one that catalogues the dimensions of the Virgin Mary's ear-lobes in French painting at the end of the thirteenth century, examining seven hundred years is all the more necessary. Errors, particularly in small details, are probable; corrections are welcome. A few features of the Devil seem to go back to Mesopotamia; but since knowledge of how such features were transmitted rarely goes beyond conjecture and generalization, much more research is needed. I hardly suppose I have resolved all the problems this book raises, but I do hope that some new questions have been asked. Most of my examples are derived from French painting and sculpture; the comparisons with the arts of Asia that occur here and there almost entirely use Japanese examples; in both cases the reasons are access and familiarity. Some conclusions might have been different had I focused on the Czech Republic and India.

Let me explain the terms I use for the Devil. Historically, the sequence of the three terms with which we are familiar is Satan, Devil, Lucifer, though scholars and writers through the ages often imagined the sequence differently. Chaucer, for example, thought that the angel Lucifer, after his fall from Heaven, *then* became Satan. Medieval and Renaissance theologians show no systematic or uniform usage of the three. Further, though all three nouns refer to the same being, in usual English (and, too, in German, French and Italian) usage, these terms sometimes are interchangeable but sometimes not. The second-century writer of the Acts of John has the dying John command: 'Let the Devil be silenced, let Satan be derided, let his wrath be burned out.' Apparently this author supposed the Devil and Satan to be different,

though he nowhere explains what that difference is. Lord Byron, on the other hand, who probably knew the Devil better than most, uses 'Lucifer', 'Satan' and 'the Devil' interchangeably, for example in his poem 'The Devil's Drive: An Unfinished Rhapsody'. Nevertheless, can we substitute Lucifer for Satan in 'the arch-enemy of Jesus is Satan sitting on his throne in Hell'? Or substitute either Lucifer or Satan in 'John, the poor devil, still dreams of getting his poems published'? The problem is not just that Satan is a name, while the Devil is a kind of being, because *the* Satan is quite correct (it designates an office in the Heavenly Council). Lucifer does not tempt Jesus, though Satan, and sometimes the Devil, does. The three terms do designate the same being but, in some cases, one of these terms came to be more commonly associated with a particular episode (for example, 'Lucifer' as a name for the Devil when he was still an angel). These complexities point to one of my themes: the discontinuity of images of the Devil. In any case, in this book 'the Devil' designates the source of evil and the adversary of God and Jesus, while 'devil' or 'devils' indicates a member or members of his network of evil demons and spirits.

Finally, a word about dates. There can be a hundred years' difference between the year a cathedral was begun and when it was completed. Until the sixteenth century a variety of dating systems was in use in this or that locality at one time or another, so that even if a date is literally inscribed in stone we cannot always be sure by our present reckoning what that date refers to. While some paintings, sculptures and manuscripts can be dated with reasonable accuracy, in numerous cases there are only educated guesses available, and in a few cases, such as the date of Genesis B, radio-carbon dating might be more reliable. I have used those dates that appear to be most widely accepted by specialists. As for sources, I have used published English translations whenever possible; where these do not exist, the quotations are translations of my own, unless otherwise indicated.

I would like to express my gratitude to Dr Gunter Franz, Director of the Trier Archives, for his kind help over a five-year period; to Professor Jeffrey Burton Russell of the University of California, the author of definitive volumes about the Devil, for his critical reading of my manuscript and for his generous encouragement; and to Professor William I. Elliott of Kanto Gakuin College, Yokohama, for comments concerning style, structure and detail, all of which helped to improve this book. The woodblock print artist Ryosaku Ito helped make the best possible prints from my negatives. In addition I am deeply appreciative of the considerations I have received from the staff at Reaktion Books.

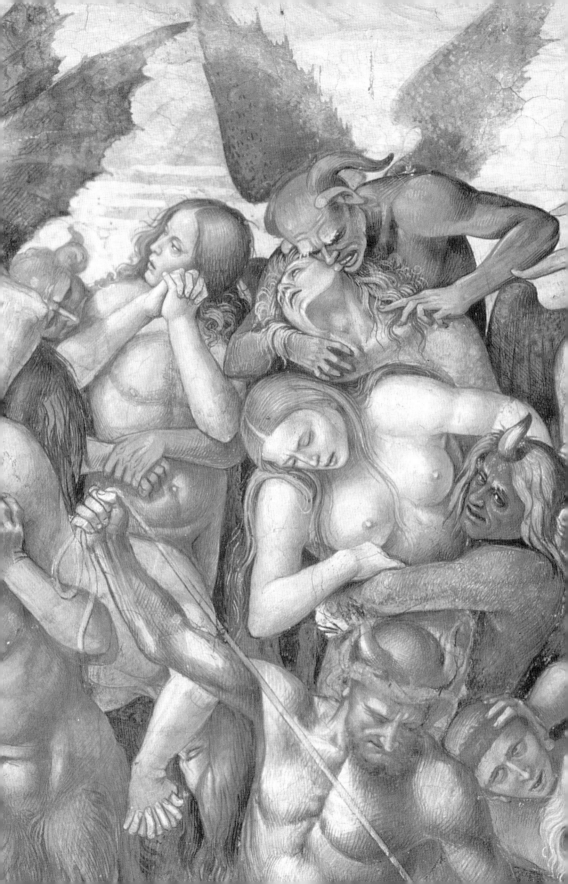

Introduction

You will never find out, by studying literary sources, how the name Frankenstein shifted from the scientist who features in the gothic novel of 1818 by Mary Shelley to the Hollywood monster that has a bolt through his cube-like head. Literary sources are also of limited help when attempting to find out why the Devil looks as he does. For over one hundred years, the popular image of the Devil has, in fact, been that of a bearded creature with horns, tail and pitchfork. The logo used for Underwood's deviled meat sandwich-spreads is a typical example.

Our ideas of the Devil, though not necessarily his pictorial image, derive from three sources: early interpretations of the New Testament; the Rebel Hero created by Milton and the romantic literary tradition of Blake and Baudelaire; and the popular tradition of Satanic cults and black sabbats. We will look at the biblical interpretations with fresh eyes. Literary treatments of the Devil (with the exception of one ninth-century Old Saxon manuscript) were mainly mere paraphrases of biblical sources until, *c.* 1589, Christopher Marlowe wrote *Doctor Faustus*. The popular tradition, a fantasy of heretics and witch-hunters, appeared in the twelfth century and was fully formulated much later. Graphically, the Devil appeared in the ninth century, but he was not the Devil that we know today until the fourteenth. Where was our Devil for the five centuries that lay between 800 and 1300?

In this book, usually, we will be looking at the Devil's features in historical sequence, but, initially, in order to glance at certain problems, we will move back and forth across time. In illustrations for fundamental Christian literature and in comic strips, the Devil usually grasps a prong or pitchfork. That implement derives from the trident of Poseidon, which in turn derives from the triple lightning of the Old Babylonian weather-god Adad, before the second millennium BC.[3] No research into *literary* sources will answer the question of why the Devil holds a pitchfork. He holds a trident only on his first appearance in the

2 Detail of Luca Signorelli's 'The Damned', from *The Last Judgment* (illus. 62).

ninth century (see illus. 16), the result of classical influences, after which it is rarely seen again until much later, in the Renaissance (illus. 6). Most of the time during the medieval period the preferred implement is the grapnel (illus. 31, 33, 36, 52, 55).

This is a detail, but a significant one, and any explanation of it is a paradigm of analysis. Many scholars of art and literature would be described as extreme diffusionists by archaeologists. If the first known wheel is discovered in a ruined temple in Sumer, for example, all other wheels discovered in Egypt or in Mexico ultimately go back, according to diffusionists, to that Sumerian one. Since the medieval artist who gave the Devil a trident did not know anything about ancient Mesopotamia, source-tracing the pitchfork to Adad or Poseidon may be interesting in itself, but worse than useless for understanding why the Devil holds that attribute. It is nice to know that the story of Prince Hamlet goes back to a Norse historian, but it is irrelevant to understanding Shakespeare's play. The first example of an image in art or of a theme in literature may point to nothing at all. What is crucial is the first example that generates reverberations because of the historical context in which it appears. The erudite Greek Christian writer Origen seems to have been the first to suggest that the Lucifer mentioned by Isaiah was a manifestation of the Devil, but it was Augustine's identification of the two that had a decisive influence. If the Devil did not have bat-wings before 1300, we have to ask why. And though the Egyptian motif of the Judgment of the Dead was available for hundreds of years, no Christian artist used it until Last Judgment depictions became popular after the twelfth century. The change from the trident to the grapnel as the Devil's identifying attribute cannot be explained by source-hunting or by an analysis of abstract aesthetic forms. Behind this change are two important historical and social facts. First, interest in classical art declined, and access was limited. Second, the use of the grapnel, or forked hook, for torturing heretics and criminals became widespread. The Devil was given a grapnel to suggest his co-operation with God in torturing the damned, and this implies that the Devil's main role was not that of God's adversary but that of his accomplice.

Two sets of representations point to a distinctive issue that is a theme of this book: the discontinuity of the Devil's image. The first set is Satan tempting Jesus (illus. 14, 27). The theme in these two examples is identical, as is the period: the first half of the ninth century. It is true that the artists, the traditions they drew on and the media are different, but what is immediately striking is the difference in concept. If we compare Satan in the Psalter and Satan on the ivory book-cover, what do they have in common? Though Jesus and Satan are similar on the book-

cover, there is not one point of resemblance between the two in the Psalter. The second set is two works by the Limbourg brothers. The Limbourgs painted both Hell (illus. 63) and the Fall of the Rebel Angels (illus. 64) in a Book of Hours early in the fifteenth century. If we compare these two images, we face a problem that points to a defining element in depictions of the Devil. Just what does the monster exhaling fire have in common with the Lucifer cast out of Heaven? The answer is nothing. Both are the Devil, but there is no way we can connect these two images. Theologically these may be two aspects of the Devil, but they are not the same person, mainly because these two images derive from distinct pictorial traditions that almost never overlapped and were never integrated. This suggests that the graphic attributes and concept of the Devil were rarely defined in the imaginations of artists, unlike, for example, those of Mary or Judas or Samson. Christ on the Cross, or preaching, or as judge at the Last Judgment, were treated differently in different decades, but at any one period we can connect Christ as judge with Christ on the Cross. Christ or Mary or Peter are a continuum, however much their forms and faces changed over the years. Christ, Mary and Peter were particular people with specific histories. The Devil, whether tormenting Job or egging on Pilate or tempting Jesus or ruling Hell, is discontinuous in his various roles. He has no history in that the Fallen Angel is not implied and cannot be emotionally deduced from the Ruler of Hell (and vice-versa), and this is partly because when the Devil was painted as a horrific monster, the artist did not then have in his mind the angel who fought Michael. The pictorial traditions did not offer this option. How and why this happened we will see as we examine the image of the Devil. He is not a person. He may have many masks, but his essence is a mask without a face. The apparent face of the Devil from the ninth century to the sixteenth is usually banal: it is a pasteboard mask with neither personality nor feeling behind it. Perhaps that is why the face of the Devil seemed harder to sketch than the face of Jesus. If you were asked to name a memorable painting of Christ or Mary or Moses, you would have no trouble. The same is probably true of Judas (if it be Giotto's or Leonardo's). But what paintings made before the sixteenth century of the Devil, the powerful adversary of God, can you recall? Probably none. Is this not curious?

From the ninth century to the sixteenth, most paintings and sculptures of Satan are artistic failures. Perhaps artists did not find the Devil worth their time or considered the Devil too tricky a subject (but if this was so, *why?*). There is a more complex reason, which I will try to explain later, in my discussion of the most important painter of the Renaissance who depicted the Devil – Giotto. We will see how the

Devil in his Judas fresco weakens the painting. In our own day the Vatican's Cardinal Ratzinger insists that 'for Christian believers, the Devil is a mysterious but real, personal and not symbolic presence'. Perhaps this is true, perhaps not. But this *was* true, we imagine, during the medieval and Renaissance periods. Yet if we look at what the artists of that time imagined, then what we imagine to have been true seems false. One reason is because the Devil, with a few exceptions (particularly in Romanesque sculpture of 1050–1130), was *not* imaginatively seen as a 'real, personal presence'. This idea may seem perverse and unorthodox, but I hope to convince you.

Japanese and Chinese artists had no difficulty in creating commanding representations of demons and devils. Compared to the terrifying impact of the magnificent Japanese Hell books and scrolls from the late Heian and Kamakura periods, most Western pictures of devils have the impact of comic strips.[4] The fanged Japanese Fudomyō-ō, for example, is as fierce as anyone could possibly want. But he is not evil; on the contrary, he fights evil and protects believers. His iconography has changed little over the centuries.[5] The iconography of the Fudomyō-ō in Buddhist shrines of the sixth century is close to that of the same deity at Buddhist shrines in Tokyo today. He has no snares; he tempts no-one. The Christian Devil is different, and a failure to stress this can lead to problems. For example, Roland Villeneuve, author of some twenty books on demonology, believes that the Devil is not essentially Christian, but rather that he is man's eternal response to unknown forces. Two forms in which the Devil appeared, says Villeneuve, are Pan and Nergal.[6] Though Pan was interpreted as the Devil by many Christians, he surely was not that for the Greeks or early Romans. The same is true of Nergal, a Babylonian god of plagues and of the underworld, who is rarely depicted on cylinder seals; in some post-Christian Parthian representations, Nergal is, mistakenly, given Devil characteristics. In both cases we are dealing with Christian-influenced misunderstandings. The Christian Devil tricks and tempts; he is the enemy of Man and Jesus. That is why he is a theological and moral problem: he is the outsider whom it behooves the Church not to define exactly. To the seventeenth-century Dutch philosopher Spinoza, it seemed absurd to imagine a Devil

who against God's will ensnares and deceives very many men (rarely good ones, to be sure), whom God thereupon hands over to this master of wickedness to be tortured eternally. The Divine justice therefore allows the Devil to deceive men and remain unpunished; but it by no means allows to remain unpunished the men, who have been by that self-same Devil miserably deceived and ensnared.[7]

Spinoza points to a defining characteristic of the Devil: he is the one to whom God hands over the sinners. By implication, the Devil is used by God, works for God, and is, in a sense, not in conflict with God. If this seems theologically unsound, it is nevertheless the common ground for most depictions of Hell. So if the Church did not provide iconographical clarity for the Devil, that is not surprising. The evil of the Devil required fudging.

The Devil is not merely a literary creation. He *is* real, part of the reality of Western civilization. Perhaps the reason the Devil interests us is because he defines God as surely as God defines him. Thank God for the Devil! This is a serious joke. We might say, as Ivan Karamazov does: 'I think that if the Devil doesn't exist and is therefore man's creation, man has made him in his own image.' If we limit ourselves to pictures of the Devil, then Ivan's remarks are, at best, only partly true. Perhaps an inadequate idea of the Devil is the same as an inadequate idea of God. What the Devil is, what his name is, and what he looks like are what we will hunt for. The results may be surprising. The full story, the history, of the Devil is of exceptional interest in itself, but in this book it will also guide us towards a new way of looking at a wide range of works of art, from frescoes in the catacombs and carvings in France to Michelangelo's *Last Judgment*. Michelangelo's work of 1536–41 in Rome's Sistine Chapel, and Lorenzo Lotto's surprising one of 1550, *Michael and Lucifer*, mark the end of our study, for reasons that will become clear. But first, before we turn to the paintings and sculptures, we will consider aspects of the Devil that are grounded in literary sources, in particular his name and his fall from Heaven, as interpreted by the Church Fathers from the second to the fifth centuries.

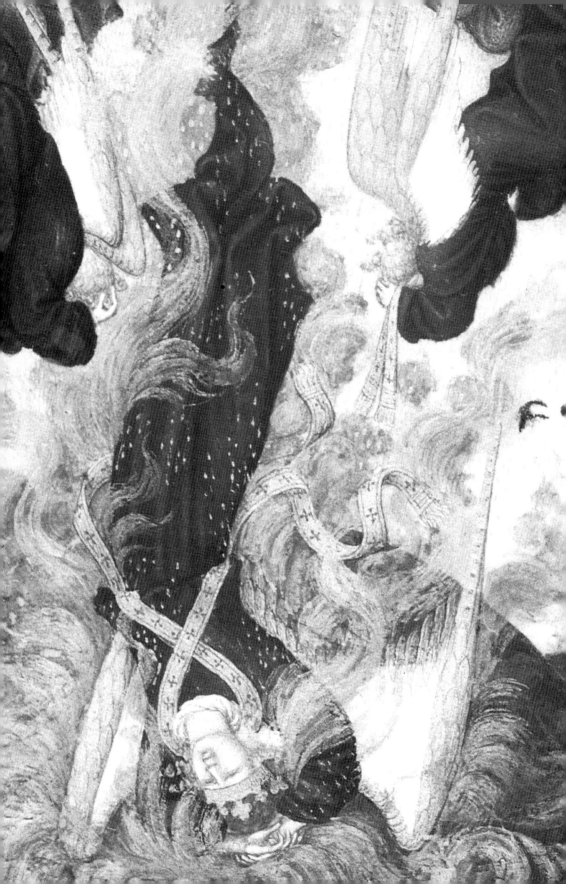

1 The Name of the Devil

The difference between the Devil and Satan

Anyone who thinks that Satan is the name of the Devil may be puzzled to discover that the word *satan* existed before the word *devil*. In all Western languages the latter term is the same: *devil*, *diable*, *diablo*, *diavolo*, *Teufel*. And all languages that have it also have *satan*. Though roughly the same, there is no Devil without Satan and no Satan without the Devil. 'Roughly the same' now, but quite different at first. *Satan* is a Hebrew word that normally means adversary, and nothing more. Sometimes he is a human being and sometimes a celestial figure. In the Old Testament Book of Job, Satan is a member of God's Council. The Satan is a position, that of inspector or prosecutor. The Satan is a title; it is not anyone's name.[8] The Satan is *not* the Devil (though he was to become that in Christian commentaries). In the Old Testament canon, except for the Book of Job, you will rarely find *the* Satan (or Satan), and when you do, he is unimportant. The adversary of God – the Devil – is called *diabolos* in the Gospels of Luke and Matthew. That Greek word meant accuser or slanderer; it was rendered into Latin as *diabolus*. The Satan and the Devil were different. More than three hundred years before Christ, however, a wild card had been introduced by the Alexandrian Jews who translated the Old Testament into Greek and rendered the Hebrew *Satan* into the Greek *diabolos*. This is why the Devil of the Old Testament and the New Testament share the same name even though they do not mean the same. The result is that the *form* of the English word 'devil' comes from the Latin *diabolus*. But the *meanings* of 'devil' come from three different words, in Hebrew, Greek and Latin – *satan*, *diabolos* and *diabolus*, confusing people over the centuries. These meanings overlapped even during the first century AD and were inconsistently used as alternatives in the Scriptures and commentaries.

Yet another word for Devil is *daimon*, or demon. A *daimon* was an

3 Detail of the Limbourg Brothers's 'The Fall of Lucifer and the Rebel Angels', from their *Les Très Riches Heures du Duc de Berri* (illus. 64).

intermediate spirit between gods and men, often the spirit of a dead hero. In Plato's *Symposium*, for example, love is a great *daimon*, intermediate between the gods and mortals. In *Cratylus*, Socrates calls good, wise men 'demons'. A demon is also a man's genius, and this is what Shakespeare's Cleopatra means when she praises Antony: 'Thy demon, that's thy spirit which keeps thee, is noble, courageous, high, unmatchable.' *Daimon* and *daimonion* also meant an evil, possessing spirit, and it was only this meaning that was developed in the New Testament and by many early Fathers. The Hellenized Alexandrian Apologists of the second and third centuries, for example, interpreted Platonic demons – who were neither particularly good nor bad – as evil fallen angels. They did so to form a new equation: pagan gods = evil demons = devils.[9] That equation justified condemning the worship of pagan gods. 'The things which the Gentiles sacrifice, they sacrifice to devils', wrote Paul. And that equation reoriented art, the sciences and social perceptions. In Exodus (ch. 32) the people grow weary of waiting for Moses to return from the Mount and ask Aaron to cast a new Calf from their gold ornaments. He does so, and they bow down before this new idol. God alerts Moses to this transgression, and Moses descends into the Israeli camp to find the worshippers feasting and dancing. Furious, Moses smashes the tablets of the Ten Commandments, and then seizes the Golden Calf, burns it, grinds its remains to powder, and casts the powder on water that he then forces the Israelis to drink. In the eleventh and twelfth centuries this subject had considerable appeal, since the Golden Calf was understood to have been the Devil taking the form of a pagan idol. On a capital in the abbey church of La Madeleine, Vézelay (illus. 4), and on another at St Lazare, Autun (illus. 20), both of which date from early in the twelfth century, Moses faces the Golden Calf, who is merely an instrument of the Devil and depicted as enormous and fierce. In La Madeleine the ferocious Devil is shown actually emerging from the Calf's mouth. Moses is shown holding a club in both carvings, understandably so because, unlike the version told in Exodus, the episode is presented as a powerful scene of confrontation and conflict. To these Romanesque sculptors, the Golden Calf was one form of the adversary of God.

Equating pagan idols with the Devil had led to much of the destruction that Giorgio Vasari was to bemoan. In the preface to the revised edition of his *Lives of the Artists* (1568), Vasari, with more than a trace of irony, wrote that Christianity

with great fervour and diligence strove to cast out and utterly destroy every least possible occasion of sin; and in doing so it ruined or demolished all the marvellous statues . . . [and] countless memorials and inscriptions left in

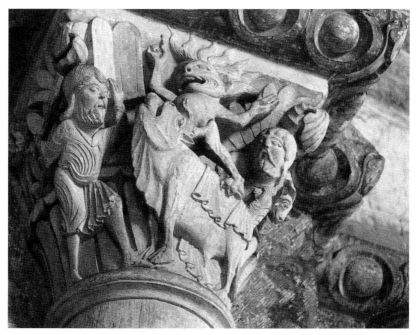

4 'Moses and the Golden Calf' on a capital, early 12th century, in La Madeleine, Vézelay, Yonne.

honour of illustrious persons who had been commemorated by the genius of the ancient world. [The Christians'] tremendous zeal was responsible for inflicting severe damage on the practice of the arts, which then fell into total confusion.[10]

The New Testament helped the confusion. Mark did not call the Devil *diabolos* but *Satanas*. And the Hebrew *Satan* was sometimes translated in Greek either as *diabolos* or as the Aramaic *Satanas*. Distinctions soon faded. Satan, Satanas, diabolos and diabolus became interchangeable in meaning. If we look at the Gospels, 1 John and Revelation, certain patterns emerge:

daimonion (evil spirit): known by Mark, Matthew and Luke (John knows no casting out of devils, but only the form 'to have a devil'). In Revelation there is one occurrence of *daimonion* referring to pagan gods and two uses of *daimon*. In 1 John there is nothing.
diabolos: known to Matthew, Luke, 1 John and Revelation. It is unknown to Mark.
satanas is known to Mark, Luke, Matthew, Revelation. It is used once by John, but unknown to 1 John.

These writers may have been referring to different beings and so used different terms; not one of them seems to have been familiar with all

21

three terms. They may have had different ideas of the essential form and specific attributes of the Evil One or considered them alternative terms. We do not know why the tempter of Jesus was called *diabolos* by Matthew and Luke but *satan* by Mark. We do know that *diabolos* was not ordinarily connected with devils who possess, while *satan* was.[11] Perhaps Matthew and Luke wanted to distinguish the adversary of God, the (upper-case) Satan, from mere (lower-case) devils. But since Mark used *satan* to describe the same being who is called *diabolos* in the other two Gospels, later commentators (and translators) quite naturally equated the two. In the event, Satan became the name of the Devil in the equation satan = diabolos, which is specifically stated in Revelation (12:9): 'And the great dragon was cast out, that old Serpent, called the Devil [*diabolos*] and Satan. . . .' With the translation of the Bible into Latin (and there were many translations from various sources before the fifth century), we are faced with semantic entanglements in which fine distinctions vanish. This reduction and fusion of different demon traditions and Devil terms were complete by the third century, and we can see the results in one of the earliest mystery plays, the mid-twelfth-century Anglo-Norman Mystère d'Adam. Adam, quite annoyed that 'Diabolus' has spoken to Eve, goes to her and says: 'Tell me, woman, what did the evil Satan want with you?' (*Di moi, muiller, que te querroit / Li mal Satan?*) So the Hebrew *Satan* that became the Greek *diabolos* that became the Latin *diabolus*, has become the French *Satan*! And in fourteenth-century English mystery plays, for example The Chester Cycle, we find that Satan, Satanas, Diabolus, Lucifer and the Devil are interchangeable; they turn into one other like a sequence on an endless loop – like a Mobius strip.[12]

How did the Devil get the name of Lucifer?

'I cannot discover', Shelley recorded in his ingenious essay on the Devil, 'why he is called Lucifer, except for a misinterpreted passage in Isaiah'.[13] We will try to understand why that passage was misinterpreted. You cannot find 'Lucifer' even if you examine every page of the Apocrypha and Pseudepigrapha. Lucifer – as the Devil's name – is not in the Scriptures. *Lucifer*, in fact, is no-one's name: it only means 'bringing light'. Lucifer is the morning star, the planet Venus, which appears before sunrise. Ovid describes how each new day begins when 'Lucifer shines brightly in the heavens, calling mankind to their daily rounds. Lucifer outshines the brightest stars.' Shelley, in his *Defence of Poetry*, hailed Dante as 'the congregator of those great spirits who presided over the resurrection of learning, the Lucifer of that starry

flock which in the thirteenth century shone forth from republican Italy, as from a heaven, into the darkness of the benighted world.' But open the *Commedia*, and at the bottom of Dante's 'Inferno' is Lucifer, a hideous monster. For Dante, Lucifer and Satan are one and the same. How and why did this happen?

The identification of Lucifer with Satan comes from Isaiah (14:12): 'How art thou fallen from heaven, O Lucifer, son of the morning!' Isaiah was *not* speaking of the Devil. Using imagery possibly from an old Canaanite myth, Isaiah described the overreaching of an ambitious Babylonian king who fell into the underworld.[14] His words came to mean a reference to the Devil through four steps: a tyrannical king is described in a metaphor (the king = a shining star); the Hebrew *Helel* (*Helel ben Shahar* = 'the brilliant one') or the Greek *eosphoros* are translated into Latin as the morning star, Lucifer; later, the tyrannical king is identified with the Devil; *ergo* Lucifer becomes another name for the Devil. The answer to the question of why that king was identified with the Devil is that it solved the vexing problem of the nature of the Devil. Origen, a third-century theologian, did not evade the issue: 'No one can know the origin of evil', he wrote, 'who has not grasped the truth about the so-called Devil and his angels, and who he was before he became a Devil and how he became a Devil. . . .'[15] If God created the Devil, and if the Devil is inherently evil, then God created evil. The implications could be disturbing (particularly since, as Spinoza pointed out, the Devil tempts people to commit evil for which they are then punished). Were the Devil born evil, could it be said he sinned? He would have *had* to do evil. If, however, God did not create the Devil, then God is not omnipotent and we slide into a Manichæan world, a conflict between good and evil with the outcome inherently indecisive. The fifth-century Christian Fathers solved the problem in two steps. Yes, God created the Devil, but no, the Devil was *not* inherently evil when created; rather, he chose to become evil. Therefore, God remains omnipotent but he is not responsible for evil. This solution required support from the Scriptures, and how that support was supplied will explain why Lucifer become a name for the Devil. The reasoning of Augustine, the leading early fifth-century Christian thinker, is instructive.

Augustine was far more influential than Origen (whom he detested), and we can judge his temperament when he says that though good and bad men suffer alike, there is a crucial difference: 'In the same fire, gold gleams and straw smokes; the lees are not mistaken for oil because they have issued from the same press. . . . The same shaking that makes fetid water stink makes perfume issue a more pleasant odour.'[16]

In the third part of *The City of God*, his major work, Augustine explains the origin of the two cities, the city of God and the city of the Devil. Originally, he says, all angels were beings of light, created to 'live in wisdom and happiness. Some angels, however, turned away from this illumination.' If the Devil is a fallen angel, then he must have fallen. Yet the first epistle of John insists that 'the Devil sinneth from the beginning. For this purpose the Son of God was manifested, that he might destroy the works of the Devil. Whosoever is born of God doth not commit sin; for his seed remaineth in him: and he cannot sin, because he is born of God' (3:8–9). Does this imply the Devil was not created by God? John's Devil and Augustine's did not seem to be one and the same, but Augustine had an answer. John did indeed write that 'the Devil sinneth from the beginning', admits Augustine, but this 'should be understood in the sense that he sinned not from the beginning of his creation but from the beginning of sin, because sin had its beginning in pride'. This manipulation leads to the answer of our initial question.

The Manichees do not understand that, if the Devil is evil by nature, there can be no question of sin at all. They have no reply to the witness of the Prophets, for example, where Isaias, representing the Devil figuratively in the person of the Prince of Babylon, asks: 'How art thou fallen from Heaven, O Lucifer, who didst rise in the morning?'. [This indicates] that the Devil was for a time without sin.[17]

Augustine's explanation shows that at the time he was writing, Lucifer was *not* a common name for the Devil. True enough, two centuries earlier, Origen interpreted sections of Leviticus, Exodus, Ezekiel and Isaiah as references to the manifestations of the Devil. But no-one had sought to make detailed deductions about the Devil from these passages, nor to *identify* the Devil with the name of Lucifer. Origen was trying to grasp the nature of evil. Augustine's motive was different: he wished to identify heretics. Who were the angels that followed Lucifer? They were, Augustine assured his readers, heretics, 'converted to their own vomit'.[18] No, says Augustine, the Devil has no powers of his own, no territory of his own, and no, he was not self-created. There is no principle opposed to God that created the Devil. What happened, he says, is that originally the Devil was without sin, but later (some said an hour, some said more than a week) he fell from the truth, and the Lucifer cited by Isaiah is one proof of this fact. In fact, Lucifer became the name of the Devil as part of the reasoning used to support the idea that the Devil was originally an angel, created by God, who refused grace and turned from the truth. The driving force behind Augustine's interpretation of Isaiah was his fight against 'the Manichees and similar

poisonous heretics who hold that the Devil derived his peculiarly evil nature from some Principle opposed to God'.[19] (Eight centuries later, Aquinas was to say the same thing about the Devil and the Manichees.[20])

To fight the Devil and to define him more clearly, the passage from Isaiah was interlocked with the fourth part of the Book of Revelation (ch. 12), where a great red dragon is seen:

And his tail drew the third part of the stars of heaven, and did cast them to the earth: . . . And there was war in heaven: Michael and his angels fought against the dragon; and the dragon fought and his angels, And prevailed not. . . . And the great dragon was cast out, that old serpent, called the Devil, and Satan, which deceiveth the whole world: he was cast out into the earth, and his angels were cast out with him.

Satan became the rebel angel. Though Satan and the Devil and Lucifer were one and the same, without the fusion of Isaiah and Revelation, Dante, in the last canto of 'Inferno', could never have written of Lucifer that

> S'el fu si bello com'elli è or brutto,
> e contra 'l suo fattore alzò le ciglia,
> ben dee da lui procedere ogni lutto.

> If he were once as beautiful as he is ugly now,
> Yet still presumed to raise his hand against his Maker,
> All affliction must indeed come from him.

Hideous and repulsive as Lucifer is in the *Commedia*, the rebel angel had won a third part of the stars of Heaven to his side and had a potential for transformation that the unimportant Hebrew Satan and the New Testament Evil One did not. Though Lucifer was a name added to that of Satan, for Dante and for most of Christendom, Lucifer preceded Satan. As the worldly Monk in Chaucer's *Canterbury Tales* explains in his narrative:

> O Lucifer, brightest of angels all,
> Now art thou Satan, who cannot escape
> Out of the misery in which thou art fallen.

Lucifer was 'once as beautiful as he is ugly now', Dante reminded his audience, but only Satan's ugliness and evil were in the minds of believers, thinkers, writers and artists for over one thousand years. Even Botticelli, that lover of beauty, drew a repulsive beast when he illustrated Dante's Lucifer (illus. 5). He did so because he was following Dante's text, it is true, but nevertheless almost all paintings and illuminated manuscripts of the Middle Ages and the Renaissance show Satan as hideous.

5 Botticelli, 'Lucifer', illustration for canto xxxiv of Dante's 'Inferno', 1497, silverpoint, pen and ink. Kupferstichkabinett, Berlin.

Michael slaying the hideous Satan in the shape of a dragon is a common theme, but Michael fighting the rebel angels is not. The fall of the rebel angels is rarely depicted, and when it is, Satan and his angels are grotesque spirits. 'Beautiful' Lucifer, Satan before his fall, is virtually unknown. One remarkable exception is the early fifteenth-century illumination by the Limbourg brothers (illus. 3, 64). God and his hosts are on high. The rebel angels are hurled down in two lines from left and right, forming a chevron that culminates in Lucifer entering Hell. These lines of rebel angels are in exquisite blue and gold, and because of the formal composition, the eye follows the two lines down to the climax, Lucifer at the apex. This movement is strengthened by the gradual increase in size of the rebel angels as they fall toward us and to Hell.

Lucifer is larger than God, and beautiful, the first 'beautiful' Lucifer in the history of art. A closer analysis would show this singular painting in a different light, but this must wait until the final chapter. It remained for Milton in the seventeenth century to imagine a Satan in Hell who yet retained the glow of the Lucifer he once had been. And the Romantics of the nineteenth century recreated the angel Lucifer by reinterpreting the reason for his fall. But most people do not know that

it was the Church Fathers of the fifth century who had made the first and decisive reinterpretation of why it was that the angel Lucifer had been expelled from Heaven.

For what sin was the Devil expelled from Heaven?

The Bible does not tell us what the Devil's sin was. For Milton, his sin was pride. In countless mystery plays, his sin was pride. In all the commentaries from Augustine onward, the Devil's sin was pride. He was the favourite of God, the brightest of the angels, and yet, as Augustine explains, he refused to obey his creator:

> The joy of Eden was short-lived because [Lucifer's] pride caused him to turn away from God to his own self and the pleasures and pomp of tyranny, preferring to rule over subjects than be subject himself.[21]

This was *not* the opinion of the early Church Fathers, nor of the leading Christian thinkers of the first three centuries. The main reason for this little-known difference is that their Bible was not the one that we know. Until the fourth century, the Book of Enoch was part of the still loosely defined canon.[22] Some scholars are sure it was originally written in Hebrew, some think the original language was Aramaic, and some think parts were written in Hebrew and other parts in Aramaic. No-one knows: the only full text we have is in Ethiopian. The first part of Enoch (chapters 1–36) is enormously important because it goes back probably to *c.* 300 BC and the earliest books of the Bible. One of the ancient sources used by the final editors of Genesis was similar to a source more fully utilized in Enoch. Familiar to the Jews and early Christians, Enoch was true scripture to Jude, Clement, Barnabas, Tertullian and other early Fathers (though Jerome and Origen had reservations). So influential was this book that it was cited even by pagan critics, such as Celsus, who studied the Scriptures. Many Christian concepts first appear in Enoch, in particular the Son of Man who becomes the Chosen One and acts as an eschatological judge.[23] The Last Judgment – a development from Matthew (25:31–3), which includes the separation of the sheep from the goats, and God's judgment – seems to derive from the Similitudes of Enoch. The Abyss of Fire, a kingdom of hell ruled by Satan and the rebel angels, first appears in Enoch. Despite its demonstrable influence, despite Enoch being considered holy scripture by leading theologians for hundreds of years, when the canon was strictly defined, the theologians who did the defining found some sections of Enoch unpalatable, so that Enoch – like the Devil – was cast out.

The origin of the fallen angels and Satan's sin is to be found in the opening verses of Genesis, chapter 6:

And it came to pass, when men began to multiply on the face of the earth, and daughters were born unto them, that the sons of God saw the daughters of men that they were fair; and they took them wives of all which they chose. . . . There were giants in the earth in those days; and also after that, when the sons of God came in unto the daughters of men . . . they bare children to them . . . who became mighty men . . .

Angels, 'the sons of God', having intercourse with women, the daughters of men, demanded comment.[24] Jewish writers interpreted 'sons of God' as sons of princes and lords. Some Christians, Augustine among them, thought that the phrase meant pious men who are spiritually the sons of God. Both Jewish and Christian writers avoided one obvious meaning: that some barrier between the sons of God and the children of men was broken, not through divine will but because of sexual lust. This sexual union prompted God to declare his purpose to 'destroy man whom I have created from the face of the earth'. Chapter 6 was probably a fragment pasted in to give a moral motivation for the story of the Flood, derived from Mesopotamian versions that lack it. The children of the sinning angels were the Nephilim, a race of antediluvian beings rendered as 'giants' in the King James version of Genesis. Though it is not stated in Genesis that these Nephilim were evil, they were considered such in Second Temple period Apocryphal writings. Furthermore, the final compilers of chapter 6 probably knew the complete story told in Enoch, with details concerning the children born of the union between angels and women, 'who will be called evil spirits upon the earth'.[25] These evil giants turned against man and created such havoc that God instructed Raphael to bind the leader of the angels, make an opening in the desert, cover him with darkness and cast him into the fire on Judgment Day. God also ordered Michael to bind the other sinning angels and their offspring, and then drag them to the Abyss of Fire for eternal imprisonment and torment.

The sin of the Devil, then, was not pride. The sin of the Devil was sexual lust. Demons and devils were the creation of the sexual union between the lustful angels and women. This influential interpretation made by many early Church Fathers is one reason why Enoch was cast out of the canon. Here is what those early Fathers wrote. Justin, martyred in Rome in AD 165, explained that some angels violated the right order of things, gave in to sexual impulses and had intercourse with women whose children we now call demons.[26] These demons are the cause of murder, war, adultery and every other evil. Athenagoras,

another Greek Christian Apologist, wrote (in 177) that the Devil was created by God just as He had created the other angels. Man has free will to choose between good and evil, and so do the angels. But in the past some angels had lusted after virgins, became slaves of the flesh, had intercourse with virgins, and sired children who were giants. Together with the souls of those giants, the angels that fell from the heavens haunt the air and the earth; they are the demons that wander about the world.[27] Clement of Alexandria, another leading Apologist, was a flexible and subtle thinker active at the turn of the first century. Condemned in the ninth century as a heretic by the illegally consecrated patriarch Photius, Clement was removed from the Roman martyrology. He imagined that the truths in Greek philosophy had been stolen by the Greeks from the Hebrews. Both Greek and Hebrew writings mix truth with error, the source of the mix-up being the Devil.[28] Ultimately, Clement argued, all truths in philosophy are from the fallen angels; this idea is derived from Enoch. One of the most extraordinary Christian Apologists was the intense polemicist Tertullian (AD 155–220). Like most of the creative early Fathers, Tertullian converted in his middle years. 'Can anyone be more learned, more acute of mind than Tertullian?', asked Jerome. Many 'technical' Christian terms used in Latin today are Tertullian's coinage; original sin, *vitium originis*, is one example. Nothing he wrote is dull, and most of it retains considerable force. This fierce leader of the North African Church joined the Montanists, a rigid ascetic group believing in progressive revelation, a teaching the Church condemned. Tertullian, like Clement, believed that the heavenly angels who had sex with the daughters of men, as described in Enoch, revealed many secret arts, including the mystery of mascara. In evocative prose, Tertullian picks up a sentence in Enoch (ch. 8) and expands it to explain that the fallen angels had taught women

the radiance of precious stones with which necklaces are decorated in different colours, the bracelets of gold which they wrap around their arms, the coloured preparations which are used to dye wool, and that black powder . . . to enhance the beauty of their eyes.[29]

Tertullian has countless references to Enoch. In his famous Apology, for example, he understands Genesis in the light of Enoch when he writes that Scripture tells us that 'some of the angels were perverted and became the source of an even more corrupt race of devils'.[30] He and other early Fathers accepted the idea of perverted angels because they understood chapter 6 of Genesis through Enoch. They interpreted the text straight, and considered the sin of the Devil to be sexual

lust. But in the fifth century, Augustine confidently stated that 'There is no doubt about the fact that these "angels" were men and not, as some people think, creatures different from men.' In our time as in Augustine's, when people say 'there is no doubt', there usually is.

Augustine argues that the 'sons of God' were angels only in spirit, and they allowed themselves to fall from grace. Before this fall, these potentially superior people had children not as the result of sexual passion but only in order 'to people the City of God with citizens':

> In any case, I would not dream of believing that it was the holy angels of God who suffered such a fall in the present instance . . . and there is no need to appeal to the writings which ran under the name of Henoch [Enoch], and contain the fables about giants [nor] to a number of writings under the names of various Prophets and Apostles which are circulated by heretics.[31]

The Book of Enoch has become a tool of heretics. But what Augustine does not tell us – and what, in fact, only recent research has unearthed – is that some sections of Enoch dealing with giants had been 'appropriated' or 'pre-empted' by the same Manichees who had taught Augustine and whom Augustine came to abhor.[32] Augustine branding this book as heretical was effective enough to bury it for a millennium.

The first publication of extracts from the Ethiopian text of Enoch, which, as I have said, is the only complete one extant, was not until 1800. The first full translation was published by Richard Laurence at Oxford in 1821, and it led to new debates about whether the 'sons of God' who had sex with women were indeed angels. Clearly stimulated, Byron used that translation for his verse drama 'Heaven and Earth: A Mystery' (1821), which, as Henry Crabb Robinson noted in his *Diary* for 1869, Goethe reckoned to be the best of Byron's serious works. Even Byron, however, still followed the tradition that the Devil's sin was pride. How could Byron have known that before Augustine discredited the Book of Enoch, for Justin, Athenagoras, Clement, Tertullian and others throughout more than three centuries of Christian teaching, the Devil's sin was not pride, but sexual lust?

The Devil's rights, and Christ as a fish-hook

Why does Michelangelo's *Moses* have horns? You cannot answer that question by staring at the statue, only by knowing how certain Hebrew phrases were mistranslated in the Middle Ages. Why, in a number of paintings, is a field of wheat shown to have appeared suddenly, hiding the path Mary takes as she flees to Egypt? The answer is in *The Golden Legend*, a thirteenth-century collection of fabulous tales about the

saints. Why do the dead rise from their graves fully dressed in the carved portal of the Last Judgment at Notre-Dame? The answer is to be found in the beliefs of the early thirteenth-century Archbishop of Paris, Maurice de Sully. Doctrines and writings directly influenced various motifs in sculpture and painting. The Devil is the exception. After the fifth century, Church writings about the Devil had little effect on his visual image. Aquinas's ideas about the Devil and evil, though expressed some eight hundred years later, are the same as Augustine's.[33] Scholastic formulations about the Devil had little influence on his image, and the doctrine of Atonement is powerful proof.

The Christian doctrine of Atonement has never been officially formulated, although it was one of the Church's most discussed mysteries.[34] Arguably, it is the first contract with the Devil. Originally formulated by Irenæus near the end of the second century, and fully worked out by Gregory of Nyssa in the fourth century, the ransom theory of Atonement was believed by most Christians for one thousand years. Though it may seem bizarre, here is what theologians from Gregory of Nyssa to Augustine and popes Leo the Great and Gregory the Great believed. Adam sinned, and for that he was punished after death by becoming a bondsman in the Devil's kingdom. A bondsman can be freed only by paying that bondsman's lord a ransom. God wanted to free man; otherwise His plan would be thwarted. Since God is just, He could not forcibly wrest man (the bondsman) from the Devil (his lord). So God decided to trick the Devil, keeping the birth of Jesus secret. As Jesus grew up, the Devil realized what a perfect man Jesus was, and wanted him for his own kingdom. He agreed to accept the death of Jesus as a ransom for man. Following Jesus's crucifixion, the Devil reached out to grasp his ransom only to discover that he had been tricked. The man Jesus was the human bait in which was hidden the hook of Christ's divinity. Man became free of the Devil's chains because Christ was sacrificed to meet the rights of the Devil: he atoned for the sins of man. 'I have come', said Jesus, 'to minister, and to give my life as a ransom for the many'. From these few words sprouted the idea of Atonement. Paul implies that Christ's death was a kind of substitution for man's sufferings, by which man can be reconciled with God. 'Since all have sinned', says Paul, 'they are justified by his grace as a gift, through the redemption which is in Christ Jesus, whom God put forward as an expiation by his blood'.

In the first century AD, Ignatius suggested that God deceived the Devil by keeping the birth of Jesus secret.[35] In the second century, Irenæus defined the Devil's rights by arguing that Adam's apostacy justified the Devil's unjust rule over man. God could not use force

because that would violate the principles of justice. Therefore, God purchased back man, using Jesus as ransom.[36] Christ was the ransom paid to the Devil to release man from his bondage, and Gregory of Nyssa expressed this in an unforgettable metaphor: Christ is bait on a fish-hook:

The purpose of the Incarnation was that the divine virtue of Jesus might be as it were a hook hidden beneath the form of human flesh . . . and that the Son might offer the Devil his flesh as bait and that then the divinity which lay beneath might catch him and hold him fast with its hook.[37]

Since God is just, he would not, argued Gregory, exercise 'an arbitrary authority over the Devil who held us in bondage', because if God had used force the Devil would then have had 'a just cause of complaint'. Christ as God's trap for the Devil, and Christ as ransom paid to the Devil were popular ideas. But another Gregory of the fourth century, Gregory of Nazianzus, was horrified: 'Outrageous! Was the ransom paid to the Devil? Did the Blood of His Only begotten Son delight the Father?'[38] Yet this 'outrageous' idea remained. Augustine accepted the idea, though he changed the image of Christ as bait on a fish-hook to an even less pleasant one – a mousetrap.[39] The Devil has rights over man, so ransom must be paid the Devil, and God tricks the Devil by using Christ as bait. These vividly imaged arguments were orthodox belief.

Anselm, the eleventh-century founder of Scholasticism, strongly rejected this idea.[40] No *ransom* is due to Satan, but a *debt* is due to God: this is the core of the satisfaction theory. Anselm rejected Gregory's idea that 'God was bound to strive with the Devil by justice, rather than by force'. 'I cannot see', argued Anselm, 'what force this argument has'. Man deserved to be punished, but the Devil, insisted Anselm, has no right to inflict it. On the contrary, since the Devil is not motivated by love of justice but by malice, it is the height of injustice. Therefore nothing is due the Devil. Anselm's satisfaction theory of a debt due to God rather than a ransom to the Devil was widely accepted by educated ecclesiastics. The above is my summary of the standard account; but whether Anselm was seriously interested in trying to find out if it was a debt or a ransom is another question. Perhaps he could not have cared less; his new formulation was a response to critics who could not see how God was omnipotent and good if he had to suffer and come down from Heaven as Jesus Christ to defeat the Devil. Robinson Crusoe faced the same problem as had Anselm when he tried to explain to his savage companion, Friday, that the Devil was God's enemy, seeking to ruin the kingdom of Christ:

'Well,' says Friday, 'but you say God is so strong, so great, is He not much strong, much might as the devil?' 'Yes, yes,' says I, 'Friday, God is stronger than the devil, God is above the devil, and therefore we pray to God to tread him down under our feet. . . .' 'But,' says he again, 'if God much strong, much might as the devil, why God no kill the devil, so make him no more do wicked?'

I was strangely surprised at his question; and after all, tho' I was now an old man, yet I was but a young doctor, and ill enough qualified for a casuist, or a solver of difficulties; and at first I could not tell what to say, so I pretended not to hear him. . . .[41]

Anselm did not have the luxury of pretending not to hear. His debt theory was a response to dissidents who raised the same questions as Friday did. Anselm pursues the subject of the Devil's rights and argues that an action can be both just and unjust, depending on the point of view. He argues that the Devil torments man justly 'because it is just for God to permit it, and just for man to suffer it. But if man is said to suffer justly, this is not because of its own inherent justice, but because he is punished by the just judgment of God.' There may be sense in this, but it is mostly hedging. Some people are fascinated by the Scholastics, but the Scholastics rarely stand up on careful rereading and seem closer to the Sophists, but without their honesty and with much weaker logic. Closely considered, most Scholastics, including Anselm, are playing with formulations that are fobbed off as logical ideas.

An important exception is Peter Abelard (*c.* 1079–1142), who, like Anselm, rejected the Devil's rights.[42] Unlike the founder of Scholasticism, Abelard sharpened the problem. What right could the Devil possibly have, he asked, for torturing man unless the Lord expressly gave him that right? And this the Lord would not do: for the Devil to have rights over man would be totally unjust, since it was the Devil that tricked man into sin. And for what possible reason must Jesus endure fasts, insults, scourgings and spitting, and finally a most bitter and disgraceful death? For our redemption? Abelard then reached beyond Anselm to ask a question that no-one had ever asked before:

If the sin of Adam was so great that it could be expiated only by the death of Christ, what expiation will avail for that act of murder committed against Christ?

Both the ransom theory and the theory of satisfaction seemed ethically repugnant. Abelard's own concept of the Atonement is that, through his suffering and death, Christ has more closely bound us to himself by love, and our hearts are 'enkindled by such a gift of divine grace . . . bearing witness that he came for the express purpose of spreading the true liberty of love amongst men'. In Abelard, the imagery of debt and

interest do not exist. But his ethical understanding of Atonement was largely ignored; Anselm's formulation became orthodoxy (and was used by Aquinas). The Devil's power was sharply diminished: a *debt* to God replaced a *ransom* owed to Satan. Theologically, this new doctrine was a radical redefinition of the Devil's role. The Devil was shorn of his rights. The facts are, however, that the extensive literature on this topic had *no* effect on the Devil's visual image. On the contrary, the Last Judgments carved for cathedrals throughout Europe show the Devil receiving the sinners due to him and enjoying the right to punish them, thus participating in God's justice.

The drastic change in the theological formulation of the Devil's 'rights' were only words: the popular visual image of the Devil remained the same for at least three reasons. First, in the fully expanded Last Judgment, the Devil's image came from a pictorial tradition little influenced by the written word. Second, pictorial traditions usually are modified rather slowly, and then only when existing forms fail to fit with contemporary ways of representing reality. And third, there were no painted or sculptural models that might form the basis for artistic reflections of this new perception of the Devil. Three centuries after Anselm, a Shropshire canon, for example, preached a sermon influenced by the ransom theory, in which he explained that Christ tricked the Devil by undergoing circumcision so that 'the Hell-Hunter might not perceive the mystery of the Incarnation'.[43] Perhaps the most decisive reason for the theory's survival is that most people, including clerics, could not easily sort out these newer distinctions. The earlier image had been in the popular mind for more than five hundred years, and probably remained the dominant image in the popular tradition. At higher levels of theological theory the Devil's role had been changed; but at the popular level, he retained his rights. Nothing in the writings of Scholastics is needed, for example, to understand anything about the Devil in the mystery plays of the fourteenth and fifteenth centuries, which are the best evidence of the oral and popular tradition of the Devil. 'Give the Devil his due' – is this idiom not a remnant of the ransom theory: that the Devil, too, has rights which remain with us to this day?

2 What the Devil Looks Like

Why is the Devil naked?

If we look at medieval paintings of different saints we see the same faces, and only with the aid of a fixed iconography of attributes can we tell, for example, Peter from Paul, or Mark from Luke. If we see the keys we know it is Peter; if we see a bull we know it is Luke. But how do we recognize the Devil? By his horns? His tail? Alas, all too often, the Devil has neither horns nor tail. Nor pitchfork. Nor cloven hoofs. And we do not recognize the Devil just because he looks mean, for sometimes he is positively comic (illus. 13). Representations of all figures, including Jesus and the Devil, changed between the fifth and the fifteenth centuries. The changes in Jesus can be plotted; those of the Devil are more difficult, because the iconography of Jesus was defined whereas that of the Devil was not. We will look at examples to make this contrast clearer, but it will be a false clarity unless we place these representations in their historical context.

The purpose of medieval media – church sermons, mystery plays, stained-glass windows, mosaics and sculpture – was to instruct, to explain and reinforce belief. The meaning was determined through iconography, and this was normally planned by individual churches and executed by their artists. The great works of medieval art prove creativity was not wholly stifled. Even so, when the sculptor Tideman made a non-traditional Christ for a London church in 1306, the bishop had it removed and demanded that the sculptor return his fee.[44] (In our own century, an unenthusiastic Rockefeller is supposed to have balked when Diego Rivera wanted to include a likeness of Lenin in a mural. 'After all', said Rockefeller on hearing of this, 'it is my wall'.) Probably the main reason Piero della Francesca added a distinct touch of anti-Semitism to his *Raising of the Cross* in the church of S. Francesco, Arezzo, was pressure from the Franciscans, who regularly in that church denounced the Jews.[45] The purpose of medieval art encouraged certain techniques, in particular one type of symbolism that is called figural realism. Typically, it is a set of correspondences, such as events recorded in the Old Testament that

point to analogous events reported in the New. An Old Testament prophet, for example, is thought to anticipate an Apostle; or the sacrifice of Isaac prefigures the sacrifice of Christ; or Samson's capture by the Philistines is an analogue for Christ's arrest by the Romans. Ideally, figural realism is different from allegory and 'pure' symbolism because the figure (Samson, for example) keeps its literal and historical meaning. Perhaps this sounds complicated, but it becomes more complex in the four levels of meaning that Scholastics used in order to explicate the Bible. These four levels were literal, moral, allegorical and anagogical (or mystical). It is as if you viewed a thin slice of tissue under a microscope: what you see depends on what stain you use. If that thin slice is Jerusalem, and if you look at it without any stain, that would be the literal level; you would see the physical city in Palestine. Use the moral stain and you see the Church of Christ; try the allegorical stain and you view the Heavenly City; and if you then use the special anagogical stain, you find yourself gazing at the Christian soul.

Symbolism in medieval art is a touchy subject. The painstaking medievalist G. G. Coulton suggested that the incredible explications of complex symbolism and four-level interpretations of medieval art (and, I should add, of literature) are often the inventions of academics. Though these theological methods are not modern, the applications of the Scholastic exegesis to specific paintings are often explanations after the fact. Few clerics could have understood such interpretations. Yet since some medieval specialists try to generate enthusiasm for paintings that do not have much appeal except for their supposed symbolic content, let us look carefully at one specific example.

Jean Pucelle was a skilled early fourteenth-century illuminator with original ideas, and among his works is the two-volume Belleville Breviary (Bibliothèque Nationale, Paris). In the first volume Pucelle explains his Psalter illustrations, which show the relationship of the Seven Sacraments to the three Theological and four Cardinal Virtues, and the figural relation of the Old Testament to the New. Pucelle suggests that if something seems obscure, the reader should ask for the meaning, and if there is anything obscure in the Psalter he has illustrated, he explains it. His explanation turns out to be a few general principles, such as 'the New Testament is all present in symbols within the Old Testament'. For each month, for example, Pucelle notes that there is a prophet whose 'veiled' prophecy an Apostle realizes as an article of faith. But if we look for a *specific* example of complex symbolism, the best one is Pucelle's illustration of the Four Evangelists:

[On this page] there are four Evangelists and the four beasts appropriate to them who are holding the four instruments of the Passion of Jesus Christ. First, the eagle holds out to St John the three nails that signify divinity, the number of three persons, and which, like the divine, is charity, that draws and joins together hearts; therefore the nails are made to attract and join together; and St John speaks especially to divinity. Next, the ox holds to St Luke the spear that signifies the torment and passion; and St Luke speaks especially of the Passion.[46]

This is not particularly complicated. Although we are dealing with a highly alert artist, we do *not* find the standard medieval scholar's formulation of four levels of meaning. What Pucelle describes is much simpler: the number four worked out in correspondences. There are also symbolic correspondences, such as the three nails, and an associated correspondence of divinity and charity. Usually, Pucelle only mentions the conventional Old and New Testament relations, and typically explains only two levels of meaning: 'We speak of the Synagogue in the time of the Old Testament and the Church in the time of the New Testament in two different ways, in the broad and material sense and in the subtle and spiritual sense.'

Dante, in his well-known letter to Can Grande, illustrates the multiple meanings of his *Commedia* according to the four-level Scholastic scheme. Yet the example he gives is not from his own work, and his definition, that all mystic senses are allegorical, undermines the rigid standard formula and is not consistently relevant, even for the *Commedia* (for example, 'Inferno', xxvi). The complex four-levels technique is theory, and Dante to an extensive degree worked it out in practice, but his is not the usual case. Even the intellectual elite made contradictory comments, which should give pause to scholars who postulate uniform readings. Abbot Suger of St Denis interpreted a scene in a stained-glass window that shows God in the burning bush appearing to Moses, but the author of the *Bible moralisée* insists on quite the opposite interpretation of the same incident.[47] Whatever the theory, I suggest the heavy four-level machinery was rarely applied in specific works because few people would have understood it, and this is particularly true for the populist paintings and sculptures in cathedrals and churches.

A representation of Jesus can usually be dated by certain iconographical features. The calm Christ who hangs impassively on the Cross with open eyes in the ninth century becomes, in the fourteenth, a Christ who suffers intense agony. To represent this innovation, a simple sign, or label, would not do, and more expressive conventions began to appear. Or consider the example of the position of Christ's

nailed feet: From *c.* 800 Christ seems glued to the Cross, his two feet parallel, and there is one nail in each foot. From 1250, in painting, his feet overlap and only one nail is used; this prototype becomes dominant from 1320. But changing a convention in painting could, in the Middle Ages, have political and theological implications. That is why in the latter part of the thirteenth century the Bishop of Tuy in Iberia complained that heretics were trying to shake the faith of the orthodox by painting or carving 'ill-shapen' images: 'In derision and scorn of Christ's Cross, they carve images of our Lord with one foot laid over the other, so that both are pierced by a single nail, thus striving to annul or render doubtful men's faith in the Holy Cross and the traditions of the sainted Fathers.' The Bishop had already seen many carved examples of this heterodox arrangement, for sculptors had begun to adopt it before 1200.[48] The dead Christ in Mary's lap, the *Pietà*, appears in Germany after 1300; some of these carvings in wood are among the most moving creations in art.

The Devil, however, is an impotent imp or a vicious demon in various guises at *any* time. His representation differs even in the works of one sculptor within the same twelfth-century Romanesque cathedral of St Lazare, Autun. It differs within the same work, as in Fra Angelico's *Last Judgment* in the Convent of S. Marco, Florence, three centuries later (illus. 32). Some of Angelico's devils have horns, others have none; some have tails, others have none; some have wings, some do not; some have fur, others not; some wear the face of a dog and some that of a cat (illus. 6). And Fra Angelico's big black Satan looks more like Godzilla than anything else (illus. 1). When you see representations of the Devil made between the eleventh and sixteenth centuries you are usually confronted by a grotesque beast, or perhaps a dragon flicking its tongue in between the well-formed buttocks of a naked witch. Or an imp, whispering in someone's ear or climbing out of someone's mouth – an imp with horns, sometimes with claws, and quasi-human. Or a repulsive creature leering at a lady who preens herself in front of a mirror. You see the angel Michael defeat a half-animal with bat-wings, an ugly creature frightened as if afflicted by some incurable disease against which struggling is stupid. Sometimes these devils look like grotesques; sometimes they look pitiful, and sometimes vicious. We see naked devils who are more often comic than frightening, but we do not see Satan, the Devil, the *adversary* of God. We do see creatures we can *interpret* as the Devil – such as a dragon. But that is something else.

6 Detail of Fra Angelico's *The Last Judgment* (illus. 32)

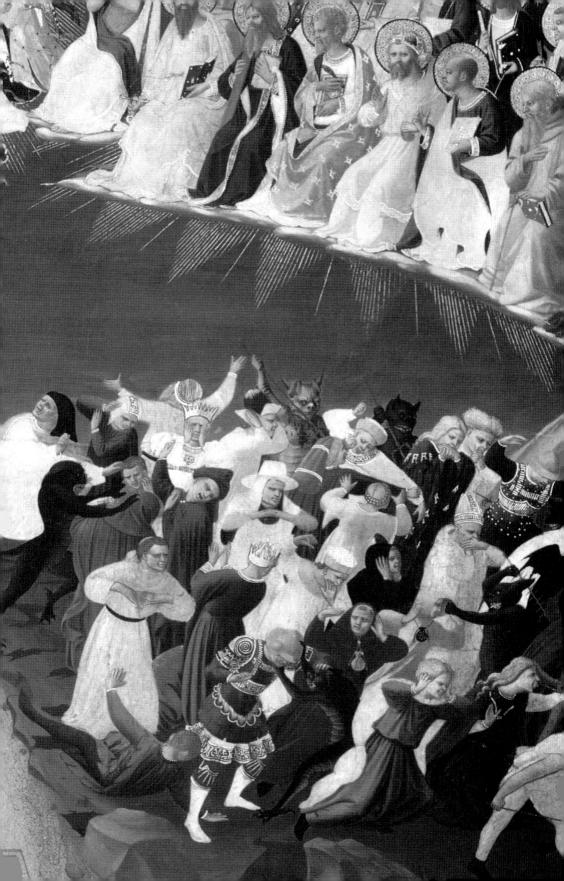

In actual practice, devils that infected every aspect of human life, from causing nosebleeds to envy, were by far the most common. The Devil's countless little agents were imagined in the Middle Ages not unlike the way we imagine microbes today – always potentially present and malign. Unlike these devil microbes, the Devil himself appeared in two main roles. First, he was the dragon that Michael fought and vanquished in the Apocalypse. His cohorts are monsters. Bruegel's *Fall of the Rebel Angels* (Académie Royale, Brussels) of 1562 is iconographically similar to a Morgan Beatus illumination of the tenth century (illus. 38). Second came the Last Judgment. Here the Devil is not the enemy: he is doing God's work, punishing the sinners. Far from being a rival, the Devil has his own place and works in perfect harmony with the holy powers. Neither adversary nor threat, the Devil tormenting the damned reinforces the system. Quite a different theme begins *c.* 800 and ends *c.* 1550: the fall of the rebel angels. The first approximation refers to the date of the Trier Apocalypse, the second to *Michael and Lucifer* by the Venetian painter Lorenzo Lotto (illus. 65). Inherently, this is a more challenging theme. To represent a horde of falling *monsters* attacked by angels (as Bruegel did) is one thing. To represent *angels* attacked by *angels* is quite something else. The awkward problem, usually avoided, is confronted in Lotto's painting. Michael and Lucifer are the same: the same body, the same face. They are twins, complementary souls. The other face of Michael is Lucifer.

Most appearances of the Devil are in Apocalypses and Last Judgments of the same time-span, from Early Christian art to the end of Christian art. Once sculpture and painting were no longer sponsored by the Church, and once the forms and functions of art had changed, Christian art became only one kind among many. In a sense, Christian art ends as the fifteenth century begins. The Church's control of media shrinks; stained-glass windows are no longer made; printed texts, woodcuts and engravings replace Books of Hours, and the Reformation begins. In Michelangelo's *Last Judgment*, the classical figure of Charon ferries the damned across the Styx to Hell, and there is no Satan. Looking at the first complete restoration of that work, recently undertaken, *Le Monde*'s art critic, Philippe Dagon, concluded that 'it is not at all a mystical painting, nor even really a religious one. It is even doubtful that it is a Christian work, so resolutely does it ignore the possibility of redemption and pardon' (10–11 April 1994). The *Fall of the Damned* (Alte Pinakothek, Munich) by Rubens is not organized by a theological concept, but by artistic concepts of light, space and interrelated masses of bodies. In fact, Rubens's works in the Alte Pinakothek are conflations. For example, the content of the 'small' *Last*

Judgment of 1619 is the expulsion of the rebel angels, to which the artist added the upper third of his 'great' *Last Judgment* of 1617. Such individualized treatment suggests a qualitative change not only in the sponsorship and functions of art but in the foci of creative impulses. Until that change, Christian art had been the medium and message for the illiterate masses. 'I'm a poor old woman who never went to school', says the mother of the fifteenth-century poet François Villon in one of his *ballades*: 'I'm no scholar; I cannot read. But I've seen pictures in the chapel with Paradise on one side with harps and pipes, and Hell on the other side, where sinners are broiled in torment. One gave me great joy, the other a great fright.'

These lines by Villon have been cited too often, and invariably by commentators who overlook the fact that Villon's mother, after all, gave birth to a poet who was not so easily frightened. Sinners broiling in Hell was an image that not everyone in those days took as seriously as do some scholars today. There are many voices from the Middle Ages and the Early Renaissance that historians tend to ignore. A barber from Languedoc, for example, insisted that 'there is nothing in the Bible about anyone going to Hell, with the exception perhaps of Judas and the Avaricious Rich Man'.[49] He was sentenced to six years in the galleys. A certain Juan Franzano from Lombardy claimed that 'there was no such thing as purgatorial fire; that it was unnecessary to confess; that [the Pope] did not follow the Gospel; that the beliefs held by the inquisitors were false'.[50] He was condemned to death. A peasant woman, Catalina Villarina, asserted in 1630 that 'there is no priestly Mass which is not a swindle and humbug'.[51] Eight years previously, Constantino Saccardino, a professional jester and distiller of medical cures, taught that religion and Hell were pure fakery: 'You're baboons if you believe in them. . . . Princes want you to believe, so that they can have things their own way.'[52] And the popular fifteenth-century priest Meffret had members of his congregation complaining that 'if the priests didn't tell us there was a Hell, they couldn't make a living'.[53]

Images of Hell and the Devil can be better interpreted and their development more clearly understood by glancing at the form in which Jesus appeared. As you walk today through the basilica of St Peter's in Rome and admire the moving mastery of Michelangelo's *Pietà* of 1500, directly under your feet is a necropolis with a mosaic ceiling completed 1100 years before Michelangelo was born. On that ceiling is a unique Apollo riding through the sky – Christ as the sun-god in his chariot (illus. 35). Christ as the Roman sun-god Helios was an attempt to solve a problem: how to represent Christ. Christ on the Cross, for example, was a serious problem from the beginning. At the opening of the fourth

century, that personable, highly readable Apologist Arnobius recorded that pagans found it incredible that Christians could actually believe 'one who suffered the penalty of crucifixion, which even to the lowest of men is a disgraceful punishment, was God'.[54] By 430, a young, beardless Christ appears on a Cross on an Italian ivory casket, now in the British Museum. Another of the earliest images of Christ crucified is on the doors of S. Sabina in Rome. What is notable is not so much the crudity of the work as its unimportant location among the many panels of the doors. That positioning is natural, since a crucifixion, as Arnobius tells us, was a sign of disgraceful defeat. Centuries passed before this motif became a symbol of spiritual triumph and before Christ was to be depicted not as standing open-eyed on the pedestal of the Cross, but suspended painfully from it. That change made the Crucifixion not just a pictorial sign that we interpret as a symbol, but an artistic, emotional symbol we feel directly. The Devil, however, never became such a symbol.

Christian catacomb paintings and sarcophagi of the third and fourth centuries are not Christian: decorations, composition, modelling, forms, expressions and poses are classical. But there are scenes that a person who knew nothing of the Bible would not be able to explain. A Christian would immediately spot the first iconographical Christ: the Good Shepherd, a youth carrying on his shoulders a sheep (not a goat, as Hermes Criophorus did). 'I am the good shepherd', said Jesus. In ivory diptychs from the fourth and fifth centuries, Christ is young and beardless, and this is also true for the great early sixth-century mosaics of Ravenna. When he appears as ruler and creator of the universe on a fourth-century sarcophagus, he remains youthful and beardless (illus. 7). The youthful, often classically modelled, Christ is gradually replaced by an older, bearded Saviour. In the end, the older, bearded, powerful Christ from Jerusalem and Syria triumphed, probably because an awesome image was more suitable for Christ the Pantocrator (illus. 8) and Christ in Majesty, themes of theological and political importance. (Perhaps a supporting reason was that between 678 and 752, most of the popes were Greek or Syrian.) The most popular formula was Christ in Majesty, developed from pictorial traditions of the Emperor.

Colour in Romanesque art was widely used not because artists had an impressionistic sensibility but because specific symbolic meanings derived from the cult of the Emperor. The liturgical colours of white, purple and gold, for example, are from imperial court ceremonies. These colours, as the Viennese historian Friedrich Heer observed, were 'glowing symbols which proclaimed that all the attributes and

7 The youthful,
unbearded Christ
enthroned above
the firmament
between Peter and
Paul, a detail from
the stone
Sarcophagus of
Junius Bassus, 4th
century AD, Grotte
Vaticane, Rome.

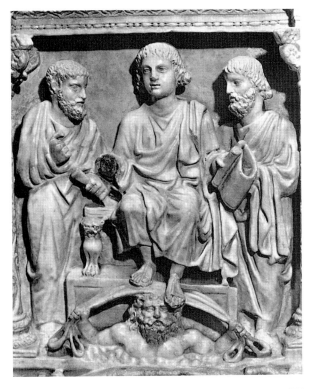

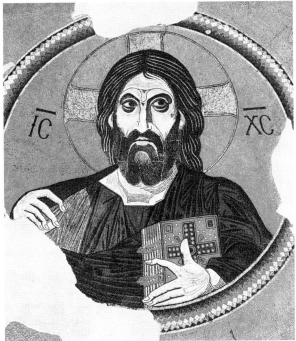

8 *Christ Pantocrator,*
c. 1100, in the
mosaic in the dome
of the Church of
the Dormition,
Daphni.

powers formerly belonging to the Roman Empire and its Emperor passed to Christ as the Emperor of Heaven'.[55] From the Roman emperor ascending to the clouds came the Ascension of Jesus and Mary. This is not surprising, because an image has to come from somewhere. And when a public image is needed, artists hunt around for a literary or a pictorial source, or both. When the pictorial tradition is lost and the artist has only a literary source, strange sights appear, such as twelfth-century paintings of classical goddesses in medieval dress.[56] The reverse can also occur: the literary source is lost. The sculptor of one of the capitals in the cathedral at Autun, for example, had somewhere seen Venus with her shell and Vulcan with his hammer. But he did not fully understood what he had encountered, so he carved a naked woman holding a stone and a devil grasping a knife. The Byzantine artist of the two Mary scenes in the Winchester Psalter shows near Mary's bed a tomb, clearly a misinterpretation, for it should be a large footstool. Christ as Apollo is just one approach among many: a classical pictorial source treated as a Christian motif.

When it came to painting the Devil, artists had a difficult time indeed. There was no literary tradition to speak of and, more vexingly, there was no pictorial tradition at all. In the catacombs and on the sarcophagi, there is *no* Devil. This lack of a pictorial tradition combined with literary sources that confused the Devil, Satan, Lucifer and demons are important reasons for the lack of a unified image of the Devil and for the erratic iconography. Something, however, is better than nothing. And there was something the Christian artist could use from classical sources that theological commentary supported – Pan. 'It is inexplicable', wrote Shelley, 'why men assigned him [the Devil] these additions [the horns and hoofs of Pan] as circumstances of terror and deformity. The sylvans and fauns with their leader, the great Pan, were the most poetical personages. . . .'[57] I will try to explain the inexplicable.

Peter Pan is still with us, a developed fragment of pastoral Pan playing his flute. Young Pan and old Silenus were satyrs: ready to fight, gifted musically, sometimes wise and often randy. Half man and half goat, often with a large phallus, Pan had pointed goat-like ears and, usually, a dense beard; he was associated so often with satyrs and fauns that sometimes, in appearance, he seems to be merging into them. Like Pan, satyrs and fauns had goat-like ears, sometimes a goat's tail, cloven hoofs, a pair of horns, and a hairy body (but sometimes, unlike Pan, they had human bodies). These differences were of no interest to theologians. Jerome called satyrs and fauns symbols of the Devil, lascivious demons, and when Isaiah described ruined Babylon as a

9 *Pan and a Goat*, 1st century BC figurine from Herculaneum: a classical source for the Devil's horns, beard, flat nose, pointed ears and hairy lower body. Museo Nazionale, Naples.

place where 'hairy ones' (Hebrew *sair*) danced, Jerome interpreted this as a reference to satyrs (and his view survives in the King James Bible: 13:19–21). 'Hairy one', or 'goat', is also typically translated as 'devils' in Leviticus 17:7 and 2 Chronicles 11:15. Five common characteristics of the Devil derive from the classical Pan: horns, hoofs, ears, tail and the hairy lower body (illus. 9). Imagine what these images meant to people, alienated from classical culture, who viewed pagan tails as threatening. Bestial, lustful and unclassifiable in the Christian scheme of the world (for would God have created such creatures?), Pan was a servant of the Devil, or the Evil One in disguise.

To imagine, though, that Pan was *the* prototype for the Devil does not fit the facts. This is particularly true of numerous carvings of the Devil in Romanesque churches and cathedrals in France, many in small towns and villages. Conques near Rodez, for example, has neither train station nor bus-stop. Though there are thousands of depictions of the Devil in paintings and sculptures made before the sixteenth century, probably the most gripping were produced for abbey churches during a very short period. You can find the Devil in Last Judgment tympana at Gothic cathedrals and on a capital here and there, but in the abbey churches the Devil is pervasive, the theme of almost one third of the capitals. It was the monks who filled their churches with the Devil;

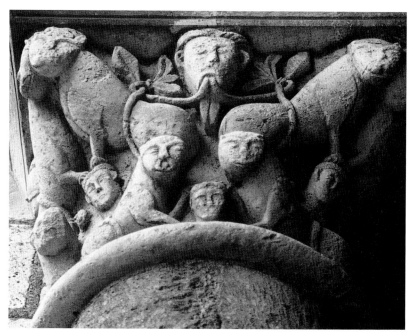

10 A figure, perhaps a Celtic god, on a capital, early to mid-11th century, in the abbey church of St Benedict, Benoît-sur-Loire, Loiret.

it was the monks who found him to be a fierce and violent force. Deeply felt and original representations of the Devil can be found on the capitals and in the tympana at, in particular, St Lazare in Autun, La Madeleine in Vézelay, St Foy in Conques, and St Benedict in Benoît-sur-Loire, east of Orléans. So much has been destroyed or restored, that only careful examination can determine the original context of these works. The famous belfry porch of St Benoît-sur-Loire (*c.* 1050?) originally was higher and stood by itself; its four sides offered four entrances. Today, that belfry porch is physically attached to the church. The specific purpose of this unusual porch is uncertain. So, too, the meaning of many of its capitals is uncertain, particularly those influenced by pagan (probably Celtic) images and symbolism; one example is the superb face of a mysterious deity from whose mouth two vines curl out over lions (illus. 10). The Abbot of St Benoît, Gauzlin, appeared at one of the first heresy trials, initiated by Gauzlin's half-brother, King Robert the Pious, at Orléans in 1022. Adhemar of Chabannes, the very chronicler who described the activities of these heretics, tells us that Gauzlin was the son of Hugh Capet and a prostitute. It was Gauzlin, a shrewd, learned and power-hungry man, who was probably responsible for initiating the porch tower with its

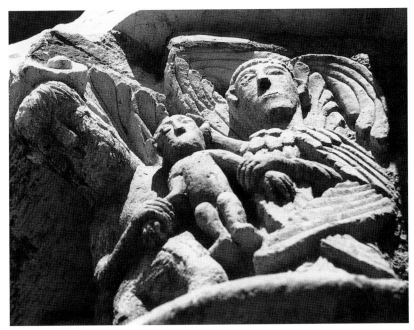

11 An Angel and a striated Devil fighting over a soul, early to mid 11th-century capital (right side) in St Benedict, Benoît-sur-Loire.

unique capitals, many of which have the arch-heretic as their subject, a subject whose reality at nearby Orléans was considered a serious threat, for which the features of Pan were hardly suitable.

No other one site has such original Romanesque capitals, many of which depict the Devil without a trace of Pan as even an indirect source. On the right-hand side of one capital a small asexual nude is held both by the Devil and an angel, arguably St Michael (illus. 11). The central part of this capital has been totally destroyed; the left side partly so. On the preserved right side the soul is curiously passive; the angel seems to have a stronger hold, since in addition to holding the soul's left hand, he places his open palm on the soul's head. The opposite side of the capital shows roughly the same scene, and though the Devil has been badly damaged it is clear that the soul's head and body are turned toward the angel. Nevertheless, the Devil is still holding the soul's hand. Whatever the central part of the capital depicted, the capital overall shows the tenaciousness of evil. The contrast between the beatific face of the angel, with a small close-mouthed smile, and who wears sumptuous plumage and wings, and the striated features of the Devil, with his open mouth, animal-like teeth and naked body, which is without wings, is reinforced by a subtle touch.

The angel faces slightly upward, the Devil downward. To photograph this capital, I waited for the sun to shine on it. By 2 pm the angel's face was in the sunlight, but since my interest was more in the Devil, I still waited. After several hours had passed I realized that the sun would never shine on the Devil's visage. The sculptor had so angled his features that they would be always in the shade.

If St Benoît has the greatest variety of original capitals, the abbey church in Vézelay has the most beautiful interior of any Romanesque building, partly because of the subtle colour changes – in response to light variations – of the carefully selected types of limestone. There, near the middle of the twelfth century, young Louis VII of France showed bad judgement in pushing for the Second Crusade. It turned out to be a military disaster, and also a personal one since his consort, Eleanor of Aquitaine, beautiful and clever, accompanied her King only to prove unfaithful to him (just as her second husband, Henry of Anjou, later Henry II of England, was to prove unfaithful to her). Louis persuaded the Cistercian abbot, Bernard of Clairvaux, to help get papal support for the Crusade, and in 1146 at Easter, the 'honey-tongued' Bernard launched the Second Crusade in an outdoor sermon to a great gathering that had been summoned to attend near the abbey church in Vézelay dedicated to Mary Magdalene. Here it was that in 1166 the exiled Thomas à Becket excommunicated several of Henry II's ministers, and condemned the King's policies. Two-and-a-half decades later, Richard of Poitou (later Richard I of England) and Philip II of France met in this same place to launch the Third Crusade. Today Vézelay has barely five-hundred inhabitants. The church that these leaders chose as the site at which to announce their important undertakings was itself begun after the discovery in the early eleventh century of relics of Mary Magdalene. St Madeleine soon became a major destination for so many pilgrims that, in 1096, Abbot Artaud felt the need to expand the building by adding a new choir and ambulatory. To cover costs he imposed such stiff taxes that the inhabitants rose up, broke into the monastery and killed him. His successor in 1106, Renaud de Semur, tried, presumably more discreetly, to continue the work, but in 1120 a disastrous fire struck. The new nave was built by 1140, and the narthex added and completed by *c.* 1160. The eight scenes surrounding one tympanum (*c.* 1125) depict very specific groups and peoples, but there is no agreement as to who they are. For example, one specialist identifies the three figures in one of the scenes surrounding the tympanum (third up from left) as people from Cappadocia (ancient central Turkey); another, as lepers; and still another, as Arabs.[58] All three views cannot be right, though all three

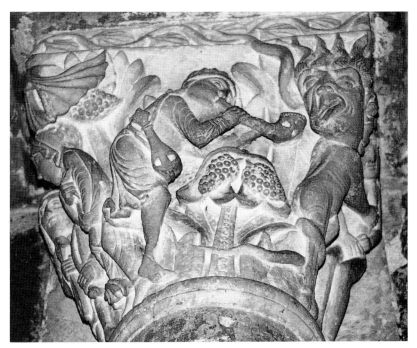

12 'Profane music' on a capital, early 12th century, in La Madeleine, Vézelay, Yonne.

may be wrong. The Holy Spirit, not Jesus, descends during Pentecost, yet most commentators (rightly, I think) call this tympanum the Christ of the Pentecost, spreading the divine word and spirit to all peoples and nations. In his detailed study, Francis Salet writes that 'nothing in Romanesque art, apart from Moissac, approaches the beauty and humanity of the Vézelay Christ'.[59] Yet it is curious that a church dedicated to Mary Magdalene has not a scene devoted to her, and that such a magnificent, peaceful tympanum in the narthex is the gateway to some one hundred capitals based almost entirely on Old Testament episodes, more than half of which are scenes of terrible violence, including many horrendous depictions of the Devil.

On the left side of the 'Profane Music' capital stands a minstrel, passively holding his lute and bow. A woman looks at him and points to the scene behind her shoulder that is the central composition of this capital. The main action is represented by a minstrel and the Devil (illus. 12). The minstrel's lute hangs from his shoulder; he makes music by blowing energetically into a horn. His pose, the modelling and the angle presented are unusually skilful. The mouth of the horn points to, and almost touches, the Devil's mouth, which is turned to it. It is as

if the music enters the Devil, causing him to fondle a nude woman's breasts. Though his body faces the woman, his head is twisted so far back in the opposite direction (toward the music) as to be an impossible pose. Like other devils, this one is naked and has flaming hair. But unlike any other devil in this church, his head is exceptionally large for the size of his body; he seems more drowsy than excited by lust, and he has a hideous grimace, his mouth gruesomely twisted. Separating the Devil and the minstrel is a large plant that Salet describes as 'pestilent flowers opening their calyx and recalling the evil atmosphere of another devil capital, Lechery and Despair.'[60] Perhaps. The large size and prominent position of that plant make questionable its function as merely atmospheric. Yet if we try to identify the plant we find ourselves in a situation similar to the one involving the tympanum that I mentioned earlier, the scene in which the people are identified by three specialists as Cappadocians, lepers or Arabs. Professor Richard Bartha of Rutgers University's Biochemistry and Microbiology Department tells me that the two fruit clusters and an identical fruit cluster in the upper left-hand corner (partly covered by a leaf) suggest a member of the *Araceae* family, which includes the phallic Jack-in-the-pulpit and others commonly used as folk medicines, and, in a few cases, some whose seeds have narcotic effects. On the other hand, a knowledgeable amateur mycologist in England, Harry Gilonis, informs me that one could read the fruit 'clusters' as speckles on the cap of the mushroom fly-agaric (*Amanita muscaria*), a reading that, if correct, would be even more interesting. If the 'plant' is indeed that mushroom, then we could argue that the speckles on the cap and the chambered hollows inside the stem are accurately sculpted. Fly-agaric is a narcotic, and this could explain the Devil's singular expression. The music and the narcotic agent cause the Devil's lust and drowsiness, since eating fly-agaric stimulates singing, hallucinations and, finally, sleep. Such effects would explain the Devil's mouth, which is twisted as if from loss of muscular control, the heavy, drowsy eyes, and, perhaps also the enormous size of his head, since that is how the partaker of this particular mushroom will sometimes feel as a result! Rather than the conventional title of 'Profane Music', the evil of hallucinogenic agents (music and narcotic fungi) and the perceptual distortions they cause, leading men to sin, seems a more appropriate characterization. What is certain is that though the theme of this capital is connected with music, there is no link with Pan or other classical influence.

The conventional notion that Pan is the main source for the Devil does not fit well with paintings either. A thirteenth-century French Psalter, probably executed for the royal court, shows a sprightly devil

13 'The Weighing of Souls', from a French Psalter, *c.* 1230, in the Lewis Collection (MS 185, fol. 25*r*), Free Library of Philadelphia.

with the tail, horns, ears and hoofs of Pan, but no hairy body (illus. 13). More important, the animal features do not designate an animal, since his expression is quite human and intelligent. Neither vicious, nor threatening nor nasty, this Devil plays his role with St Michael. Devils in the twelfth-century Doom (or Ladder of Salvation) wall-painting in the parish church at Chaldon, Surrey, have no Pan features, nor do devils in the early Apocalypses. Devils in the Winchester Psalter have tails and horns only. In the *Last Judgment* at Bourges and at Chartres, perhaps some ears and bearded faces derive from Pan, but nothing else. Autun's famous *Last Judgment* owes nothing to him. Clearly, the conventional notion that Pan is the main pictorial source of the Devil is too simple. In fact, the satyr was sometimes dissociated from the Devil. Christian doctrine stressed that the distinction between man and beast was not physical but spiritual. This led to the curious idea that even a satyr could go up in the world. Isidore of Seville and the compilers of *The Golden Legend* picked up a story about a satyr who met St Antony and begged him to pray to their common God, who was to save the world.[61] In the marvellous mid-fifteenth-century painting *The Meeting of SS. Antony and Paul* (National Gallery of Art, Washington), a centaur and a satyr kindly help St Antony find his way.

The Wild Man tradition is another consideration. From the twelfth century, the idea of a wild man appears both in literature and art.[62] Wild men lived in forests, were sexually aggressive, and abducted women, who were then on occasion rescued by courtly knights. Sometimes the abducted woman managed to tame her wild man. The

utcuftodicantte inomnibuf uuf tuuf ·

Nmanibuf poxtccbunttc
uc foxxc offendccf adlccpide pedcomtuum
uup afbidem &bccfilifcum abulccbif.

14 'The Temptation of Christ', illustration for Psalm 90 (91), from the *Stuttgarter Psalter*, early 9th century. Landesbibliothek (Cod. bibl. fol. 23, 107), Stuttgart.

wild man had a human body completely covered with thick hair, and he wielded a heavy club. By the fifteenth century the wild man nightmare had changed into a vision of the noble savage, and this dream of a Golden Age was reinforced by the discovery of 'savages' in the New World. To complicate our difficulties, the wild man and the satyr were often conflated.[63] Some hairy devils seem modelled more after wild men than satyrs, but separating out these two elements is not easy, and the interactions need more research. Particularly in Germany during the Renaissance, the wild man appeared to lead a peaceful life with his family, and this is epitomized in the much copied Dürer engraving of 1505, the *Satyr's Family*.

If the devils at the cathedrals of Autun and Bourges and in many Psalters derive neither from Pan nor from the wild man, what do they have in common? They are all naked, and usually black. Probably the first extant representation of Satan tempting Christ depicts Satan as black and naked (illus. 14). Why is the Devil black? His blackness contrasted with the beautiful white of the angels. The blackness represents evil and pollution. Satan seated on his throne in Hell is always black. When he falls from the sky, he is usually black. Perhaps the Devil's blackness is connected with Egyptian and Nubian gods.

Nubia was always in close contact with Egypt, and for some periods Nubians ruled Egypt. The Devil is described as a black Ethiopian in Apocrypha, probably of Egyptian origin, from the second to the fifth centuries. In the Acts of Peter (XXII), for example, Peter sees the Devil in the shape of a foul-looking woman who was all 'black and filthy like an Ethiopian, not like an Egyptian.' The Devil as a black seductress was not uncommon. In Palladius's early fifth-century tales of the holy Fathers (the Historia Lausiaca, ch. XX), a young monk, disturbed by his sexual desires, visits Pachomius for advice, and the older monk relates his own conflicts with the fiend:

The devil of lust took the shape of the Ethiopian girl whom I used to watch as a young man when she was bending to gather canes in the summer. And now she came and sat on my knees and set me on fire with such lust that I imagined I was having sex with her and my heart was burning.

By the fifth century Christianity was established in Nubia, and large immigrations of Copts (early Egyptian Christians) in the seventh century led to systematic destruction of traditional Egyptian and Nubian temples and statues. The Egyptian god Anubis, a model used for the Weighing of Souls, which I discuss in chapter Three, was a black jackal with a bushy tail or a black man with a jackal's head. At least from the XVIII Dynasty, many Egyptians were black Africans. The Senegalese physicist Cheikh Anta Diop has provided melanin analyses of skin attached to ancient Egyptian skeletons (before mummification became common) that indicate black African skin, and ancient writers often described Egyptians as black. Statues, reliefs and drawings show Egyptians with black African features. The earliest sketches of the Sphinx (before man-made alterations) strongly suggest a black African profile.[64] The sphinx at Kawa (seventh century BC) in present-day Numibia definitely has a Nubian face. The Devil wearing Egyptian clothing in a thirteenth-century Soriguerola altarpiece is black (illus. 34).

If the Devil is naked because classical pagan gods were naked, then perhaps one reason he is black is because some Egyptian gods were black. But the main reason is probably the most obvious one: the Devil is shown black as a sign of polluted filth, in contrast to the white, pure angels. The Devil is naked, and so were Adam and Eve in Paradise. Clothing is society. Michael and his angels are *always* dressed in robes or armour as they hurl the rebel angels down from Heaven. The rebel angels have, at best, loincloths, but they are usually naked in the tenth century and they are still naked in Rubens's paintings. So strong was this convention that even in the transformation of the Devil from a

repulsive demon to a proto-Romantic tragic hero, one of the agents of this change, William Blake, shows Satan in Hell as naked (illus. 15).

Why is the Devil naked? That nudity was connected with sin would be a reflex response. Among the well-born in Rome, athletic nudity was a mark of status, and since the public baths were part of social life, appearing naked among one's peers and in front of inferiors was a daily fact.[65] In Christian art, however, nudity was avoided. The nude infant Christ is an excellent example because there are no examples available from the tenth century to the thirteenth. The first naked Christ child seems to be the infant in Jean Pucelle's Book of Hours of 1325 made for Jeanne d'Evreux. Decades passed before another nude infant Jesus was painted. (The *putto*, the naked child, is dragged across the centuries from the Hellenistic Eros only in the 1400s.) Between 1150 and 1200 there are occasional nude classical figures, such as Atlas, Hercules, various wrestlers, the Four Winds in the Apocalypse (in the abbey church of Castel S. Elia, Lazio, for example) and the unusual Four Riders of the Apocalypse, naked on a buttress of Notre Dame in Reims.

Jesus was sometimes shown nude in early sculptures and in occasional Byzantine mosaics, but rarely after the sixth century, when access to classical models diminished. As the sexual connotations of nudity grew in the clerical consciousness, by the Carolingian era men and women were no longer baptized nude and Christ on the Cross was clothed. From the third to the seventh centuries, Christ undergoing baptism was often portrayed as a naked child;[66] from the tenth century, he is a bearded man up to his waist in water (even in the shallowest river), his genitals hidden or brushed out. From *c.* 900 for the next four hundred years, except for persons undergoing baptism in a river or tub, or Jonah swimming in the ocean, usually the only naked people to be seen were Adam and Eve, when pure and innocent; and the Devil. The crucial difference is that Adam and Eve were *created* naked, whereas the Devil *became* naked. To strip a person of his uniform or clothing is a universal symbolic gesture of degradation. Cast out of society, the naked Devil could never be saved, and Augustine, in particular, could not forgive Origen his speculation that perhaps in God's infinite mercy, even the Devil might one day be forgiven.

Whether God has a penis seems never to have been discussed by even the most punctilious Scholastics. Yet the question was addressed indirectly because, in response to particular theological problems, the humanity of Christ was stressed in the mid-1400s, and this stress generated a new genre of painting, one that displayed the genitals of Jesus. This new genre of the fifteenth century was grounded on

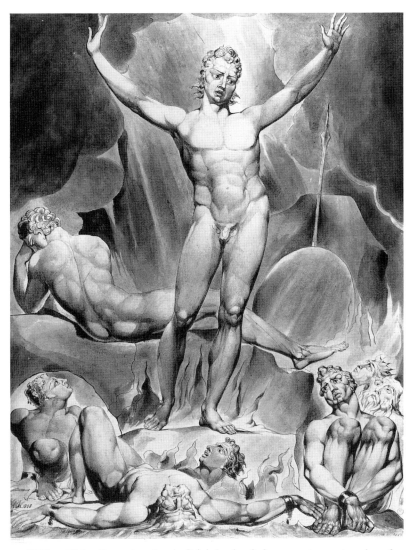

15 William Blake, *Satan Arousing the Rebel Angels*, 1808, preparatory watercolour for an engraving for Milton's *Paradise Lost*. Victoria & Albert Museum, London.

intellectual, ideological and theological changes in the Renaissance. In his brilliant work on the sexuality of Christ, Leo Steinberg has argued that 'a large body of devotional imagery in which the genitalia of the Christ Child, or of the dead Christ, receive such demonstrable emphasis [requires us to] recognize an *ostentatio genitalium*'.[67] These paintings dramatize the fact that Christ had become a man of flesh and blood: Christ's genitalia in particular (the circumcision is one example) became a forceful way of revealing that Christ was a man, and this was

supported and stimulated by incarnational theology. None the less, even in the Renaissance, Christ is rarely shown naked. Though the Devil supposedly had fierce sexual powers, and though this was much written about, in what work of the Middle Ages or the Renaissance do we see the Devil's genitals?[68] Perhaps the specific incarnational theological symbolism signified by the genitals of Christ made it unwise to show the sex of the Evil One; if genitalia humanized Jesus then it might also humanize the Devil, but that result would receive limited applause. Perhaps the Devil is without genitals because originally he was an angel. If we recall, however, the intercourse of angels with virgins (in Genesis 6), then that explanation is not terribly convincing. Perhaps the idea of procreation by the Devil seemed unappealing. In the event, though naked, the Devil in the arts is deprived of genitals.

To discover why the Devil is naked we must ask this: which pictorial and sculptural tradition had nudes? The most obvious answer is classical sculpture and painting. Since Christian ecclesiastics believed pagan gods were 'devils' and these gods were often nude, devils were nude, or more precisely, naked. Nudity became *nakedness*, and nakedness became a degradation and humiliation, and a sign of being cast out like a madman or like an animal, to whom reason or water can be denied with impunity. Judicial torture was sometimes performed on the naked accused. Criminals were driven naked through the streets of medieval and Renaissance Europe. Nakedness became a symbol of pollution as a wedge to pry out pagan gods from Christian consciousness. In the push to demolish paganism, casting out the naked devil meant sweeping classical learning and science off the table and down the sewer. Or in the immortal words of Pope Leo I, the Manichees, Jews and pagans – 'all that is profane and blasphemous in all the heresies is gathered together with all manner of filth, as if in a cesspool'.

To see how the cesspool was cleansed, I will digress and look at the attitudes held towards classical Greece and Rome. Jerome knew the classics; and when he read the prophets he found their style 'rude and repellent'. He was not alone. Arnobius and Origen tell us that the New Testament was considered crude, trite and pocked with sloppy constructions and poor grammar. But Jerome decided that his dislike of the Bible's style was a trick of the Devil. Afflicted with a serious fever, Jerome imagined being brought before Christ, the Judge, who asked who he was. Jerome replied: 'I am a Christian. But He who presided said: "Thou liest, thou are a follower of Cicero, not of Christ".' And then Jerome finally understood. Tertullian warned that Athens had no more in common with Jerusalem than had heretics with Christians. The idea that Christianity and its monks treasured classical

learning and were 'islands of knowledge' during the Dark Ages contradicts the known facts: barely one monk in fifty did any writing at all.[69] Work on cathedrals generously undertaken without pay, or monks building their own monasteries, are legends that the French scholar Jean Gimpel has revealed are based on confusions of terminology and ignorance of actual practice.[70]

One capital in the cathedral at Autun has Constantine astride his horse; just below the horse's hoofs is a naked, cringing pagan. In Christian art, nakedness as a sign of degradation and humiliation is reserved for devils, pagans and heretics. The identification of pagan gods with devils and the use of Pan for the form of some devils are not accidental. They reflect how the Church mangled classical science and philosophy, desiccating them for centuries. Eratosthenes, the third-century BC astronomer, for example, accurately measured the earth and proved its shape to be spherical. In the Middle Ages the earth became a flat disc. In the early eleventh century, six hundred years after the murder of the Alexandrian mathematician Hypatia, two learned men of the cathedral cities of Liège and Cologne, Ralph and Reginbald, corresponded about a mathematical puzzle they found in one of Boethius's commentaries on Aristotle.[71] What baffled them was the remark that the interior angles of a triangle are equal to two right-angles. Neither of these scholars had any idea of what a triangle's interior angles were. They were not alone: generations of medieval scholars strained to solve this simple problem. Yet even today we are reminded that the 'Dark Ages' is merely a metaphor and that monasteries preserved learning carefully. What learning? Such ignorance must give us pause: how could cathedrals have been built? In addition to the practical skills of craftsmen, foreign architects were employed. The essential help arrived with translations of Arabic works that assimilated and developed the mathematics of antiquity, particularly at the unique multi-cultural translation school (whose leading scholars were Jews) in Toledo during the early twelfth century.[72] The Gothic cathedrals could hardly have been designed without the work of people like Adelard of Bath, who introduced Euclid's Elements of Geometry to the West through his translations, which in turn were based on those from Toledo.[73]

Consider the example of Cosmas, a monk who studied at Alexandria in the sixth century and wrote the first comprehensive cosmology to replace Hellenistic concepts. He headed his first book 'Against those who, though professing Christianity, believe as the heathen do, that the heavens are spherical'. A century earlier, in Hypatia's Alexandria, Cosmas would have been laughed away. Carefully considered, the

nakedness of the Devil is a reflection of what Christianity distorted and discarded. The murder of Hypatia illustrates the Church's success. Pantagruel, in Rabelais's early sixteenth-century satires, brought together as *Gargantua and Pantagruel*, decided to visit the university at Toulouse, but left quickly when he saw that the authorities were burning heretical professors at the stake (ii, 5). He went, instead, to the university at Orléans, where he studied the mathematics and physics of Theon (ii, 7). Theon was the most important savant connected with the Museum at Alexandria early in the fifth century. The world's first cosmopolis, Alexandria, was ruled by Greeks. The native population was Egyptian, but there was a large Jewish community, Arabs, Persians, Indians, Buddhist priests and Africans. The city was the setting for astonishing achievements in mathematics, astronomy, physics, physiology, geography and philology for three centuries.[74] The works of Euclid, Archimedes, Apollonios, Eratosthenes and others were supported and grounded on a wide-ranging processing centre, the Museum, and a massive storage-centre, the Library of Alexandria. The Museum provided freedom and organization for scientific research unprecedented in human history. The Library was unequalled for the variety and quality of its (possibly) 700,000 scrolls. Never before had so much accumulated knowledge been so accessible.

Theon's daughter, Hypatia, was the first woman mathematician and a distinguished teacher of Neoplatonism. The end of Alexandria as the capital of science and research was not caused by a change in climate nor by reductions in exports of papyri. The Library was seriously damaged in 391 by the Bishop of Alexandria, Theophilus, who Edward Gibbon described as 'a bold, bad man, whose hands were alternately polluted with gold, and with blood'. The Bishop attacked and looted the temple of Serapis, an important pagan cult centre, where much of the Library was stored. Theophilus's successor, Cyril, continued the destruction, and he was also involved in the murder of Hypatia. Cyril organized a pogrom against the Jews, who had been living there for six hundred years. The violence that followed diminished Alexandria forever. The expulsion of the Jews threatened the city's civil authority, and so the city's Prefect, Orestes, opposed Cyril; the latter responded with a mob of five-hundred Nitrian monks, who almost killed the Prefect. Next, roused by Cyril, the hooded monks marched into Alexandria again, surrounded Hypatia's chariot, dragged her out, stripped off her clothing and, with shards of smashed pottery, scraped her to death.[75]

A dozen years after Hypatia's murder, Leo I, the first pope to achieve some stability amidst the fractious factions disputing the relation of the

Son, the Father and Mary, preached his Christmas sermon in Rome on the Devil:

[He] has built his citadel upon the madness of the Manichees. All that is idolatrous in the heathen, all that is blind in carnal Jews, all that is unlawful in the secrets of the magic art, all, finally, that is profane and blasphemous in all the heresies is gathered together with all manner of filth, as if in a cesspool.[76]

Leo describes the four terms of the Devil molecule: black magic, the Jews, the heretics, and the pagans. All are from and of the Devil. Leo may have believed what he preached. But is he talking about the adversary of God? Or of the adversary of Leo? In 1975 Iranian leaders followed in Leo's footsteps, chanting with demonstrators 'America is Satan'. And in 1982, speaking of the Soviet Union, the President of the USA warned the world of the 'evil empire'. From Pope Leo to Ronald Reagan, the Devil is a way to stain anyone who disagrees with those in power. I do not know if Cyril really believed that Hypatia was a devil because she was a pagan. I do not think it matters. But if the Devil is sometimes merely a rhetorical device, this does not mean that evil is. Insofar as the Devil does not refer to real evil and is a rhetorical device, the Devil becomes a justification for real evil by users of that device.

The Devil's features

Though the Devil is represented as naked, he is rarely stark naked. Instead, he usually wears a distinctive skirt, which seems never to have been commented on. This skirt first occurs in one of the few first certain pictures of devils, in the Utrecht Psalter (illus. 16).[77] A devil in Hell as shown in Armentia (Alava, Spain) wears a skirt of skins that we would associate with cave-men. We find the same skirt in the Winchester Psalter, the Conques tympanum, a twelfth-century illustrated Bible, an eleventh-century Anglo-Saxon illumination – indeed, in so many other instances that these cave-man skirts can be defined as an attribute of the Devil. It is a sign of a being who is outside of society, uncivilized and wild; it is a sign of disorder.[78]

Where do these shaggy cave-man skirts come from? Only devils wear them. They are not to be found in any Egyptian, Greek or Roman works. The strong influence of the Utrecht Psalter, the most original pen-and-ink work of the Middle Ages, which was copied many times in different countries, may explain how this motif spread, but where did the artists of the Psalter find such dress? This is a vexing problem. If we look at sculptures from Ur we see clothing that would seem a source for the skirts, but these Sumerian works date from before 3000 BC.

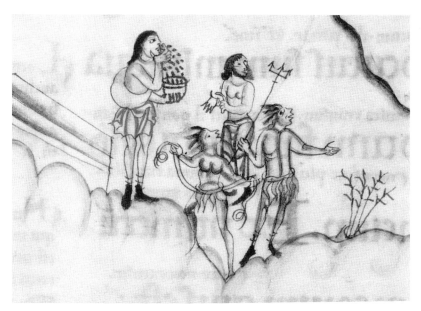

16 Detail from Psalm 38 in the *Eadwine Psalter* (a copy of the earlier *Utrecht Psalter*), showing the problematic cave-man skirt of the Devil, early 11th century, pen and ink. Trinity College (MS R.17.1), Cambridge.

Chnoubis, the snake god derived from Typhon, frequently wears what might have been misunderstood as that skirt. But Chnoubis himself is not well understood. Was he a figure who belonged to the Jews? To some other sect? There is not much agreement. Probably the Devil's skirt derives from Greek paintings of satyr plays, because those satyrs with their confident phalluses represented that which horrified the Church. Here was an image of the Devil that the artist of the Utrecht Psalter could have used, and it would explain, for the first time, where the Devil's skirts came from. Most representations of satyrs, particularly those on Greek vases, derive from satyr plays (illus. 17). Probably the shorts were seen as an attribute of the wild and undisciplined sexual behaviour of such satyrs. The fact remains that the 'naked' Devil appears in three forms: completely naked, in a cave-man skirt, and completely furred.

The furry devil is particularly common for the concept of the Devil as Microbe (Satan's extensive network of minor infesting agents). This devil has horns, but is without flaming hair, usually without wings, and is often comical. Costumes worn by minstrels seem quite similar, and with many furry devils we can almost sense the performer lurking within his costume. Perhaps that is why the furry devil, though popular, is neither threatening nor frightening but amusing. No artist could

60

17 Preparations for a satyr play, from the Pronomos Vase, perhaps a source for the Devil's cave-man skirt. Late 5th century BC. Museo Nazionale, Naples.

have considered him as a dangerous adversary of the Lord. We have seen that Pan and nakedness (from classical gods) are important sources for the Devil's pictorial features. We can now list the specific visual characteristics of the Devil. If we omit, for the moment, composite monsters, the common important characteristics of the Devil's *body* are his nakedness (shaggy shorts or short skirts of animal skin are variants) and hairy body; his open mouth and large, prominent teeth; his hair, often quite shaggy, or like flames. His most important *appendages* are hoofs, or claws or an eagle's talons; a tail; horns; and wings like those of a bat or an angel.

One source of many Devil characteristics is, I suspect, Bes (illus. 18). Historians and students of mythology have shown little interest in this dwarf deity (who is probably from Nubia, possibly from Punt – an unlocated country, perhaps an area that today falls within Somalia – which supplied Egypt with exotic goods), yet he was to be found in more homes than any other Egyptian god. Never a leading deity, his popularity grew to be such that between 1500 and 1000 BC, many middle-class Egyptians kept a statue of him in their homes; they also named children after him. Whether Bes originated in Egypt or Mesopotamia is not clear. Ugly dwarf figures in the typical Bes squat appear in Mesopotamian and Archaemenid cylinder seals. (Probably

18 A figurine of Bes, the most popular Egyptian talisman against evil, 22nd Dynasty (950–730 BC), glazed stone; possibly used as a rattle, as the holes along the top edge may have held rings and a stick will fit into a hole in the base. The University Museum, University of Philadelphia.

there was a Bes-like figure in Mesopotamian tradition, but fully developed Bes features came to Mesopotamia from Egypt.) As a talisman against evil and a protector of childbirth, ugly Bes was worshipped at Carthage, at Abydos, and he is found on vases, kohl vessels, walls and furniture of the Hellenistic period. He was also to be found on bedposts, *mammisi* (birth-houses), and appeared on the prows of Phoenician ships when Aksum (in northern Ethiopia) became a key trading centre after Nubia came under Christian control. During the mid-fourth century, the Bes oracle at Abydos (500 kilometres south of Cairo) was so popular that Constantius II sent a nasty witch-hunter (dubbed Tartareus, or 'Hell-fire Paul') to a nearby city, where he proceeded to murder hundreds accused of 'Bes worship'. In the mid-seventh century, large numbers of Egyptian Christians fled to Meroe because that ancient African kingdom had converted to Christianity and was thus a haven for those fleeing Egypt after it had fallen under Islamic rule. Bes would indeed have been a household name even if it was anathema to Egyptian Christians, the Copts.

If one reason the satyr was a model for Devil traits is that he was often depicted with his phallus, this could also be a reason for

19 Bes, *c.* 650 BC,
bronze, Musée du Louvre, Paris.

imagining that Bes, too, was a form of the Devil. Ithyphallic represent-
ations appeared especially around the fourth century BC, when Bes's
attributes were increased to increase his protective powers. An
excellent example is the expressive ithyphallic bronze of Bes in the
Louvre (illus. 19). Transformed from a short fat dwarf, this Bes is a
confident protector against evil, with the outspread wings of Isis, while,
instead of the conventional headpiece of feathers, his head-dress
supports eight *uraei* (sacred cobras). Though Bes protected against evil
spirits, this typically grotesque Egyptian god (see illus. 18) would have
been perceived as a devil by some Christians. Here we approach an
area of culturally determined unconscious responses. Typical reactions
to Asian and Indian deities by Christians in the West can be askew:
fierce figures who, in Eastern cultures, defend good against evil are
imagined by Europeans to be devils. Even the most knowledgeable
scholar of the Devil and demonology, Jeffrey Burton Russell, has
labelled a Japanese figure an 'evil' demon when, in fact, that figure is a
guardian against evil (illus. 23). 'Universal' images can turn out to be
no more than erroneous constructs by scholars. It is highly likely, then,
that Christians misinterpreted Bes. Sometimes shown naked, some-

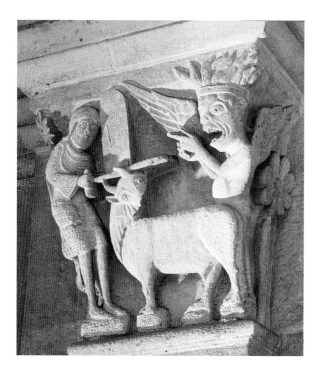

20 A Bes-like Devil
in a carved capital
depicting 'Moses
and the Golden
Calf', early 12th
century, in St
Lazare, Autun.

times in shorts of skins (or Syrian kilts), Bes has the shaggy hair, prominent mouth and teeth, tail, animal ears, bearded face, thick lips and protruding tongue that were to be Satan's. He is often shown with monkeys and snakes, which would have reinforced the identification of Bes with evil. Christians in the Middle Ages used the monkey as a symbol of sin and lust; and it was said the Devil often appeared in the shape of a monkey. The fierce Devil challenging Moses, carved on a capital at St Lazare, the Romanesque cathedral at Autun, has tremendous flaming hair and a singular headband (illus. 20). That headband did not derive from Greek or Roman gods. But Bes often wore a headband in which ostrich feathers were stuck (illus. 18), and if those feathers were misread as flaming hair, then we have our Bes-Devil in that capital.

Bad manners it may be, but traitors and miscreants in medieval art often stuck out their tongues, mocking their victims, and so, at times, does the Devil. Devils do it to mock victims and to deride what is sacred. In medieval art, kings and nobles rarely (if ever) open their mouths; devils and lower-class figures do.[79] Most medievalists think that the protruding tongue motif is wholly indebted to the classical Gorgon, but it may also have something to do with Bes, who was seen more often by Coptic monks than were Gorgons. One objection to Bes

as a source for the Devil is that there seems to be no reference to him that would be relevant. But neither do there seem to be any explicit indications that Pan was turned into the Devil. Bes may well be the main source of the Gorgon; but even if this is not so, the Gorgon was able to reinforce Devil-like features that originated in Bes. The main impact of the Gorgon on Devil iconography is that it served as a model for the Mouth of Hell, a mouth that has fangs, which Bes does not.

Shaggy or flaming hair meshed with the Devil's nakedness is a further sign that he had been cast out from civilized life. In perhaps the two earliest images of the Devil, flaming hair is a clear characteristic (illus. 14, 16), with its suggestions of wildness, bestiality and power. But, as in the case of nakedness, if we want to find other examples of flame-like hair, we can find them in classical art. Portraits on Greek and Roman coins, for example, frequently have the shaggy or flame-like hair of the Devil (illus. 21, 22). Some scholars suggest that such hair was inspired by the greased, upswept hair as worn by barbarians.[80] This assumption began with monks reading Diodorus, a historian who sometimes fabricated facts; Diodorus says that the Celts washed their hair in lime to stiffen their locks; this may have been true, but such a specialized source is unlikely to have influenced artists. Flaming hair early became an identifying feature of the Devil. You will not find any Christian who wore his hair in that fashion, but you can find it adorning Eastern deities who represent a force for good. Though the Devil's flaming hair does not, I think, derive from non-Western art, it will be

21 A flame-haired Pan, on a gold stater coin of *c.* 360 BC, from the Greek colony of Panticapaeum on the west side of the Bosphorus. Bibliothèque Nationale, Paris.

22 A flame-haired Apollo, on a tetradrachm coin of *c.* 380 BC, from Clazomenae, Greek Ionia. Bibliothèque Nationale, Paris.

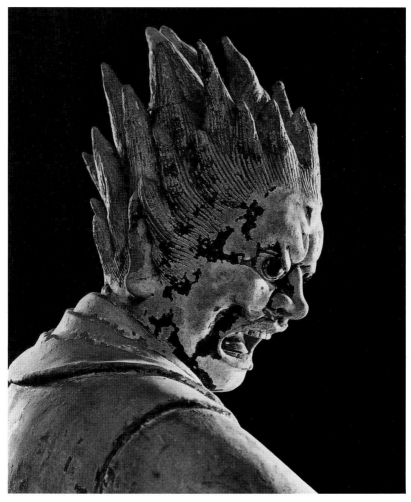

23 *Meikira Daisho (formerly Basara)*, a Divine General, 8th century AD, stucco. Shinyakushi-ji, Nara, Japan.

useful to take a brief look at some examples. At Nara, Japan's first capital, a temple called Shinyakushi houses an eighth-century Yakushi Nyorai, an enlightened Buddha who combats ignorance. This seated Buddha is surrounded and defended by Twelve Divine Generals (*Jūni-Shinshō*). Western visitors to the temple would probably assume that several of these Generals, in particular Meikira, are devils (illus. 23). But since Meikira's fierceness is in *opposition* to evil, his flaming hair represents rage *against* evil (technically known as *funnu-gyo*). Two of these Divine Generals normally have this flaming hair, an established iconographical feature called *enpatsu*. The most typical Buddha figures with flaming hair are also the fiercest: the *Myō-ō*. In esoteric

Buddhism, these fanged and frightening deities embody the wrath against evil. Without entering a bifurcating iconographic jungle, we can note that Indian Vajra deities often have flaming red hair both in Hindu works and in Chinese Tang silks.

The point that is of considerable interest is this: flaming hair is an indication of evil in Christian art, whereas in Buddhist art it signals the tremendous tension generated by wrath against evil.[81] This example is a reminder of how the application of Jungian or universal theories in attempts to interpret iconography may do more to confound than enlighten: one French expert on demonology, Roland Villeneuve, equates the flaming hair of Romanesque devils with the flaming hair of Buddhist figures who fight evil.[82] More relevant to our concerns is that these fierce, frightening deities in Buddhist art, in contrast to the Christian devils, are often memorable masterpieces. Anyone who has studied Japanese painting and sculpture, for instance, can recall with ease a particular *Myō-ō* that has impressed him (or her). No-one having once seen the Shinyakushi-ji Divine General Meikira, or the *Myō-ō* deities in Kyoto's Tō-ji (Dai-itoku and Kundari deities), will forget those images. The artists of such divine wrath believed in it strongly enough to create figures that embody the kind of unappeasable anger that will register with every viewer.[83] To find a devil who has flaming hair is easy; to find a medieval devil who is a supernatural being with powers beyond that of an insect is tasking.

Devils often have no wings in Hell, but they certainly had to have them when they were being cast out of Heaven or were fighting Michael. From the ninth century to the thirteenth, Satan and his devils have the feathered wings of angels even if their pinions are blackened, shortened and ragged. By the fourteenth century the Devil is growing the black ribbed wings of the bat; his feathered wings are fading away. Black bat-wings are, of course, a more dramatic contrast with the light, white or beautifully coloured, feathered wings of angels. No-one seems able to say exactly when or how this change happened. Jurgis Baltrusaitis has suggested the influence of winged Chinese demons, some of whose wings were ribbed.[84] He notes that by 1307, Pope Clement V had appointed the Franciscan Giovanni Montecorvino as Archbishop of Peking, and the altar of 1375 by the Master of the Parement de Narbonne does depict a Chinese mandarin among those watching the Crucifixion scene. Nestorian missions did have contact with the West. Yet, how many Chinese paintings were available to medieval artists at the turn of the thirteenth century? I think this is another case of compulsive diffusionism and should be more carefully examined.

In the final canto of the 'Inferno', where Dante describes Lucifer, is the detail of Lucifer's two immense outspread wings – 'not feathered wings but resembling those of a bat' (*Non avean penne, ma di vispistrello / era lor modo*, lines 49–50). Dante's implicit insistence on the bat-like shape suggests that feathered wings were still the norm in his day for descriptions of the Devil, and we might imagine it was Dante who was the source for the Devil's bat-wings except for one decisive reason. The 'Inferno' was probably begun *c.* 1307 and completed about seven years later. But Giotto had finished painting his St Francis frescoes in Assisi *before* 1300, and Dante had almost certainly seen them since he mentions Giotto's popularity in 'Purgatorio' (*e ora ha Giotto il grido*: xi, 95). In one of those frescoes the devils flying in the sky have bat-wings. It is not absolutely impossible that Dante and Giotto both saw a Chinese painting and, awestruck at the detail of a demon's bat-wings, were instantly inspired to use the image, but I prefer to follow Ockham's razor and suggest that the source of Giotto's bat-wings is not to be found in Chinese painting but derives from the artist's own imagination. This should not be a surprise since Giotto's accomplishments go beyond technique and include influential iconographic innovations. Leo Steinberg pointed out that it was Giotto and his contemporary in Siena, Duccio, who originated a diaphanous loincloth on the crucified Christ.[85] And it was Giotto who made the first naturalistic depiction of a comet, instead of the usual stylized star of Bethlehem, in his *Adoration of the Magi, c.* 1304, in Padua's Arena Chapel. That rendition almost certainly drew on the artist's personal observation of Halley's comet in 1301.[86] The reflexive response of some scholars when they find, for example, a painting of Mary with a mole on her left ear is to ask: Where did that come from? Particularly with second- and third-rate artists and writers, source-hunting makes sense. The Rabbula Gospels' *Ascension*, for example, was still being copied in Florence almost five centuries after it was painted. But sometimes the source of a work is the work itself, and Giotto's bat-winged devils seem a specific instance of this.[87]

Today's Devil may have split hoofs, but in the Middle Ages the Devil was as likely to have talons as hoofs. The hoofs derive, as we have seen, from Pan, and the talons from harpies or a wide variety of creatures transmitted by Sassanian art. Most of the time the Devil carries a prod, which is usually the grapnel that jailers used.

We have now looked at representations in painting and sculpture that served as sources for some common visual features of the Devil. What the Devil looked like, though, often had nothing to do with the pictorial traditions of the past. Nothing has the impact of that which we

have seen with our own eyes. Perhaps this is why an important source for the face and form of the Devil is the Devil that people have seen not in their dreams but on the stage. When the new-crowned Louis XI visited the city of Tours in 1461 he was entertained with mystery plays, and to ensure that the performances were of a professional standard, the city officials paid Jean Fouquet to stage them. Normally we think of Fouquet as a painter, not as a professional man of the theatre. He is one of those rare artists, like Jacques Callot or Diego Velázquez, who record with exceptional precision the world they see, untinted by personal visions or passions. The special tone of aristocratic elegance (even preciousness) that films the illuminations of the Limbourg brothers or the instantly identifiable personality in a Michelangelo cannot be found in Fouquet's Hours of Etienne Chevalier (1445). But we can see exactly how cathedrals were built, what the interiors looked like in his day, and the tools the carpenters used. It is typical that it was Fouquet who painted the first known topographical view of Paris, in a work he called the *Descent of the Holy Ghost among the Faithful*. Fouquet sometimes presents space and perspective as if we were seeing the paintings through a modern fish-eye lens. *St Martin and the Beggar* is a good example; so is the *Martyrdom of St Apollina* (both works are in the Hours of Etienne Chevalier). The latter work is of exceptional importance for us because of its connection with mystery plays; aspects of many of Fouquet's paintings, their deep perspectives, for example, were influenced by ways that mystery plays were staged. The *Martyrdom of St Apollina*, however, is a scene *of* a mystery play itself (illus. 40), and it is pertinent for three reasons. First, since it was Fouquet who painted it, we know the scene is accurately depicted. Second, we can see – and the documentary evidence supports this – that the staging of medieval drama was extensive, elaborate and relatively realistic. Third, we can see Hell Mouth and the Devil, and devils with their horns, animal faces, claws and furry bodies.

The main source for the Devil in presentations of the Last Judgment was not from the culture of the upper classes, or from the endlessly argued descriptions of scholastics, nor was it classical sarcophagi, Pan, bulletins from the Pope, speculations of monks. The main pictorial source was the Devil that painters and sculptors had seen for themselves in the mystery plays. The popular pictorial image of the Devil is an excellent example of Mikhail Bakhtin's insight that the culture of the elite has its counterpoint in popular culture. Medieval costumes for the Devil of the mystery plays are behind the Devil's representations as early as the Winchester Psalter of 1150.

Between the tenth century and the thirteenth, clerics sometimes

castigated and sometimes praised liturgical drama. Despite serious gaps, we do have the text of the Mystère d'Adam mentioned earlier, which was not written in Latin but in Anglo-Norman. It dates from *c.* 1125, and was intended for outside performance. The extensive stage directions and implied theatrical effects require a stage and costumes similar to those of Fouquet's time, the mid-fifteenth century. Four hundred years earlier is the first liturgical play extant, a fragmentary 'oratorio' of the Harrowing of Hell. We do not know how it was performed, but the Devil would have been one of the earliest stage characters, and demons with claws and animal hair were probably part of profane drama before the tenth century. The Mystère d'Adam text does not specify the costumes of the demons or of the Devil, and this is probably because traditional costumes were already in existence. Of course, performances in the Middle Ages added refinements, effects and an organized scale, particularly for mystery cycles. But the dramaturgical sophistication of the Mystère d'Adam proves that liturgical plays, with Devil costumes, must have been performed before 1100.

The idea that Devil costumes from the mysteries became the most important source for the face and form of Satan makes considerable sense. If we look at the first two temptations of Christ and at the tortures of the damned in the Winchester Psalter, we see that these devils are costumed. This is especially true of the Devil on Jesus's right (illus. 50, top register) and the middle devil in the top Hell register (illus. 52), who wears a horned animal mask and lower body costume. Equally important and convincing is an illustration of *c.* 1320 of a minstrel troupe in the famous Roman de Fauvel (Bibliothèque Nationale, Paris). In that curious and distinctive work, we see the animal furred bodies and horned heads, flaming hair and large ears that devils are made of, and also (middle register, far left) a wild man. In the Renaud de Montanban of the 1400s there is an illustration of a knight-actor who has changed into a devil's furry costume and is about to put on his devil's head, an outfit similar to that of an itinerant actor in the middle register of the Fauvel illustration and, too, to that of the devil on the extreme left of the tortures of the damned (illus. 52, lower register) in the Winchester Psalter; that devil has the same kind of long grapnel as the knight-actor. The wardrobe records of England's Edward III for 1347 and 1348 reveal an extensive collection of masks and heads, including dragon heads, human heads with bat-wings and a dozen dragons' head-masks. The famous Cailleau illustrated manuscript of 1547 (Bibliothèque Nationale, MS 12536, fol. 2*v*) shows actors as grotesque devils coming out of the Hell Mouth, while sinners within

are boiling in the cauldron. These are not the artist's fancies, but depictions of what he would have seen on the stage.

Though Emile Mâle's original studies have established the influence of medieval drama on painting and sculpture, what is still debated, by the doyen of Christian iconography, Louis Réau, for example, are the specifics – the chronology and the interaction. Réau argues that sometimes it was the paintings that influenced the décor and costumes for the plays. And he is correct. 'Can't we argue that painting and sculpture influenced the costumes?' No doubt some costume details did come from the pictorial tradition. Some came from biblical texts. In Romans 16:18 and Philippians 3:19, Paul speaks of heretics, people who create dissensions, 'persons who do not serve our Lord Christ, but their own belly'. This description is behind the countless grotesque images of a devil with a face on his own belly or his knee that we find throughout the centuries (illus. 55). Glynne Wickham, a scholar of medieval drama, is probably right in seeing the mandorla behind the cloud machines used for ascensions in mystery plays. We have to be careful, though, because it is easy to agree that the visual media influenced the plays, and that the plays influenced the visual media, and that there was interaction. But this is not enlightening. What matters are specific cases. And we can see that Gislebertus's devils in the Last Judgment are not wearing costumes (illus. 46), that the Soriguerola devil never appeared on any stage (illus. 34), yet that devils in the Winchester Psalter are wearing costumes. Probably, the divisions in Fra Angelico's Hell do come from mystery plays (illus. 6), and, almost certainly, the Devil led by an angel from house to house to spread the plague among the Egyptians in the Visconti Book of Hours does too (illus. 36), and that every detail of that Devil is from a mystery costume. Fouquet's Devil interrupting St Bernard in the Chevalier Book of Hours is in costume, and so, too, in an illuminated manuscript, are the devils with drums challenging Charlemagne (illus. 24), and the popular pose of a devil bearing a sinner into the Hell Mouth (as in the Last Judgment at the cathedral at Chartres). If these specific interpretations are correct of works that were produced within the period that lies between the twelfth century and the fifteenth, then the single most important source for the look of the Devil was what he looked like on stage.

Tabulating the Devil's traits may be handy, but it veers toward the ahistorical. Context is crucial. Before we try to find the Devil in his specific settings, let us briefly review and suggest some patterns that we will trace in historical context. The function and role of the Devil in art come from fifth-century theology, and so do his names. His face and form come from Hellenistic sources (including adopted Osirian gods

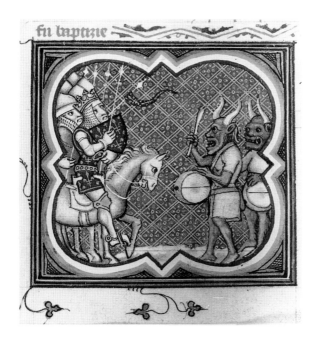

24 Saracens disguised as devils troubling Charlemagne's army, from the 14th-century *Grandes Chroniques de France*. Bibliothèque Nationale (MS 2813, fol. 119), Paris.

and Bes) and the liturgical drama. Roughly, what follows is how the Devil makes his appearance. The first Christian paintings are in the catacombs at Rome, but there is no Devil. Authorities puzzle over why there is no picture of the Devil before the sixth century.[88] I would say there are none before the ninth. The reason for this is, I suggest, twofold: confusion over the Devil, and a void, the lack of any usable pictorial model during the period when specifically Christian art forms and motifs emerge and separate out from classical influences. Although Christian art-forms blossom between 500 and 800, there is still no Devil (though there are a few examples of exorcised demons that some scholars take to be depictions of the Devil, and a Ravenna mosaic, which I discuss on pp. 109–10).[89] He first appears in the ninth century with the face of Pan and in cave-man skirts, and also as a polluted spirit cast out from Heaven (illus. 38), usually in the form of a dragon (illus. 71). When Lucifer is ejected from Heaven as an angel (rather than as a dragon), he is usually naked (or with cave-man shorts), pathetic and has flaming hair.

The Devil as the Ruler of Hell (illus. 30, 59) has no pictorial connection with the first ninth-century devils. The Devil in his Kingdom is typically a fat, naked, ugly black gorilla, the essence of Leo's 'cesspool of filth'. The Ruler of Hell often has no wings, horns, hoofs or tail. During the twelfth and thirteenth centuries the Devil has

horns and hoofs (or talons), tail and grapnel. He is more often without wings than with, and when he has wings they are angel wings, but which change during the fourteenth century from those of an angel to those of a bat. In the separation of the blessed and the damned of many Last Judgments he is a furry primitive in Romanesque works, and a naked creature with a human body and gross facial features in Gothic works (illus. 55). As the King of Hell he changes little, but his form and functions are sometimes influenced by Dante's description: he often has bat-wings and horns, and he eagerly ingests and defecates his sinner inmates (illus. 5, 57). He remains a grotesque monster in Last Judgments during the Gothic era and the Renaissance.

A different theme begins in the fifteenth century and is fully developed in the sixteenth: that of the rebel angels. Now the Devil becomes more and more human, until he is barely distinguishable from his opponent, Michael. The Godzilla Devil branch – which is often modified by the Devil who separates the blessed and the damned – continues into the seventeenth century (particularly in images of witchcraft). The other branch, the Lucifer versus Michael theme, continues into the Romantic era, examples of which include Blake's watercolours and engravings of a heroic Satan and Delacroix's lithograph illustrations for Goethe's *Faust*.

Where is the Devil to be found?

We can find the Devil in nine motifs, the first two of which are the most important, while the last involves his little agents: I the Apocalypse (one part of which becomes the rebel angels); II the Last Judgment (with the Leviathan Hell Mouth); III Temptations of Jesus; IV the Harrowing of Hell; V Theophilus, his story; VI the Tempting of Job; VII the Garden of Eden; VIII devils attacking and tempting Antony Abbot; IX devils tempting, lying in wait anywhere, anytime.

An early thirteenth-century Cistercian abbot called Richalm wrote what the medievalist G. G. Coulton identified as 'the completest handbook of medieval demonology', a model account of the Devil as microbe. 'Devils', complained Richalm, 'make me shortwinded when I work, and it is devils who raise my spirits so high I burst out laughing, and all the snoring and coughing and sneezing and spitting in the choir is their work'. Devils even prevented Richalm from reading: they made him sleepy, and if he stuck out his hands to chill them so as to keep awake, the devils attempted to warm his hands. Whatever was Richalm's ailment, devils were the cause:

Behold, I am now troubled with coughing and flatulence; that is their work. Lately I drank a little wine, by occasion whereof they have sent me this flatulence and gripes, to the intent that I may cease from my wine; yet wine is good for me. . . . The devils would fain stir me to dislike of nuts, that I might believe my hoarseness to come from the nuts that we have. . . . 'Indeed [says Richalm's pupil] I hear a wondrous sound [that] would seem to proceed from some distemper of your stomach or bowels.' 'Nay [explains Richalm] but it is the demon's sound; it is not as you think.' 'I should have found it hard to believe you [replies the pupil], considering the quality of that sound.'[90]

Monks can catch demons – just like they can colds – from others. 'I myself caught them from Brother William, when we were together in the Infirmary; they left him and fastened upon me. I hear them', claimed Richalm, 'in the voice of birds, and in the plashing water that falls into the Cloister basin'. The Devil was not just a microbe in the body social, he was even in the regulators of Brother Richalm's digestive gases. The Devil as microbe is by far the most common of his forms until the mid-fifteenth century. I will usually ignore this group since it is a trifle difficult to imagine that the adversary of God is dedicated to causing flatulence. Eden (motif VII) also offers little because a snake is a snake even if, at times, the snake does have a human head, usually that of a woman.

St Antony as a subject has generated some horrific monsters, but these devils are the Devil's agents and rarely can any of them be identified with the Devil himself. In the Tempting of Job (motif VI) the Devil is typically quite small, and about as dangerous to God as a fly might be to you or me (illus. 33). There are a few exceptions in sculpture, the most powerful being the Devil in the north porch of Chartres, a thirteenth-century masterpiece of malignity. Here, the arch-fiend's sense of triumph is unusual. The scene hardly suggests that this Devil is under God's control, particularly since he is looking up towards the Heavens as if in defiance (illus. 25). The story of Theophilus (motif V), a monk who made a pact with the Devil because he was unfairly treated, seems to prefigure the Faust story. It is, however, really a story to glorify the Virgin Mary, whose pity saves the poor monk. Originally written in Greek at the end of the sixth century, this particular legend became popular in Latin versions, and spread throughout Europe after 1100. It was made the subject of drama, and the sculptured depiction on Notre Dame in Paris is probably from a theatrical performance.

The melodramatic Harrowing of Hell (motif IV) was widely illustrated and remained for centuries a popular theme for mystery plays, but it is not to be found in the Bible. In the original third-century

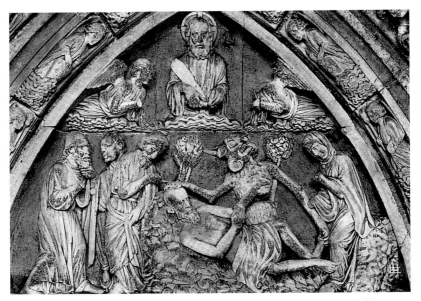

25 'Job and the Devil', *c.* 1200–30, from the right bay of the north portal of the Cathedral of Notre Dame, Chartres.

account by Nicodemus, Hell is personified as the ruler, while Satan is the prince who is thrown out of Hell to fight Jesus. Predictably, Satan fumbles his mission. Jesus tramples on Death, chains Satan, subdues the Kingdom of Hell and releases its prisoners. With such miserable results, Hell, understandably, rebukes Satan for having killed Jesus. As a punishment, Satan is placed under Hell's rule for eternity, replacing Adam and his children. (It is as if Satan replaces Adam, redeeming him; a kind of black-humour Atonement.) Jesus, the hero, smashes down Hell's gates or prises open its jaws to free the prisoners. In this drama Satan is in chains; he merely lies there growling and writhing like some nasty chained-up dog.

Hell Mouth, also found in the Apocalypse (motif I) and the Last Judgment (motif II), is a powerful symbol, and it was derived from both pictorial and literary sources. The main pictorial ones are Egyptian paintings of the Devourer of the Damned, Ammit, with his crocodile jaws; classical paintings and sculptures of the Gate of Hades; and the Gorgon's mouth, which was probably the most influential of the three. The chief literary ones comprise the description of Leviathan in Job; the account in Revelation of the angel with a key who locks the Devil in the bottomless pit; and a variety of biblical references that have been interpreted as Hades. The descriptions of God casting the rebel angels down to Hell and keeping them in everlasting chains and darkness until

Judgment Day (derived from Enoch in the Book of Jude and 2 Peter) were also often illustrated with Hell Mouth. This could be a force separate from the Devil with a will of its own; simply a vessel of God to contain the Devil; or a tool of the Devil. Though Hell Mouth may have had only one theological meaning, the three variations are pictorially different. The first variant is found in the Harrowing of Hell, the second in the Apocalypse, the third in the Last Judgment. In the Harrowing of Hell, Hell considers Satan to be a source of trouble. It is a Hell that Satan cannot control, and this fact is emphasized when Christ forces Hell Mouth to give up its entrapped souls. Precisely because it has a consciousness, this is the variant that the writers of mystery plays preferred. Hell speaks, argues with Satan, blaming him for the arrival of Christ: 'Just look what you've done, you bloody fool!' While the first and third variants are simply huge jaws, a force distinct from the Devil, the second variant derives from ancient symbolic forms. If a three-dimensional mask is split in half along its back (leaving just the skin of the front plane attached), and then opened up toward the front from the back and flattened, an abstract geometrical design is created (the T'ao-t'ieh mask on Chou Dynasty bronze vessels is an example). This distinctive pattern is also found in Indian sculptures of Kirttimukha (the Face of Glory), a lion-headed demon, which could have been transmitted through Alexandria. Some scholars, however, have argued that the Gorgon is the main source for this variant.[91] Hell Mouth in the Harrowing of Hell opens up; people leave. The Hell Mouth of the Apocalypse is shut forever by an angel who locks sinners and furry devils inside (illus. 26). This mouth is inherently devoid of conflict. Its Devil often seems entertaining, a kind of theological court jester who, even in Dürer's woodcuts, never rises above the level of a comic strip. As an adversary of God this Devil is as hopeless and as helpless as the Satan in the Harrowing of Hell.

In the third variant – a tool of the Devil – the Leviathan Hell Mouth of the Last Judgment, Hell Mouth is a powerful, primitive force, a denizen of the deep who receives what Satan casts in. This Hell Mouth cannot be called evil any more than can a cauldron. It is a tool of Satan that is best understood in the context of Last Judgment scenes. There are yet three further motifs: the Apocalypse (I), the Last Judgment (II), and the Temptations of Jesus (III). The Temptations might seem ideal for contrasting Jesus and his adversary. There are not many examples, but we will look carefully at those in the capitals of Autun's cathedral and in the Winchester Psalter. A person-to-person conflict between the Devil and Jesus would seem a dramatic scene, but it seems rarely to have inspired artists. Initially, in the ninth century, the Devil some-

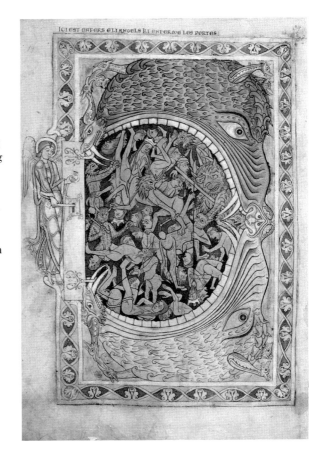

26 'An Angel Locks the Gates of Hell', *Winchester Psalter*, 1150. British Library (Cotton Nero MS C iv, fol. 39*r*), London.
A symmetrical Hell Mouth mask typical of the Angel locking the gates of Hell motif. This psalter was probably executed for Henry of Blois, Bishop of Winchester, at the Priory of St Swithin or at Hythe Priory.

times has a human shape; this soon was replaced by a winged, claw-foot furry grotesque, and then, in the fifteenth century, the Devil reappears at times in human form.[92] One of the first pictures of the Devil is a temptation scene, early ninth century, in the Stuttgarter Psalter (illus. 14). Two naked, black-winged devils (or perhaps this shows two stages of the same Satan, first tempting Jesus and then, rejected, fleeing him) tempt Christ from the left, while two angels lift up the world that Christ is destined to save. This book illustration of appalling workmanship seems centuries apart from a German ivory book-cover (only a few decades later) that has one of the most unusual temptation scenes (illus. 27). The ivory's central panel shows the first temptation, which should take place in the desert, though a flourishing tree appears in the middle. Christ and Satan are alike in appearance, height, dress and bearing. Two outward differences are that Satan's feet are bare, while Jesus wears sandals, and that Satan wears a Roman soldier's chlamys, while Jesus is in a Christian pallium. The conflict is

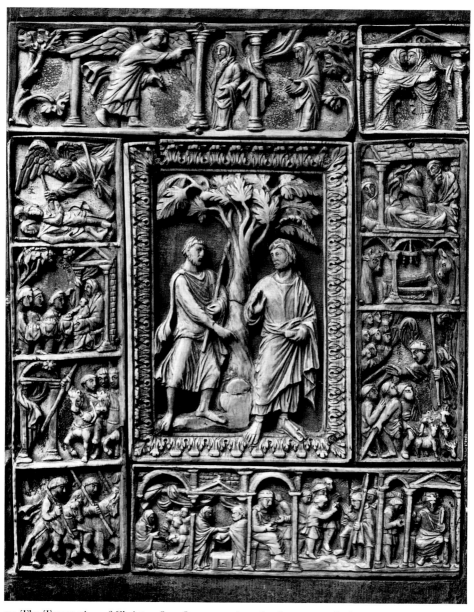

27 The Temptation of Christ, *c.* 830–850, on an ivory book-cover made for MS
Barth. 180, Ausst. 68. Stadts- und- Universitätsbibliothek, Frankfurt.

psychological. 'Command these stones be made bread' (the only words spoken by Satan in the New Testament) are dramatized by the strong, threatening personage to whom Jesus must respond, and he does so with a confident gesture of rejection. This Temptation shows classical influence, which is not unusual for this medium. Though ivory was used for many objects, from small liturgical vessels (*pyxides*) to Emperor Maximilian's throne, the most common use was for diptychs and book-covers. Diptychs (pairs of hinged ivory panels) were traditional presents given by Roman consuls to the emperor and senate until the middle of the sixth century, when the office of consul was abolished. Under Christian emperors, court artists continued producing these consular diptychs (though Christ often replaced the emperor), so it is not surprising that classical influences are stronger in ivory work than in other media. Nevertheless, the psychological dimension of this particular work is untypical. Usually, the confrontation between these adversaries is rather wooden because they face one other without the slightest interaction on any pictorial level (illus. 50). They are simply signs: this is Jesus and that is Satan, and Satan is tempting Jesus. To make the Devil a serious tempter of Jesus meant providing the Devil with a power that was beyond the inclination, ability or imagination of most artists until the fifteenth century.

The grand themes of the Apocalypse and the Last Judgment are those in which the Devil has to be more than just a furry joker. When Irenæus attacked Gnostics (such as Marcion), he denounced their religious rituals as a 'pattern instigated by Satan to lead [believers] to renounce the baptism of rebirth to God, indeed to deny the whole faith'.[93] When Tertullian attacked heretics, he posed the rhetorical question 'Who interprets the meaning of those passages which make for heresy? The Devil, of course, whose business it is to pervert truth, who apes even the divine sacraments in the idol-mysteries.'[94] The Devil was the source of heresy, and the public function of the Apocalypse and the Last Judgment was – at least in part – a response to heresies.

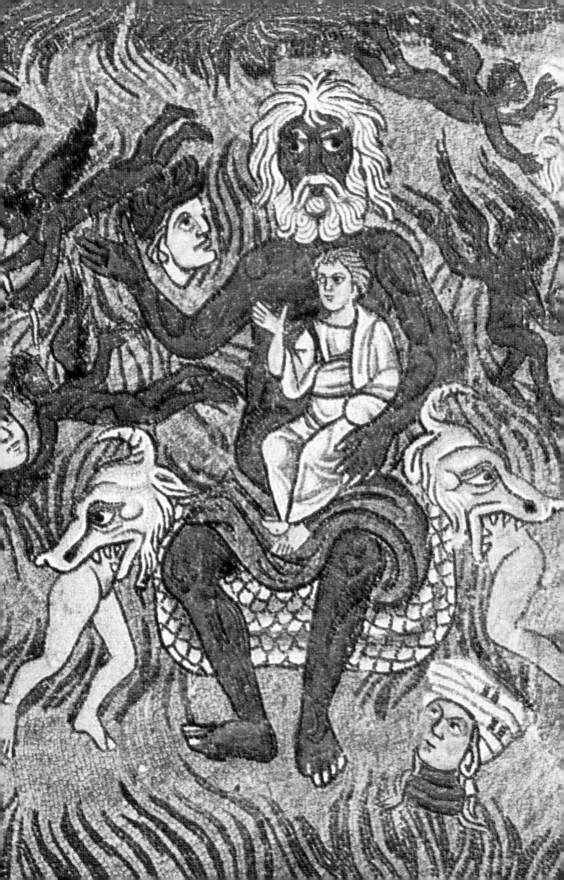

3 Heresy and Hell

Dualism, and the paradox of the Devil

You cannot commit heresy by yourself. Heresy depends on an authority defining what is orthodox, and that is why it is not as ironical as it seems to discover that Church orthodoxy was not self-generated but was often a response to alternative interpretations, in order that those interpretations could then be called heretical. The Italian historian Momigliano, comparing pagan and Christian historians, incisively encapsules one of our themes:

Ecclesiastical history was bound to be different from ordinary history because it was a history of the struggles against the Devil, who tries to pollute the purity of the Christian Church as guaranteed by the apostolic succession.[95]

If Christianity did not create heresy, it did make heresy more important in human history than ever before. For the Greeks, heresy (*hairesein*) denoted choosing from among different philosophies, and for the Greeks, Jews and Romans the word was without any moral connotations. In the New Testament the word bristles with pejorative nuances, and by the sixth century heresy is a dangerous Devil-derived deviation from Christian doctrine. Roughly, there are two types, internal and external. Historically, the Church was primarily concerned with internal heresies until *c.* 1000 and with external heresies thereafter.[96] The Devil is a harmonious part of the Christian universe in representations of the Last Judgment at the height of the struggle against *external* heresies (such as the doctrines of the Cathars). But it was in the struggle against *internal* heresies (such as Adoptionism) that the power, scope and nature of the Devil were defined. This was the context in which the monk Beatus laid the grounds for the iconography of the Apocalypse, a context described below in 'Beatus and Pollution'.

Before an idea can be called heretical, orthodoxy must be clearly defined, and that took the Latin Church more than five centuries. When Marcion, in the second century, discarded the Old Testament and insisted that the ten epistles of Paul and a truncated Luke

28 Detail of *The Last Judgment* mosaics at S. Maria Assunta, Torcello (illus. 42).

comprised the true canon, he could be condemned only *after* the Church defined purity in the oldest extant canon, the Muratorian Canon, in 185. The Trinity was never defined until after Arius, an Egyptian priest, preached a view of the Son as subordinate to the Father. Though condemned, Arius continued to preach, was excommunicated in 321 and forced to leave Egypt for Bithynia, where his ideas spread widely enough for the controversy to irritate Constantine to call the first Ecumenical Council. That Council formulated what became the Nicene creed. Next followed the innumerable configurations and interpretations about the relation of the Son to the Father that appeared in the fourth century: the Anomœans (who considered the Son to be unlike the Father), the Homœans (who believed the two alike), and the Homoiousians (who thought the nature of the Son and the Father to be similar). Some nuances were condemned one year in Antioch, others in Rome the next. A condemned sect rarely vanished, and often no-one recanted. Normally, though, no-one was executed in struggles against internal heresies, partly because no mechanism existed. This failing was remedied in 1184 when Pope Lucius III and Emperor Frederick I drew up a target list, and in 1231 the Papal Inquisition made enforcing machinery operational. The Cathars are an example of external heresy that the authorities locked onto. At the start of the thirteenth century heresy was a crime against the Emperor: heretics were legally burned, and Pope Innocent launched his crusade against the Cathars and their church. Though internal and external heresies might overlap in theory, the difference in the heretic mortality rates is unambiguous.

Christianity was like a stream of pure refreshing water fed by subterranean streams from seen and unseen mountains. Water drawn from a well dug by the Church, the only true guardian of purity, was offered to all. Other wells parasitically sucked off purity: Jews became well-poisoners; other well-diggers were brigands diverting the waters from the true owners. In attacking heretics such as Marcion and Valentinus, Tertullian used the imagery of legal terms and property rights. The heretics, he said,

acquire no right to Christian literature, and we have every right to say to them: 'Who are you? When did you arrive, and where from? You are not my people; what are you doing on my land? By what right are you cutting down my timber, Marcion? By whose leave are you diverting my waters, Valentinus? This property belongs to me. . . . I have good title-deeds from the original owners of the state. I am heir to the apostles.'[97]

The more precisely the boundaries of doctrine were drawn, the nastier the frictions. Valentinus, the most famous of the Alexandrian Christian

Gnostics, was taught by a personal disciple of Paul. He believed in salvation not through rites but through knowledge of the Gospel of Christ and illumination through Jesus. This 'appropriation' of Jesus is why Tertullian insisted that *he* had the title-deeds from the Apostles. Tertullian was fighting for correct apostolic succession, which alone could guarantee the purity of the Church. Religious leaders such as Marcion and Valentinus were trying to pollute that purity, and behind them was the Devil.

Our immediate concern with Gnosticism is only with one defining feature: its dualism. Most Gnostic schools taught that the universe is composed of spirit and matter, light and darkness. God was supreme, but even if he did create the universe, he did not oversee it. The universe of matter and darkness was ruled by some other being, often malign. 'The God of the Jews, creator of a cosmos threatened at its roots by incurable disease, is nothing but an unconscious puppet manipulated by the invisible strings of higher powers.'[98] Christ can help man recognize his true nature so that man can return to the world of light. This return is salvation. Unlike Christians, for whom time was linear – from Creation to Judgment Day – Gnostics considered time as a mode of the world from which they wished to escape. Matter and time were defilements from which man's spirit must free itself in order to enter the timeless realm of light. Though Gnosticism drew on strains of Jewish mysticism that were influenced by both Greek and Chaldean thinking, its dualism derives from Persian religious thought. To orthodox Christians, however, Gnosticism was simply a belief that the world was ruled by the Devil. Indeed, the Devil created the world, if we follow the Book of John, a Manichaean version of Scripture that a renegade Bogomil priest from Bulgaria, Bishop Nazarius, supplied to the Inquisition.[99]

From the third century, however, the Church had a more serious heresy about which to worry. Mani, a Persian who travelled to India, was supported by Shapur I, lost favour with Shapur's successor, Bahram I, and died in prison in 277. (His most famous follower was Augustine, until that good Father's conversion.) Manichaeanism had roots in Gnosticism and ties with Zoroaster, Jesus and Buddha. For our purposes, we note that Manichaeanism intensified the Persian dualism in Gnosticism: the principles of light and darkness were equally strong, equally eternal. Five centuries of conflict against internal heresies that overlapped with Gnosticism and Manichaeanism had left their mark on the Church's thinking. No form of dualism could be tolerated: it jeopardized critical Church doctrine, from the Trinity to the very function of the Church itself. This is why defining the Devil

as the adversary of God was a tricky proposition. It led to the paradox of the Devil. If God created the Devil, then dualism dissolves. But such dualism raises this question: Why did God create the author of evil? Cyril of Jerusalem made this problem explicit in one of his lectures of *c.* AD 350: 'When [the Devil] sinned, it was not because he was naturally prone to sin because if that were the case, then the cause of that sin would be God himself.'[100]

More than a millennium later, Shelley pointed to the same crux in rather a different tone:

[The Devil] can have no tendency or disposition the seeds of which were not originally planted by his creator;. . . . It would be as unfair to complain of the Devil for acting ill, as of a watch for going badly; the defects are to be imputed as much to God in the former case, as to the watchmaker in the latter.[101]

If acts of the Devil are only possible with God's permission, then perhaps Satan is not much of an adversary. If the Devil is only a microbe, the function of the Church is reduced and the mission of Jesus is diminished. But to make the Devil a true adversary with independent power, a *real* threat, to give him a substantial body that can cast shadows and control events restricts the light emanating from Jesus; it is like admitting nightmares that no-one wants fully to explore because of what they might reveal of the dreamer and of those who made him dream. The effort to avoid this was a complex balancing act – or, if you like, a contradiction – that shaped artistic conventions of the Devil motifs in the Apocalypse and the Last Judgment.

The Last Judgment and the Apocalypse: the difference

The medieval concept of the Apocalypse is derived from the Revelation of St John, a concept that is rich, complex, and treated in various media. Our interest is restricted to one episode: the expulsion of the Devil from Heaven. The principle of Apocalypse is conflict, a struggle between two representative opponents – St Michael and the dragon. It is war, and the loser is cast out. Purity is achieved. All believers will be saved. The effect is relieved awe. Since Michael will win, to be wise is to be on the winning side. An Apocalypse scene can provoke two important questions: Who is Michael? And who is the dragon?

The principle of the Last Judgment is not conflict, but harmony through judging and separation. All are included. The Last Judgment is a judging machine: there are adjustments, but there is no real struggle. The scale in which souls are weighed goes up or goes down; all are separated out. The soul goes to Heaven or to Hell. Sometimes

Mary or John may intercede, but when the Last Trump sounds and the dead come to life, the final adjustment is made for eternity. The effect is fear. No-one who is guilty can escape. Neither king nor bishop can fool Jesus or his Church. Justice is certain and absolute. But who is judging, and how? Who is being judged, and for what? The Apocalypse is an expulsion of pollution; dirty beings are cast out in order to cleanse a system. The Last Judgment is an ordering, a rearrangement of people within the system.

The Apocalypse became particularly popular between the eighth and tenth centuries, during codification of Christian doctrine that identified and extracted internal heresies. The Apocalypse is directed against *internal* enemies: pollution has to be cast out. But the Last Judgment is directed against the Church's *external* enemies, pollution from outside. That is why the Last Judgment is the theme for the tympana of many cathedral portals of the Gothic era; the Apocalypse, however, is the theme of none.

Images of pollution were used for internal heresies by Irenæus, Tertullian and Augustine against anyone who interpreted the Scriptures differently. The aim of such heretics, warned Tertullian, was 'not to convert the heathen but to subvert our folk. . . . They undermine our constructions to build their own. [The effect of the Gnostics and Marcion's followers may be illustrated by] the parable where the Lord sows the good wheat-seed first and the enemy, the Devil, afterwards adulterates the crop with barren tares.' Mani, the founder of Manichæism, wrote Eusebius, 'stitched together false and godless doctrines that he had collected from the countless long-extinct, godless heresies, and infected our empire with a deadly poison that came from the land of the Persians'.[102] The Emperor Diocletian used identical imagery, expressing his concern that the Manichees would 'attempt through the accursed morals and savage laws of Persia to infect . . . the modest and peaceful race of the Romans with the poison of a malignant serpent'.[103] This poison, this adulteration, this pollution had to be cast out of the body social, and it is why the Devil is flung from Heaven, and why the rebel angels are often explicitly shown as polluted angels (illus. 29). In this rendering, these evil beings have angel wings and haloes but no devil attributes, except for flaming hair and their obvious nakedness. The middle rebel angel shows some resentment; his companions are sadly resigned. In its rhythms and atmosphere, no other work conveys so perfectly the casting out of dirty pollutants from inside the system.

Internal enemies for Augustine were the worst. Such heretics, said Augustine, 'entertain in Christ's Church unsound and distorted ideas'. It was against such groups *in* the Church that Michael was fighting. It

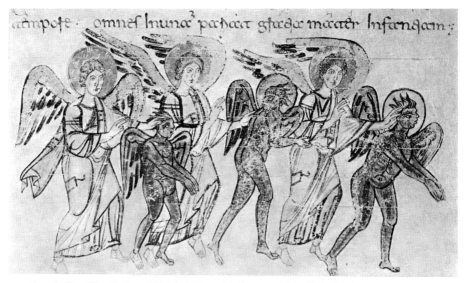

29 'Angels Expelling Polluted Spirits', from the *Benevento Benedictio Fontis*, *c.* 970–80. Biblioteca Casanatense (Cod. 724, BI13, II), Rome.

was the Devil, insisted Augustine, who 'inspired heretics to oppose Christian teaching under cover of the Christian name'. Bad though our enemies from without may be, there is 'that other heartache of seeing heretics too, using the name and sacraments, the Scriptures and the Creed of genuine Christians'.[104] Gnostics were the first to write commentaries on the Gospels,[105] and this fact is behind the words of Vincent of Lérins, the monk Pereginus, one of Augustine's contemporaries, who had the same heartache as Augustine but wrote in a more colourful style. 'Scampering heretics' (Christians who studied the words of the Bible rather than fixed glosses) were to be feared, located and swiftly cast out. Pereginus nicely expresses the dangers of social pollution:

Here perhaps someone will ask whether or not the heretics make use of testimonies derived from divine Scripture? They certainly do make use of them and vigorously, for you may see them scamper through every single book of the holy law, through the books of Moses, through the books of Kings, through The Psalms, through the apostles, through the Gospels, through the prophets. With their own people or with others, in private or in public, in conversations or in books, at banquets or on the streets, they almost never adduce any argument of theirs which they do not try to darken in words of Scripture also. . . . You may see a mountainous heap of proof texts, hardly any page without camouflage drawn from the sayings of the New and Old Testaments. They are, however, the more to be avoided and feared, as they lurk secretly the more under the shadow of divine law.[106]

86

To observe how the Devil appears, we must remember that much of the subject-matter for paintings, sculptures and illuminations in the Middle Ages was not taken from the Scriptures but from commentaries on them. *The Golden Legend*, that thirteenth-century collection of entertaining and edifying tales, is the source of more paintings of saints than is the Bible. What artist did not depict the story of the Flight into Egypt of Mary and Joseph? The Bible simply tells us that an angel warned Joseph to flee and that he took the young child and mother to Egypt. That is all. Or consider the fixed iconography of the three Magi: one is the oldest and one the youngest. The Bible does not even specify how many Magi there were.

The iconography of the Flight into Egypt had no particular theological or ideological implications. But Christ in Majesty was a bit different. The Virgin crowning the Emperor was a popular theme on gold coins. And when Christ appeared on one side of a coin and the Emperor Constantine on the other, fact became symbol. After all, the Emperor was Christ on earth. Here is how Eusebius, the founder of Christian historiography, described Constantine at the first Ecumenical Council:

At last he himself proceeded through the midst of the assembly, like some heavenly messenger of God, clothed in raiment which glittered as it were with rays of light, reflecting the growing radiance of a purple robe, and adorned with the brilliant splendour of gold and precious stones.

Only one man decided the true doctrines of the Church: the Emperor. The Churchmen could debate, but only the Emperor could literally execute. Emperor Theodosius I in 380 proclaimed that those who do not follow the established Christian doctrines were

extravagant madmen, we brand them with the infamous name of Heretics. . . . Besides the condemnation of Divine Justice, they must expect to suffer the severe penalties which our Authority, guided by heavenly wisdom, shall think proper to inflict upon them.[107]

Guided by Heavenly wisdom, in 452 the Emperors Valentinian III and Marcian confirmed the Council of Chalcedon and announced that 'public disputations and debates are the source and stuff of heretical madness. This sin, as we believe, will be punished by the judgment of God; but will also be restrained by the authority of the laws.'[108] Guided by Heavenly wisdom, the Emperor and Pope in the twelfth century co-operated to execute subversives (such as Arnold of Brescia); in the following century, the Inquisition emerges. If the Devil is the adversary of God, and if God's representatives on earth are the Emperor and his Church, then *any* opponent of the Emperor and his Church was the Devil.

When representations of triumphs over false prophets by the Empire and Church became important, the iconography of the Apocalypse appeared and, like the Flight into Egypt, the Apocalypse's shaping source was not the Scriptures but commentaries, in this case, the commentary by Beatus.

Beatus and Pollution

Beatus was an Asturian monk who wrote his interpretive commentary on Revelation in Liebana, Spain, *c.* 775. His two interlocking passions were his Commentaries and his fight against the Archbishop of Toledo, Elipandus. The story is a paradigm of internal Church conflicts, and shows that the casting out of heretical pollutants is the implicit stimulus and referent for Apocalypse depictions.[109]

Muslims had controlled most of Spain from the eighth century, and the best Charlemagne could do was establish a buffer zone east of Asturias, where resistance against the Muslims was strongest. Hispanics and Mozarabian Christians were reasonably content (and formed the cultural base for Toledo to become the medieval Alexandria from the early 1100s). *Convivencia* signified the 'living together' of Christians, Muslims and Jews. But Migetius, a member of a mission to tighten Spain's ecclesiastical ties to Rome, attacked Christians if they even dined with Muslims. This Migetius also pushed Trinitarian doctrines so hard that Elipandus decided to end these irritations by having the troublemaker condemned by a synod at Seville in 785. At that synod Elipandus, for good reason, referred to Jesus as the adopted son of God. Muslims, in particular, were in difficulty when the human and divine aspects of Jesus were sharply contrasted, and Elipandus was more interested in winning souls than in winning points with Rome. Normally, the entire episode would have ended with Migetius returning home. Unhappily for Elipandus, the problem became political. Asturians backing Alfonso II made an issue of the Archbishop's 'Adoptionism', and two loud supporters of Alfonso were the Abbot Beatus and his follower Etherius. They accused Elipandus of denying the divinity of Christ, to which Elipandus replied with an anathema. Beatus and Etherius then published a polemic against Elipandus in 786 and persuaded the Pope to call Elipandus a follower of Nestorius (a fifth-century Patriarch who supposedly denied Mary was the mother of God and who was excommunicated because Archbishop Cyril bribed the Emperor's advisers).

Unhappily for Beatus, few in Spain were taken in by this Nestorian red-herring and most ecclesiastics supported Elipandus. Undaunted,

Beatus and his friends made a clever move by attacking an Elipandus supporter, Felix, the Bishop of Urgel. This was clever because Urgel was under Charlemagne's rule, and since the Franks strongly stressed not the human but the divine aspect of Christ, the Franks were dragged into the controversy. Before long Felix was pressured to recant in Regensburg and then again in Rome. The moment he returned to Muslim Spain, however, he renounced his recantation and supported Elipandus once more. Elipandus now had a handle with which to counter-attack, by protesting to Charlemagne about the treatment of Felix. Emperor and Pope found this conflict distasteful enough to join forces, holding a major council in Frankfurt in 794 to officially reject Elipandus's Adoptionism. The dragon was cast out. Beatus and Etherius were clear winners, with the accession of the man they had supported, Alfonso II. In 798 Charlemagne prodded the compromised Pope Leo III to condemn Adoptionism as a heresy. Felix was pressured and again recanted; Elipandus was pushed into an enclave that was steadily losing power. Beatus became good friends with Charlemagne's favourite theologian, Alcuin, and the kingdom of Asturias no longer had to listen to Toledo. This tenacious fighter's legacy in the formulation of Apocalyptic iconography has had considerable influence.

Recent researches show that illuminations of the Apocalypse from the ninth to twelfth centuries can be divided into four main groups, three of which have a common origin in early Roman prototypes of the sixth century and mosaics of fifth-century Roman basilicas.[110] The fourth group differs in artistic techniques and in spirit. And it is the Devil of that fourth group which was to be the most influential in sculpture and painting, particularly as the Ruler of Hell. Of that fourth group, more than twenty-four illustrated manuscripts from the ninth through to the fifteenth centuries are based on Beatus's commentaries. Even if Peter Klein is right in suggesting that the influence of the Beatus Apocalypse is overrated, this does not hold true for the image of the Ruler of Hell that was generated.[111] The earliest and most influential surviving example is by Magius in the tenth century, the Morgan Beatus. The Whore of Babylon does not, as in the biblical text, appear on a throne above streams; instead she sits on a Muslim divan wearing a Muslim crown with the crescent. Belshazzar appears in a setting copied from the mosque in Cordoba. Islam is the dragon, the beast with seven heads, the embodiment of evil. Mohammed, some claimed, had died in 666, which was the number of the Antichrist.[112] The meaning to the Spanish reader was clear. The dragon was not in the Heavens, but right there in Spain. If, however, the Apocalypse's subtext is the attack against internal enemies, is not the fight against

Islam a battle against an external enemy? It should be, but, for two reasons, it is not. The Muslims were in Spain, which was Church territory. And, more importantly, ignorance about Arabs distorted basic facts. Islam was not considered a different religion but a heresy; it was so listed by John of Damascus a few years before Beatus started his commentaries, and languished in that category for hundreds of years after.[113]

Saracens were demonic, barbarous, cruel, ugly and perverse followers of the immoral Mohammed, an Antichrist.[114] Though Philippe Sénac marshals evidence for anti-Muslim attitudes, John Williams doubts that, at this time, Beatus had anti-Islamic references. Nevertheless, Williams notes that 'the Apocalypse, by its nature – and the predominantly Tyconian commentary, by the historical circumstances that produced it – were eminently suitable for reappropriation in the context of heresy and persecution'.[115] Whether or not the Apocalypse is inherently an anti-heretical concept, it certainly became that. We do not need explicit references, though there is at least one example. A German Apocalypse of 1310 reflects the specific ideology of the Order of the Teutonic Knights, showing the Knights baptizing pagans and Jews.[116]

In the Morgan Beatus we find Satan – big, black and deformed (illus. 38). He has no wings, no claws, no garments. This is a naked black gorilla form, one chained in the stocks of the criminal or falling horizontally into some dark void. This is the Satan of Magius and Beatus. At bottom right, unarmed angels cast out naked pollutants, human forms that look not one whit like rebel angels, and who are falling with Satan. Satan is a huge, black undifferentiated mass of filth.

Satan is also King of Hell in the Gerona Beatus. He sits surrounded by devils with snakes coiled around his legs, while the jagged spokes around his head may be a crown but probably represent flaming hair (illus. 59). This Satan is not much to look at, but he is the basic Ruler-in-Hell type, and continues unchanged in fundamentals through the Renaissance. He sits on a throne, sometimes with a sinner or two under his feet, a configuration that is an inversion of Christ the victor, seated on a throne as the Pantocrator, here treading down a pagan titan (illus. 7). Satan seated on a throne is the reverse of Christ on a throne, and with some distinct differences. First, Satan ingests sinners. The earliest example of the ingesting Satan is in the dragon heads on the arms of the throne Satan reposes on in the Torcello *Last Judgment* (illus. 28, 39). That image seems to be the source of a famous example that adds a second step: defecation of the sinners (Baptistery, Florence, mid-thirteenth century). Giotto used that Baptistery mosaic with little

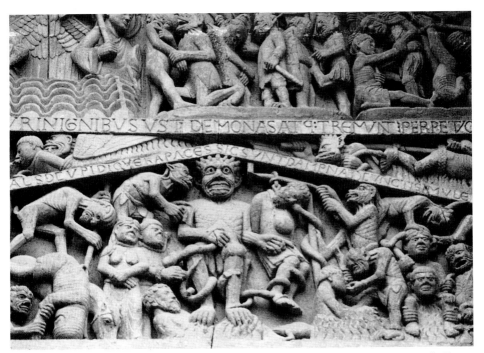

30 *The Last Judgment*, with Satan on his throne as King of Hell, *c.* 1130, at St Foy, Conques, Aveyron.

modification for his own *Last Judgment*. The simultaneous ingesting and defecating possibly has its psychological origins in inferences from the filthy throne Satan squats on. The concept behind Fra Angelico's Satan (illus. 1) is no different than this primitively executed early example. Sculptors also used this Gerona Beatus Satan as a model. In the *Last Judgment* at Conques, characterized by devils eating the damned, the Satan in Hell is virtually identical (illus. 30).

The Beatus-based Satans sometimes have horns, but normally have no wings, no claws, no split hoofs, no talons, no tails, no tridents. They are always naked and usually have large ears, prominent mouths and fangs. They are always fat, black and disgusting, but rarely are they threatening. Defeated by the angels, the Ruler of Hell is a passive fixture to receive all pollutants that will be cast out in the future. Philippe Ariès rightly says that the Conques Christ is still the Christ of the Apocalypse.[117] The iconography at Conques is an overlapping of motifs from Revelation and the Last Judgment (from Matthew). A nasty looking creature – and one we could hardly identify as the Devil if he were alone – argues with Michael about the Weighing of Souls. This operation the Beatus Devil could not do, and that is why the Devil

in these two different functions (King of Hell and opponent of Michael, or Weighing-of-Souls Satan) is normally never shown in the same work. The mischievous, even charming, Devil who tries to tip the balance in his favour has some connection with the real world and is usually a character, partly at least from connections with mystery plays. But the Gerona Beatus' type of Godzilla in Hell is merely an abstract, often clumsy, iconographical sign.

Prior to the early Renaissance the most typical form of the Devil, especially when Michael is fighting against him, is as a dragon, usually with seven heads. Probably the description in Revelation of the great red dragon with seven heads is the literary source for the seven heads in the graphic arts. Why St John imagined a seven-headed dragon in the first place is another question. Perhaps that dragon derives from the story and pictures of Hercules slaying the Hydra – but the Hydra has nine heads. Ancient Near East sources are suggestive. A passage on a tablet from Ras Shamra in Syria, as translated by Cyril Gordon, reads:

> When thou shalt smite Lotan, the fleeing serpent,
> [And] shalt put an end to the tortuous serpent,
> Shalyat of the seven heads . . .[118]

This is interesting, because the Babylonian Flood story is the basis for the Flood episode in Genesis. And the only version of that story known outside of Mesopotamia comes from Ras Shamra. An Akkadian cylinder seal from before the second millennium BC, found in Tell Asmar (near Baghdad), depicts two gods attacking a seven-headed dragon.[119] Possibly that Akkadian motif continued and was the basis both for St John's concept of the dragon and for the shape of that dragon in art. This plausible notion is weakened by the fact that no other seals with seven-headed dragons have so far been found. More likely a pictorial source, one showing seven-headed dragons, inspired John's image, and that literary image inspired medieval pictorial images.

Fighting the dragon and casting out false prophets and the Devil is only one episode from the Apocalypse. In the Last Judgment, however, the Devil has a pivotal role. For that role, an iconography that involved casting out the Devil and simply left him sitting in his corner in Hell would not do. Originally Augustine urged that men should be led to worship God by teaching rather than by fear. Later, when the Donatists, a schismatic African group, insisted that man is free to believe or not to believe, he changed his mind. After all, demanded the Donatists, against whom did Christ use violence? Augustine replied:

Is it not a part of the care of the shepherd, when any sheep have left the flock . . . to bring them back to the fold of his master when he has found them, by the fear or even the pain of the whip, if they show symptoms of resistance?[120]

By 1000, the Church was not interested in throwing people out, but in keeping everyone in. The days when an Elipandus could be expelled and allowed to stray were over. Now an Elipandus would be whipped back into the fold, or burned.

Heresy, and the Devil's new role: 1184

In the Last Judgment, the world ends and the dead are raised. In Joyce's *Portrait of the Artist as a Young Man*, Stephen Dedalus remembers listening to a description of Doomsday, when time is, time was, but time shall be no more:

All are assembled on that supreme day. And lo, the Supreme Judge is coming! No longer the lowly Lamb of God, no longer the meek Jesus of Nazareth, no longer the Man of Sorrows, no longer the Good Shepherd, He is seen now coming upon the clouds, in great power and majesty. . . . He speaks: and His voice is heard even at the farthest limits of space, even in the bottomless abyss. Supreme Judge, from His sentence there will be and can be no appeal. He calls the just to His side, bidding them enter into the Kingdom, the eternity of bliss prepared for them. The unjust He casts from Him, crying in His offended majesty: *Depart from me, ye cursed, into everlasting fire which was prepared for the devil and his angels.*

The single most important change in the early twelfth century was the concentration of power in the hands of the Pope and the Emperor. Two critical consequences were greater regimentation and control, and power conflicts between Emperor and Pope. Both wanted to preserve order. The question was – *whose?* In the year 1184, both pushed aside their disagreements and joined to judge and separate the peoples of Europe into the blessed and the damned. In Last Judgments on tympana of abbey churches and cathedrals of the twelfth and thirteenth centuries, the Devil has a new role. A new role needs a new mask. The dragon could not be the Devil's new persona, nor could the Beatus-Satan, squatting gorilla-like on the throne in Hell. The new Devil was shaped by his role in the Last Judgment, and the emotional content and psychological function of this theme were moulded by the dynamics of the twelfth century's social matrix.

Every heresy had political implications because the Emperor was God's representative on earth. Leo the Great's letters, for example, make it clear that it was the Emperor who decided when and where the Fourth Ecumenical Council was to be held. It was the Emperor who

had the final say in any doctrinal decision that had real teeth. A defining feature of Carolingian illuminated Bibles is the royal dedication miniatures. The one in the ninth-century Vivian Bible, for example, depicts the clergy offering the Bible not to the Pope but to the King. The Holy Roman Emperor was anointed, was a canon in a cathedral church, and appointed the Pope. The latter, until the mid-eleventh century, was simply the Emperor's most important bishop.[121] Since bishops and abbots had considerable secular authority, the Emperor liked to control their appointments. Heresy sparked friction between Emperor and Pope over who should appoint bishops – the Investiture Controversy of the 1070s. Heretical groups appeared throughout Europe from time to time, but until the 1070s they were isolated pockets of intellectuals or merely popular local groups. They followed neither Mani nor Zoroaster; their heresy was simply that they placed the value of a personal, pious life above rites and relics. King Robert the Pious in 1022 in Orléans was the first to burn heretics; others were hanged or tortured, but none had been of serious concern for the authorities. Quite unexpectedly, in 1077, heretics asked the Pope for protection against the Bishop of Cambrai, who wanted to burn them. This appeal to the Pope is a detail that reflects a new alignment of social forces. Mass heretical movements become a factor in the fight between Emperor and Pope.[122]

When the archbishop of Milan died in 1071, no Heavenly signs pointed to a successor. The Emperor, Henry IV, tried to force his nominee through, but he was too busy rolling back a rebellion in Saxony to dispute the Pope's confirmation of a reformist, Atto. Atto was not the Pope's choice; he had been selected by a popular reform party, the Patarines, named after a poor quarter in Milan. Gregory VII shrewdly supported the Patarine archbishop as a solid wedge against the Emperor. That wedge started a crack that split Europe for centuries. In the struggle between Emperor and Pope, control of the archbishopric of Milan was pivotal, and it was the weight of the Patarines in the Pope's balance-pan that tipped the scales. These were the same Patarines that Gregory had contacted to support popes Nicholas II and Alexander II, the same Patarines with whom Gregory had no real sympathy at all. Within decades, Patarine was a synonym for heretic. Pope Innocent III decreed that any heretic, 'especially if he be a Patarine, should be swiftly punished and all his goods confiscated'. Emperor Frederick II demanded that the Patarines 'should be burned alive in the sight of the people'.[123] This mutual feeling of Pope and Emperor reflected a new equilibrium after their tenacious conflicts, a division of labour for the Kingdom of Hell that had begun some years

earlier, in 1184 to be exact. That year, on 4 November, Pope Lucius III and the Holy Roman Emperor Frederick I convened the Verona Synod. Lucius was an honest but spineless man who, earlier in his career, had enjoyed the support of St Bernard and Hadrian IV, two persecutors of Arnold of Brescia. Red-bearded Frederick was the man who added 'Holy' to the title of Roman Emperor. On that day, Pope Lucius issued a decretal, the 'Ad abolendam', the first firm blacklist of heretics as determined by the Pope and Emperor. The list specified Cathars, Patarines, Humiliati, Poor Men of Lyon, and Arnold of Brescia's followers. Decisive procedural and judicial changes erased the need for any accusation to prosecute heretics. Bishops were instructed to sniff them out. The Church instituted proceedings and its judgement was executed by the secular arm. An imperial edict established the machinery to mesh with the teeth Pope Lucius gave the inquisitions he encouraged. The Pope labelled the heretic; the Emperor executed him. The Pope consigned him to Hell's flames; the Emperor ignited the faggots.

The year 1184 is a point in time from which we can look forward and backward. Looking back fifty years, we can see the first full Romanesque representations of the Last Judgment appear in various media at Torcello (mosaics), Autun and Conques (sculpture), and in the Winchester Psalter (illuminations). Looking forward fifty years we see the creation of the great Gothic Last Judgments at Chartres, Paris and Bourges. The iconography, the appeal and impulse behind the Last Judgment coincided with the Church's strongest assault against external heresy during that one hundred year period. These attacks were a response to the growth of heretical groups described by a mid-twelfth-century chronicler based near Cologne, Prior Eberwin. The Prior distinguished between apostolic idealists who believed the Church corrupt and the 'new heretics' who offered an organized religious alternative.[124] The new heretics were the Bogomils from the Balkans who became the Cathars of Italy and France (where they are also called the Albigenses). That prior's division was sound: heresies were mass movements of two main types:[125] reform movements that were cast out, and movements that were outside to begin with (and not interested in reforming that which they had rejected). Arnold of Brescia, a former abbot, calling for apostolic poverty, was the typical reformer. 'He was acute in intelligence, steadfast in the study of the Scriptures, fluent in speech, and a vigorous preacher of contempt for the world', noted one contemporary, John of Salisbury: 'He taught doctrines that were in closest harmony with the law of Christians, but as far removed as possible from their lives'. 'Arnold is like the Devil',

said St Bernard, 'who hunger and thirsts for the blood of souls'. Yet it was Bernard who attacked Abelard, and Arnold who defended him. Arnold was also an effective revolutionary organizer, thrown out of one country after another by popes and kings, and finally hung by the Holy Roman Emperor in an agreement with the Pope that marked a new level of ruling-class co-operation.[126]

A more orthodox reform movement was the Waldensians, called the 'poor men of Lyon'. Translating the Bible into the vernacular so that the common people could read scripture for themselves, the Waldensians tapped so many frustrations that the Third Lateran Council (1179) only rebuked them (though it condemned the Cathars). Pope Alexander III still hoped to bring these souls back into the fold. Walter Map, the archdeacon who examined a delegation of Waldensians to the Pope in Rome, wrote down his impressions:

These men have no fixed abode, and go about two by two, barefooted and without linen undergarments, without possessions, holding all in common as the Apostles did, following naked in the footsteps of the naked Christ.

Five years later, the Waldensians were excommunicated.

The 'poor men' movements pushed for Church reform and were condemned because their pushing was outside of Church control. Waldensians and other heretics were often accused of having a relish for sexual orgies and infanticide, the same charges that had been made against Christians during the first and second centuries. All the early Christian Apologists – Justin, Tatian and Tertullian – reject the slanders that Athenagoras, another Apologist, mentions: 'Three charges are brought against us: atheism, Thyestean feasts, and Oedipean intercourse.'[127] Tertullian mockingly described some of the rumours made about Christians.[128] Supposedly, the Christians met at night in a room illuminated by candles; bits of meat were placed at the base of the candles to attract dogs who then knocked over the candles, thus extinguishing the light. Blasphemous, incestuous sexual orgies and infanticide feasts followed. By the fourth century, clerical writers transfer the *identical* features to gatherings of Gnostics and heretics. Bishop Epiphanius in Cyprus, a leader in the harassment of Origen and his followers, had the gall to ascribe his derivative fantasies as his personal experience.[129] Original variations include heretic rituals in which semen is offered to God as the body of Christ, and the addition of spices and honey to pestle-ground infant powder. In the eleventh and twelfth centuries, such lies against heretics, including that curious feature of dogs knocking over the candles, were commonplace. Heretics, from Waldensians to Cathars, were hideously depraved

31 'The Martyrdom of St Lawrence', *Rohan Book of Hours*, *c.* 1425. Bibliothèque Nationale (MS Latin 9471, fol. 219), Paris.

The forked hook and, in particular, the curved fork grapnel (used in the tortures of criminals and heretics), is the most common instrument of the Devil (used for the torment of sinners).

32 Fra Angelico, *The Last Judgment*, c. 1431–5, tempera on wood. Museo di S. Marco, Florence.

33 Initial (showing the Devil, in his cave-man shorts, wielding a grapnel) from the Book of Job in the *Bible de Souvigny*, late 12th century. Bibliothèque Municipale (MS fol. 204), Moulins.

34 'The Weighing of Souls', showing the Devil in an ancient Egyptian-style *shenti*, from the Soriguerola Altarpiece, 13th century, tempera. Museu Nacional d'Art de Catalunya, Barcelona.

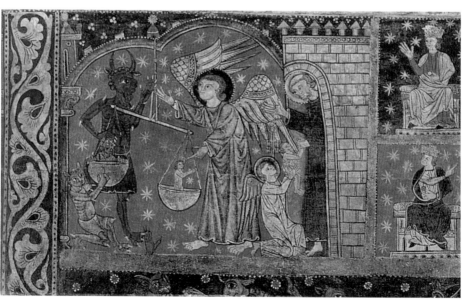

35 Christ as Apollo-Helios, before 350 AD, from a mosaic in the
mausoleum of the Julii in the catacomb (excavated in the 17th century)
beneath St Peter's in Rome.

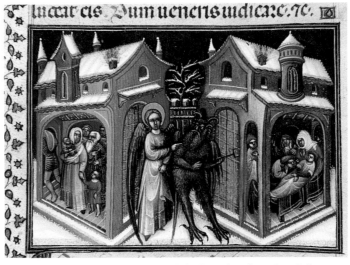

36 Belbello da Pavia, 'The Plague of the First-born': an Angel directs
the Devil where to spread the plague. From the *Visconti Hours*, 1412.
Biblioteca Nazionale Centrale (MS LF 95), Florence.

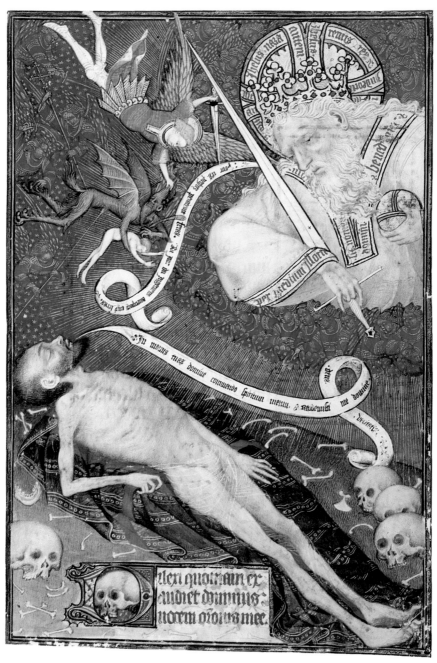

37 'Office of the Dead', *Rohan Book of Hours*, *c.* 1425. Bibliothèque Nationale (MS Latin 9471, fol. 159*r*), Paris.

Particular Judgment, the moment before death when the soul accepts God's grace or rejects it, determines the soul's future. The Rohan Master depicts the soul being saved from the Devil by Michael.

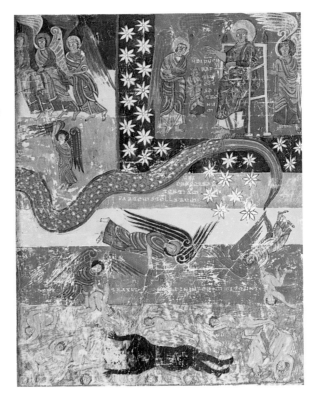

38 'Apocalypse', with Satan and his Rebel Angels hurled into the burning pit, from the *Morgan Beatus, c.* 940. Pierpont Morgan Library (MS M.644 fol. 153), New York.

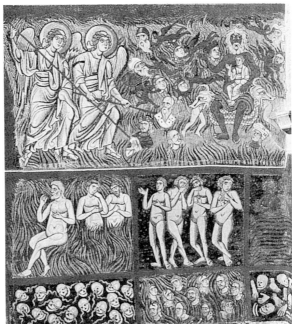

39 Detail of *The Last Judgment* mosaics at S. Maria Assunta, Torcello (illus. 42). Here, angels torment the damned, a function soon to be exclusively that of the Devil.

40 Jean Fouquet, 'Martyrdom of St Apollina', with Hell Mouth featured in a mystery play, from the *Book of Hours of Etienne Chevalier*, 1445. Musée Condé (MS 45), Chantilly.

agents of the Devil; therefore, executing them was justified. After many disputes with the Spiritual Franciscans, Pope John XXII made two points official and clear. He ruled that the right to hold property existed even before Adam and Eve were driven from Eden, and, furthermore, any who doubted this would be excommunicated.

The Church was the Devil himself to the Bogomils and Cathars who adopted and adapted the Persian dualism that informed Gnosticism and Manichaeanism. The Church was Satan, part of the visible world controlled or created by an evil god. The rejection of the Latin Church by the 'new heretics', their dedication to the pure life, and their roots among the common people drew large followings. In 1204 the Pope thought it discreet to send a representative to dispute with the Cathari bishop, Bernard Simorre. The Pope's man seems to have been a poor debater, for the Cathars continued to grow. Four years later, tired of talking, Pope Innocent III launched a crusade to wipe them out. After all, had not the Cathars murdered an inquisitor, Pierre de Castelnau, in 1208? About fifty years later, another hated inquisitor was assassinated, Pietro di Verona, who was then became a saint. In the sixteenth century this saint became a subject for paintings; in fact, Pordenone, Palma Vecchio and Titian were in intense competition to win a contract for such a work. Titian won, but his painting, an altarpiece for SS. Giovanni e Paolo in Venice, was destroyed by fire over a century ago. Good copies and engravings are extant, however, and make one wonder what was in Vasari's mind when he said that the original work, the *Death of St Peter Martyr*, 'is the most finished, the most celebrated, the greatest'.

At the turn of the thirteenth century the Pope declared heresy to be high treason, a crime against the Emperor. The crusade against the Cathars began and the Fourth Lateran Council (1215) affirmed sacraments against Cathar denials of such rituals. 'Transubstantiation' became an official term for the first time. Not only were all heresies condemned, even those

who are merely under suspicion of heresy shall be smitten with the sword of anathema and shunned by everyone. . . . The secular powers, no matter what offices they hold, shall be advised and persuaded and, if necessary, compelled by ecclesiastical censure [to] strive in good faith to exterminate all heretics. . . . If any temporal lord fails to purge his land of this heretical foulness after being required and warned to do so by the Church, he shall be bound with the fetters of excommunication . . .'[30]

The Council demanded that Jews and Muslims wear a distinguishing badge. About a decade later, burning heretics became legal throughout the Empire. Though Pope Gregory IX excommunicated Frederick II,

he had no compunction about using a law of Frederick's of 1224 to establish the Papal Inquisition in 1231. He staffed the institution with full-time professionals (Dominicans and Franciscans), who were accountable only to the Pope himself. The Synod of Verona had articulated the ideological basis for the machinery of the Inquisition; the Fourth Lateran Council reinforced and expanded that base, and Gregory's decretals now made the Inquisition a practical, functioning reality throughout Europe. The cause of the Inquisition, according to the Pope, was the Devil. We must search out the heretics, instructed the Pope. We must rise up against them and confound them, and turn every statute against them and against all who fail to denounce Satan's followers. To authorities who help us, 'we concede to them the free faculty of wielding the sword against the enemies of the faith'. The justification for the sharp edge of this decretal was the Devil:

That inveterate enemy of the human race, the instigator of all evils . . . by his wicked deceptions led mankind to the Fall and to the labours of wretchedness. He craftily tries to ensnare mankind in his pestilential nets. In these recent times, he has spread deadly poison. . . . Heretics now presume to rise against the Church publicly. We desire to do battle with these poisonous animals.[131]

In 1232 Gregory IX rambled on in his decretal letter, Vox in Rama, about witches, devils and heretics. In that letter to Henry VII, King of Germany, Gregory explains that when novices are initiated into heretical groups, they kiss a toad's hind parts and its mouth, and then they suck the toad's tongue and slaver. He continues his heretic ritual fantasy by explaining that after the ceremonies are finished, the lights are extinguished and sexual orgies begin. 'These most unfortunate people', claims the Pope, 'believe in Lucifer and claim that he was the creator of the celestial bodies and will ultimately return to glory when the Lord has fallen from power'.[132] Heretics sucking the tongues of toads was not Gregory's only problem. Both Church and state felt threatened not just by the social implications of the 'poor men' movements but by freethinking scholars and new ideas emanating from Paris, the intellectual centre of Europe from the close of the twelfth century.

What ignited Paris were transmissions of translations from Toledo, where Archbishop Raimundo had recruited Jews, Christians, Mozarabs and Muslims to organize the first interdisciplinary translation school (1130–1300). 'It is a commonplace to refer to the work of the School of Translators of Toledo, especially during the reign of Alfonso X, as a channel of Western culture', Jaime Vincens Vives has remarked. 'But within the last few years it has ceased to be a commonplace, and

has become a vibrant and poignant controversial matter, to learn how much impact the Jewish and Muslim mentalities have upon the innermost recesses of Christian mentality.'[133] Vives's judgements are supported in a recent study of Moorish Spain that documents the fact that not only medicine, mathematics and astronomy but even science came to Europe from Moorish transmission of classical texts supplemented by original contributions.[134] The most important scholar in Europe during the first half of the twelfth century was probably the Jewish translator, compiler and writer Johannes Avendehut of Toledo. But perhaps the most fascinating figure connected with that school (and with the Devil) was Michael Scot (or Scott or Escotus), whose life is interwoven with conflicting strands of the politics, philosophy and personalities of the early thirteenth century.

Just before the dawn of the thirteenth century, the future Pope, Honorius III, began tutoring the future Holy Roman Emperor, Frederick II (Frederick later became the teacher of Honorius and gave him a few political lessons that the Pope found unpalatable but had to swallow). To thicken this curious nodus, Frederick was also taught (according to an anonymous commentator on Dante) by Michael Scot. Even more remarkable, despite conflicts between Frederick II and Honorius, and nastier fights between Frederick and Honorius's successor, Gregory IX, Michael Scot was patronized by both emperor and pope. Perhaps Scot did indeed have the magical powers for which he became so renowned that Boccaccio described him in his *Decameron* (day VIII, tale ix) as the great master of necromancy who, when he visited Florence, was wined and dined by the city's nobility. Almost five hundred years after Boccaccio, Sir Walter Scott was to write *The Lay of the Last Minstrel*, in which (II, xiii) an aged harpist sings of a monk who, at Melrose Abbey in the moonlight, told his listeners of his travels in Spain and beyond:

> In these far climes it was my lot
> To meet the wondrous Michael Scott;
> A wizard of such dreaded fame,
> That when, in Salamanca's cave,
> Him listed his magic wand to wave,
> The bells would ring in Notre Dame!

In his extensive 'Notes' to the poem Sir Walter Scott also tells us that 'any work of great labour and antiquity' in Scotland used to be ascribed to Michael Scot, or to the nationalist hero Sir William Wallace, or to the Devil. Indeed, it was to Scot that Leonardo Pisano dedicated the revised, enlarged edition of his *Liber abbaci* of 1228, the book in which

this important mathematician introduced Hindu–Arabic numerals to the West. Yet Scot's reputation suffered because of his unusual interests. Albertus Magnus, 'the Universal Doctor', said that Scot understood nature and Aristotle rather badly, a curious assessment since Albertus (more famous in his own day than was his pupil Aquinas) used Scot's translations for his own work, copying him word for word.[135] Ultimately considered to be a mocker of Christ (Benvenuto, in his version of Michael Scot's death, gives his opinion that Scot had little faith in our Lord), and placed by Dante in the fourth bolgia of Hell, Scot was a man of exceptional intellectual curiosity, whose influence seems underrated today when we consider that he was one of the few learned men attracted to Toledo in order to master Arabic and translate Aristotle, Averroës and Avicenna. Roger Bacon records (in his *Opus maius*) that Scot personally transmitted Aristotle's writings to Oxford and Paris in 1230.

When Aristotle's works began to appear in accurate translations they were condemned. But by 1250 these same works became legitimate in the prophylactic versions of Thomas Aquinas. Before Aquinas carpented his filtering framework, Clarembald and Amaury had studied Aristotle through Averroës, the twelfth-century Arab philosopher, at the remarkable school of Chartres.[136] Teaching that everything is knowable, even God, their ideas undermined orthodox notions of sin and redemption. In these ideas the historian Friedrich Heer locates the origins of 'militant, non-Christian humanist thinking ever since, right down to Gide, Sartre and Camus'.[137] Thirteenth-century authorities did not have Professor Heer's perspective. The Fourth Lateran Council of 1215 condemned the principles of Joachim, Amaury of Bene and David of Dinant, and ordered that their books be burned. Amaury's body was thrown out of its grave because he had read Averroës. Men like Amaury lucidly expressed ideas implied in the odd, original visions of the influential mystic Joachim, who was placed by Dante in Paradise, 'shining with a true prophetic spirit'. Roger Bacon, Michael Scot's contemporary (and, like Scot, an alchemist), was also attracted to Joachim, which was probably one reason for Friar Bacon's imprisonment in the late 1270s. Joachim narrowly missed imprisonment for his visions of a new age without a sacramental system and without the Roman hierarchy; his vision linked the ideas of heretical scholars and popular heretical groups. The spirit of poverty and peace and the ideals preached in the Sermon on the Mount were to replace the institutionalized Church. Joachim and the Fraticelli influenced the Apostolics, led by Segarelli, who was imprisoned and then burned at the stake in Parma in 1300. Fra Dolcino of Novara then became their

leader, winning thousands of supporters. Hunted by the Inquisition, the Apostolics fled into the mountains to wait for the Angel Pope, a dream configured to late thirteenth-century Apocalyptic expectations. Unhappily, Clement V was Pope on earth, a Pope rendered spineless before Philip IV's assaults on the wealth of the Knights Templar, which Philip justified with lies about blasphemous Templar rites. Pope Clement did, however, have the backbone to exterminate the Apostolics, those 'polluting devils'. In the 'Inferno' (xxviii), Mohammed tells Dante:

> And you, who will probably soon see the sun,
> tell Fra Dolcino that unless he wants
> to join me down here rather quickly,
>
> he'd better stock up on food. Or blinding snows
> will give his enemies a victory
> that otherwise they could not easily win.

'A victory that otherwise they could not easily win.' Dante understood the strong support the poor men of Christ continued to generate. And it was for Clement V, Dolcino's persecutor, that Dante reserved with pleasure a place in his Hell. Dolcino's commune resisted the Pope's forces until winter snows and starvation defeated them. In 1307 Dolcino was torn to pieces with red-hot pincers (just as in the torments of Hell), and one hundred and forty of his followers were burned.

During the Church's most intense struggle with heresy, the Last Judgment became a popular theme for the portals of abbey churches and cathedrals. A recent revaluation of Romanesque sculpture concludes that monumental sculpture first appeared as a medium for the Church's message on political and social issues to monastic chapters and to the public.[138] This is the context of the Last Judgment in tympana, perhaps the finest example of which is at Autun, where we find the visage of the Devil.

The first suggestion of the Last Judgment is the sixth-century mosaic in S. Apollinare Nuovo, Ravenna, which (following Matthew 25:32–3) shows the separation of the sheep from the goats (illus. 41). Christ is between a red and a blue angel, and, according to several scholars, that 'blue angel' is the first picture of the Devil (as a result this mosaic is so captioned in many popular accounts).[139] This attribution is probably incorrect. Christ is seated between two standing angels, one red, one blue; three sheep are to his right and three goats to his left. However, if you visit S. Apollinare Nuovo you will not see much

41 'Separation of the Sheep from the Goats' – perhaps the first Last Judgment, but not the first Devil, *c.* 500, mosaic. S. Apollinare Nuovo, Ravenna.

because that mosaic is only one in a large series depicting Christ's miracles, arranged in a band high up, just below the ceiling. In this inconspicuous position the miracle scenes are all conventional in theme and execution. If the blue angel were the Devil, not only would this be the first, but the *only* Devil to be seen on the left side of Jesus during the Last Judgment, and such an innovation seems implausible in the context of the series' orthodoxy. Some people, however, believe in a blue rebel angel motif; some believe in the tooth fairy. Blue is, in fact, often the colour of the Virgin Mary. In a major, large mosaic below the miracle series is the Madonna flanked by four angels with blue haloes. If anything, the red of Hell would be more suitable for the Devil. There are, arguably, a few, much later, examples of blue angels that can be interpreted in various ways, yet almost all blue angels are unambiguously holy. An obvious example is a mid-fifteenth-century mosaic on one Baptistery wall in S. Marco, Venice, of Jesus being baptized while watched by three angels, two of them blue. Or earlier, the Angel of Resurrection in Emperor Henry II's Book of Pericopes (first decade of the eleventh century) is blue. Nothing out of context means much. Look at the Ravenna mosaic: does anything *intrinsic* to it point to the Devil? Everything points the other way. Notice, for example, that the blue angel is identical to the red angel except for his

eyes which – just like those of Christ – regard the sheep. Notice, in particular, that the stance of the blue angel is identical to that of the red angel. This is important, because medieval artists typically indicated a deceiver and devils by unstable foot positions.[140] Is there anything that anyone can point to that even suggests the Devil, except for the fact that the goats are in front of the blue angel? Where, then, could the goats have been placed? Perhaps the artist should have left blank the space on Christ's left side.

From the eleventh century, the Last Judgment expands into three main parts: the Parousia (Christ's Second Coming to Judgment), the separation of the blessed and damned, and the resurrection of the dead. On Torcello, an island in the lagoon of Venice, is the huge basilica founded in 639. The present mosaic (illus. 42) in this cathedral is, one hopes, an accurate reconstruction of an eleventh century one. The work is on an enormous scale, but lacks artistic unity. Today's visitor does not know where to look first, or in what order. This is a Last Judgment that does not seem to have been copied as a configuration, and the source of its iconography is not known. It has a wide selection of fixed complexes that were to be developed for centuries after, including the Anastasis, the Parousia, the Deësis, the Hetimasia and the Weighing of Souls. Particularly because Torcello contains elements that were to be selected in a far more effective iconography of the Last Judgment, it is worth studying.

The first level is the Anastasis: the Resurrection with the Descent to Hell. Christ has smashed the doors of Hell, scattering a collection of keys, and rescues the righteous. He is flanked by two enormous, richly clothed angels holding the orb of empire for the Church. The second level is the Parousia (the Second Coming). 'Parousia' was the official term for royal visits and therefore avoided by early New Testament writers; Christ did not come in royal glory but in humility. Later, the Church had no qualms about the word. In this Parousia, Christ, now one-third the size, is within a mandorla. A mandorla, or almond, is an oval, a holy frame, a kind of protective womb that developed from a 'holy' cloud in fifth-century mosaics in Rome's S. Maria Maggiore, and appears in the famous Ascension in the influential sixth-century Rabbula Gospels (possibly copied from an earlier mosaic). The mandorla is pervasive in Romanesque art, and much Gothic art too, but during the Renaissance it was dropped as an inert device. (Nanni di Banco, who may have had mandorla-mania, finished the motif forever with his carved *Assumption of the Virgin* of 1414–21 in the gable of the Porta della Mandorla at the Duomo in Florence.) In the Torcello mosaic, the Virgin and John, at the side of Jesus, act as intercessors;

this is the Deësis. The third level is Hetimasia (Psalm 9:7), preparing the empty throne with divine symbols. (The empty throne had been a standard feature of Buddhist iconography since the second century.) In the centre of the fourth level is the Virgin. On her right are the blessed; the damned are on her left. Directly above the Virgin in the fourth level is possibly the first known painting of the Weighing of Souls, a scene featuring Michael and the Devil. One reason why this scene became widely rendered was its potential utilization as a reflection of the separation of the blessed and the damned, the orthodox and the heretical.

The final zone contains one panel of saints and six small panels of Hell. There are a few odd features, but the strangest are scenes in Hell connected to Jesus in the mandorla by an umbilical red flame expanding into Hell-fire. In that scene (illus. 39) two large angels poke the damned with long staves (in the future, devils will perform this task with grapnels). Within those flames, like balls bobbing in water, are the heads of the damned. Tiny blue-winged angels pull beards, hair, or the turbans of heretics. Angels tormenting the damned are a feature of early apocryphal Apocalypses, which were quite popular and included visions of Heaven and Hell. In the 'Inferno' (ii, 28–30), Dante the Pilgrim is compared to St Paul the 'Chosen Vessel', who had already travelled through the heavenly spheres and the under-world. Most commentators see here only a reference to Heaven, but the reference probably includes Hell too, for Dante was influenced by the popular, and populist, fourth-century account of Hell in the Apocalypse of Paul. That account, in turn, depended heavily on the second-century Apocalypse of Peter, which, widely circulated, was very well-known in the second and third centuries. Closer to literature than theology, these graphic descriptions of Hell include angels punishing the damned. Paul sees 'angels without mercy, without pity and whose faces were full of fury' (xi). He refers to the three-pronged grapnel (xxxiv) when he tells us that he saw 'a man being strangled by angels, the guardians of Tartarus, who had in their hands an iron instrument with three prongs with which they pierced the intestines of that old man'. Angels, not devils, led the damned to their place of punishment. 'I saw', says Paul (xxxix), 'girls wearing black clothing and four dreadful angels who had blazing chains in their hands. And they set [the chains] on their necks and led them into darkness.' The separation of the damned from the elect, leading the damned to their

42 *The Last Judgment*, 12th-century mosaics, since restored, in S. Maria Assunta, on the island of Torcello near Venice.

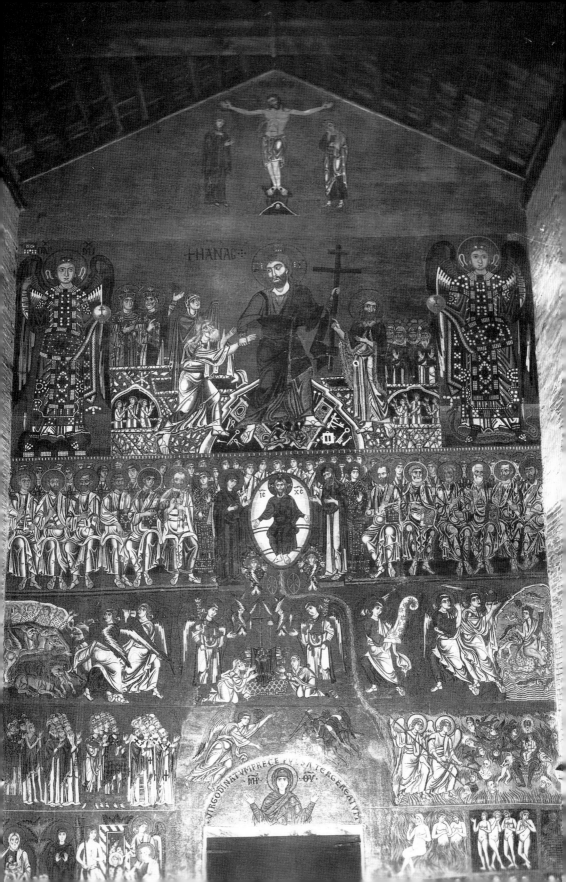

destined place of torment and then punishing them were tasks of the angels that became those of the Devil and his crew. The Torcello mosaic is the only major Last Judgment that reflects those early, popular Apocalypses. Perhaps one reason the ferocious angels and concepts of Hell in these works were not much used by artists is that authorities did not find apocrypha amusing. Pope Leo, for example, let it be known that 'The apocryphal writings, however, which under the names of the Apostles contain a hotbed of manifold perversity, should not only be forbidden but altogether removed and burnt with fire.' Before we scorn Leo's words, consider that M. R. James, the scholar who provided the first serious English translations of these apocryphal gospels and Apocalypses, was distressed about the fact that such works had 'exercised an influence wholly disproportionate to their intrinsic merits'. His translations rightly remained the standard ones until 1963; nevertheless, James explained to his readers that while he regretted the loss of so many apocryphal works, yet 'with the verdict that consigned them first to obscurity and then to destruction I cannot quarrel'.[141]

After the monumental Torcello mosaic, no longer would angels be enraged against evil and punish sinners. Instead, from the end of the eleventh century onward the Devil and his crew gleefully torture the damned. To the right of the two large angels, a large blue ogre sits on a throne (modelled after the famous bull capital of the fifth-century BC palace of Artaxerxes at Susa, Persia). The throne's arms are the heads of horned monsters devouring two naked bodies. Seated comfortably on the ogre's lap is a small figure, dressed like the angels, except he has neither wings nor sandals. Who is the ogre? Is the little man Antichrist? Jeffrey Burton Russell suggests it is Judas. Probably this ogre is the personification of the Hell the Devil serves in the Harrowing of Hell motif. The Devil was sometimes called *magisterulus*, the little master, and this seems to fit.[142] The same ogre is found in at least two other mosaics of Christ trampling on Hell as he descends to free those held captive (in S. Marco, Venice, and in an early twelfth-century work in the church of the Dormition, Daphni). In any case, the combination of elements in this Hell is amusing and confusing, and the entire work is a true conglomerate: a miscellany held together physically by the paste of theological symbols and formulas for colour, size and sequential arrangement. The different levels reflect, perhaps, the more rigid ordering of society on earth, the distinct separation of those who follow the teachings of the Church and those who presume to propagate teachings of their own.

43 The Papyrus of Ani,
c. 1300–1400 BC, in which
Ammit, the crocodile-lion-
hippo monster, watches as
ibis-headed Thoth records
the results of weighing the
dead man's heart against a
feather of Maat, the
Goddess of Truth. British
Museum, London.

44 Jackal-headed Anubis
adjusts the scales for the
'weighing of souls', from
the Papyrus of Ani
(illus 43).

The Weighing of Souls

You will not find anything in the Scriptures about the Weighing of
Souls. You will not find it depicted in any manuscript or any church
before 1100. But you will find it in countless New Kingdom Egyptian
tombs and manuscripts illustrating the Book of the Dead (illus. 43).
The Egyptians were arguably the first people to pass moral judgement
on a man after his death.[143] Before a dead man begins his future life,
Horus leads him to the judgement hall of Osiris. His heart is judged by
the scales of divine justice. If it is heavier than a feather of Maat, the
goddess of Truth, the dead man is thrown to the monster Ammit, who
devours the deceased with his crocodile jaws. Ammit had a crocodile
head; his body was part lion and part hippopotamus. Anubis, the
jackal-headed mortuary god, adjusts the tongue of the balance (illus.
44). Ibis-head Thoth, scribe of the gods, records the verdict as Ammit

watches, waiting. Twelve deities witness and confirm the verdict. If the scales do not move, the dead man is vindicated and 'Ammit shall not have power over him. Entrance to the presence of Osiris is granted.' Horus then leads the dead man before the throne of Osiris.

The classic representations are from about 1300 BC, though the theme continues for centuries. In papyri from *c.* 500 to 300 BC much has changed, and not just the atmosphere. It is as if part of the meaning has been lost or misunderstood, because Ammit is not watching Thoth, and both Horus and Anubis are fiddling with the scales. When the original meaning of a theme's iconography is lost, usually it is because the original beliefs have become watered down; it becomes received belief, not belief experienced. An identical development occurs in seventeenth-century Western treatments of the Weighing of Souls.

How did this Egyptian theme, the Weighing of Souls, or psychostasy, reach the cathedrals of Europe? Either Egyptian Christians adopted the theme and Irish monks transmitted it, or, more likely, Irish monks replaced Osiris with Christ, and changed the team of Anubis and Thoth to the two antagonists Michael and Satan. The Egyptian connection is certain. St Patrick himself is thought to have visited Lérins, a Mediterranean island with a famous 'Egyptian' monastery. Irish monks maintained direct contacts with Egypt and Syria. The interlace patterns of the late seventh-century Lindisfarne Gospels are similar to those in Coptic art. And on one great Irish cross monument of the early tenth century, Muiredach at Monasterboice, Louth, we see the earliest surviving Weighing of Souls. Visitors to Ireland could have been responsible for transmitting the theme; probably it was the erudite and artistic Irish monks who established monasteries throughout France and Italy during the seventh century who adapted the Weighing of Souls to the Last Judgment.

No-one seems to have noticed that the Devil competing with Michael on the thirteenth-century Soriguerola altarpiece is dressed in Egyptian clothing worn more than 1500 years earlier (illus. 34). A recent study argues that early biblical picture-rolls came from Egypt, were drawn on papyrus, and strongly influenced Christian art.[144] The Soriguerola master must have had some copy of Egyptian religious rituals. Though the artist unimaginatively retained the Egyptian *shenti*, he did make certain necessary, traditional changes. In the Christian version, man's good deeds are weighed against his evil ones. Since the Christians would not want to use Maat, they replaced her feather with a devil-imp. A devil-imp was in one balance pan, with the soul to be judged in the other. If the soul goes down (the weight of his good deeds making him heavier than the little devil), then that soul is saved and

joins the blessed. If the devil-imp's pan sinks and the soul flies up, that soul is damned. The physics may be fuzzy, but that is how it was supposed to work. And that is why we see a devil cheating by trying to pull down his fellow imp's pan. By the thirteenth century, this aspect is often a comic scene in paintings and in mystery plays (illus. 13).

Though it had been available for over a millennium, the Weighing of Souls motif is used only from the twelfth century onward. Why was it not used before? That seems a reasonable question, but a more cogent one is this: Why was it used at all? This is a more interesting one because the Weighing of Souls should *never* have been used: it is contrary to a critical Church dogma, the Particular Judgment. How is the fateful decision of whether man goes to Heaven or Hell decided? Good or evil deeds are not decisive. Even the vilest man *will* be saved if he accepts Christ and has faith in grace at his last hour. The initial group of cantos in Dante's 'Purgatorio' are about those who repented *in articulo mortis*, in their last hour, when the soul leaves the body.

Until his last moment, Marlowe's Faustus *could* have been saved. Of course, a good man goes to Heaven soon; an evil man must suffer and perform penance before he can enter Heaven (that is the function of Purgatory), but he is *certain* to get there. Particular Judgment means that man's fate – Heaven or Hell – is decided at his last hour, and that is the moment when the Devil may try to grab his soul. This orthodox doctrine and imagined situation is depicted with expressionistic power by the Rohan Master (illus. 37).

Particular Judgment locks a man's fate on his death-bed; the Weighing of Souls decides a man's fate years later, on Judgment Day. Either makes the other redundant, even ridiculous. Then there is the baffling complexity of the Resurrection of the Dead. The iconography of this event on Judgment Day required showing the blessed and the damned. Their fate has already been fixed. We can see this in their faces and gestures. But if their fates have already been determined, what is the purpose of the subsequent weighing? The only writer who seems to have noticed this oddity is Philippe Ariès, in his analysis of the Autun *Last Judgment*:

The fate of the dead is still determined from the moment of their resurrection. Some go directly to Paradise and others to Hell, which makes one wonder about the purpose of the judicial operations that are taking place. . . . One has the impression here that two different conceptions have been juxtaposed.[145]

The oddness of judging the prejudged (psychostasy of the resurrected) is minor when compared to the temporal and theological contradictions of the Particular Judgment and psychostasy. Perhaps because the Last

Judgment was not a fixed dogma with specified bifurcations, most Scholastics were not disturbed. Considering the esoteric issues many medieval schoolmen were obsessed by, it is curious that this glaring gap was left unrepaired. Aquinas glosses over the issues by simply stating that there is twofold Judgment. The first is when the soul leaves the body, and the second, a general Judgment, when the body and soul rejoin. This explains nothing. Earlier, we noticed that the Atonement doctrine which defined Christ as bait on a fishhook remained tenaciously in the mind, and one reason was its appeal to the imagination. Visually, if an idea is too complicated, viewers ignore it, or become bored. Perhaps the Weighing of Souls appeared together with the Resurrection of the Dead because of the dramatic quality. The images could all be imaginatively grasped, regardless of theological implications. But by itself, intrinsic imaginative appeal seems a wobbly base for explaining why bishops, cardinals and popes welcomed an iconography that contradicted Church doctrine. Another explanation is that the problems these two Judgments implied were submerged during the long period when there was no Purgatory.

The doctrine of Purgatory was not official before 1274. Though passages of the early Fathers were later interpreted to refer to Purgatory, the French historian Le Goff has found that the earliest use of the noun 'Purgatory' (*purgatorius*) was in the second half of the twelfth century.[146] For most people, the change from the binary scheme (Hell and Paradise) to a trinary one (Hell, Purgatory, Paradise) became real between 1150 and 1250. By then all the major Romanesque and Gothic tympana of the Last Judgment had already been finished.

In one of the first Last Judgments, the one at Torcello, we can see the angels tormenting the damned (illus. 39). This made sense since, in life, it was the Church (and secular authorities under its guidance) that located, examined, tortured and executed heretics. But that role of the angels was taken over by the Devil in Last Judgment iconography. That change suggests an answer to an important question: How is it that the Devil participates with God in the Last Judgment? The conflict between Michael and Satan for the soul is a pictorial motif of a traditional idea. Implicit in the 'objective weighing' is recognition of the Devil's right to garner evil souls. But the Devil has two further functions: he helps Michael separate the blessed from the damned, leading the latter in chains to Hell. And he punishes the damned. In the Last Judgment, then, the Devil usually performs three tasks: he participates in the judging and in the actual separation, and he executes punishment.

To what in the real medieval world did the Devil correspond? Who judged, separated and punished lost souls on earth? The answer is the Inquisition, the Imperial and Papal authorities. Though Ariès perceptively notes the shift in Last Judgments 'from eschatology in favour of judicial machinery', he sees the driving force as heightened consciousness of legalism throughout the medieval world rather than the machinery of heresy hunting and inquisitional activities.[147] Heretics were described as tools of the Devil and, just possibly, some early representations of fallen angels and devils had the faces of heretics. But this could *not* be true for the Devil of the Last Judgment, because he is a tool of God. Neither Cathars nor Jews punished the damned. When we turn to Giotto's *Last Judgment* we will see that the instruments the Devil uses for inflicting torture are *identical* to those actually used to punish heretics.

If the Last Judgment does or does not reflect the mind-set that resulted in prosecuting heretics, it is certain that psychostasy, the Weighing of Souls, became a standard part of Last Judgment separational iconography from *c.* 1130, when it was first artistically integrated into this vast theme by the sculptor Gislebertus in a city in Burgundy, Autun.

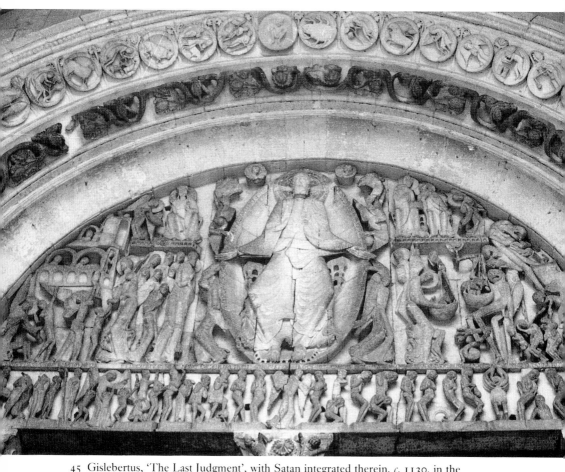

45 Gislebertus, 'The Last Judgment', with Satan integrated therein, *c.* 1130, in the tympanum of St Lazare, Autun.

4 Gislebertus, Giotto, and the Eroticism of Hell

The first Last Judgment

'I alone judge. I alone decide who goes to Hell and who to Paradise' is the inscription surrounding the Christ in the tympanum of the cathedral of St Lazare in Autun. This *Last Judgment* tympanum was the creation of the city's bishop, Etienne de Bage, and the sculptor Gislebertus.[148] The Bishop probably determined the iconography, and the sculptor realized it after his own vision. Christ, by far the largest figure, holds the entire semicircle of the tympanum and its elements in suspension by his power (illus. 45).

Gislebertus's *Last Judgment* is the most memorable executed prior to Michelangelo's in the Sistine Chapel because of the expressive power of the participants' strange agitations and tensions, to be seen even among the blessed rising to Paradise. Not everyone has thought highly of Gislebertus's work. Kenneth Clark told his television audiences that he found it distasteful, while at least one historian of medieval art thinks it entirely a 'makeshift arrangement' intended to show 'gory details'.[149] The tympanum at Autun is curious because the sculptor used Byzantine conventions to create what I would call Byzantine expressionism. The entrances to Paradise and Hell are absurdly small. Christ's lower body is a diamond-shape, with one point at his navel expanding to the two points of his knees and the final point being his feet. This particular posture and arrangement of the feet derives from representations of Sassanian monarchs, although Gislebertus may not have had direct knowledge of such imagery. As treated here, it is an impossible physical position, but one that contemporary viewers would have understood to indicate that Christ was sitting on his throne within a mandorla. The main figures are disciples and devils unnaturally elongated, as if they were by El Greco or Modigliani, to intensify the ultimate drama: the End of the World.

Angels separate the elect from the damned. The rounded forms of the blessed contrast with the sharp angles of the limbs of the damned and their extreme discomfort. The damned soul second from the extreme right holds a knife: he is the Jew ready for ritual murder and he

holds the Eucharist, which he defiles. Since the orthodox could use the Host for increasing apiary production, protecting cabbage leaves, and for seduction (a priest pushed the Host into the mouth of a woman he was kissing 'to incline her to his desires by virtue of the Sacrament'[150]), they could well believe Jews were worse offenders. They believed, in fact, that the Muslim King of Granada had plotted the destruction of Christians by bribing the Jews, who concocted poisons from powdered consecrated hosts with Satan's help, which they instructed lepers to drop into wells.[151] Thousands of Jews were murdered in France as a response to this fantasy. Jews were not, however, always sent to Hell. The Last Judgment tympanum (1130) of the abbey church of Beaulieu-sur-Dordogne shows confused, gesturing men that have been identified by Henry Kraus as Jews alive at Judgment Day who might yet be saved.[152] This identification has been rejected, though, in favour of the explanation that these men are probably heretics.[153] But Kraus's analysis, in which he adds that the men pointing to their genitals indicates that they are insisting they are children of Abraham, seems convincing. This feature is of some interest since there are virtually no other examples of heretics or Jews appearing in Last Judgment tympana.

Above the naked damned in their tortured positions at Autun is a ghoulish Satan with an emaciated, striated body. He has hands, claw-like feet, shaggy hair and a cavernous mouth with prominent teeth. This is Satan because he is opposite the archangel Michael. Between them, the hand of God holds the scales with which to weigh souls (illus. 46). Two other devils are larger and fiercer, and a fourth, much smaller and with a human body, hangs out of Hell's mouth in order to drag in sinners with his fork and chain. These fierce evil spirits are repulsive, but nothing approaches the terror of one lost soul's petrified face as two giant, long, smooth clawed hands, from out of nowhere, carefully encircle that soul's neck like a steel trap (illus. 47). This is an image of terror not seen before and not seen again. The terror is not so much at what the Devil can do but what Christ's judgment means when a soul is damned. Often in Last Judgment scenes, it is not the Devil who inspires horror in the viewer, but the anguish of the damned, cast off by God. (This is as true of Michelangelo's *Last Judgment* as it is of that by Gislebertus, and a clue as to why most depictions of the Devil are so drab.)

The body of Gislebertus's Devil derives from some of the oldest carved representations of the Evil One. Medical textbook illustrations of the human face with the skin removed to show the muscle tissue are rather like this Devil, an emaciated striated creature. A specific

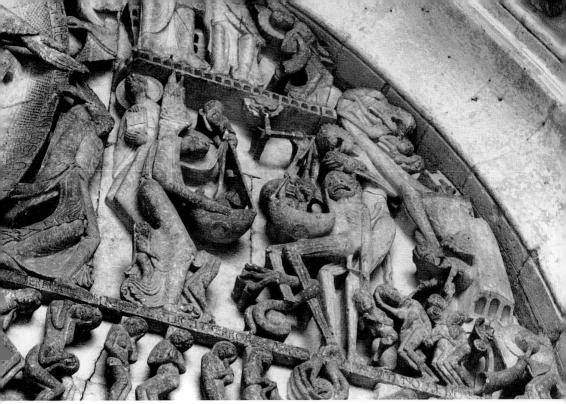

46 Detail of illus. 45: Satan and St Michael participating in the Weighing of Souls.

47 Detail of illus. 45: A lone soul seized from the ranks of the naked damned, in the area just below Satan's feet.

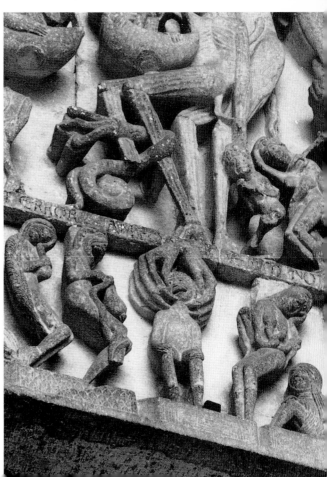

example is the capital in St Benoît-sur-Loire from the mid-eleventh century, which shows both Michael and the Devil grasping the same human soul (illus. 11). The Devil as Ruler of Hell in the Conques *Last Judgment* has an emaciated body (illus. 30), while a carved capital in the early twelfth-century basilica of St Andoche in Saulieu shows Judas being hanged by a devil with the same rib-showing body. There is no striated Devil in the graphic arts. It is unlikely that these sculptors were interested in displaying the Devil's muscle tissue, so where did this convention come from?

Gislebertus's Devil at St Lazare typically has no flaming hair, no grapnel, no wings, no clawed feet, no tail, no horns. There is nothing like this Devil in classical sculpture, nor in illustrated Psalters, nor in Apocalypse cycles. Though putatively implausible, one possible model is a figure type identified as Humbaba, the demon defeated by Gilgamesh. A terracotta Humbaba head of the seventh century BC shows the same open mouth, bared teeth and grooved face as this Devil (illus. 48). The clearest example of a striated body is also from Mesopotamia, a representation of the feared demon Pazuzu. How facets of Mesopotamian demon sculpture might still have been available more than one thousand years later is hard to explain. The Phoenicians who spread the Bes cult to Cyprus may have played a role. In the sixth-century Cyprian tomb at Amathus a demon-head was found together with a head of Bes. That terracotta head (now in the British Museum in London) is of considerable interest because it is a conflation of features from Pazuzu and Humbaba. There is no doubt,

48 The demon Humbaba, resembling a striated Devil, 7th century BC, terracotta. British Museum, London.

49 'Shroud of St Victor', with a traditional Mesopotamian design showing a hero overcoming lions, later thought to depict Daniel in the lions' den, 8th century AD, Buhyid (Persian) silk. Sens Cathedral.

however, that the painter of the thirteenth-century Soriguerola altar-piece (illus. 34) did have available to him some copies of ancient Egyptian painting, since that Devil is wearing an Egyptian *shenti*. This seems equally true for the creator of the marvellous Weighing of Souls at Bourges (illus. 55): the odd, big-eared imp in one pan and the curious object in the other continue to puzzle commentators, but both probably derive from an Egyptian representation. Usually a feather of the goddess of Truth, Maat, is depicted, but sometimes a mini-Maat is shown in one pan and a canopic jar (containing the preserved heart) in the other. It seems likely that this was the combination that the Bourges sculptor adapted by replacing the canopic jar with a chalice containing Christ's blood, and substituting the tiny Maat with the ugly head of the soul being judged. Mesopotamian motifs were available in the Middle Ages – for example Sassanian silks used in churches were imported before the tenth century. These silks had motifs (illus. 49) that went back centuries before Christ. Even so, it is hard to imagine Humbaba's

head on such a silk, and perhaps even harder to imagine where the St Benoît-sur-Loire sculptor (illus. 11) could have seen such a head. However, the resemblance between Mesopotamian demon carvings and the Romanesque striated Devil seems too close to be a coincidence. Gislebertus's Devil probably derives from a carved devil type that had been made more than half a century before he worked out his own designs.

The carvings at Cluny supposedly influenced Gislebertus, who may himself have worked there. But little of Cluny remains. Perhaps the capitals at Cluny that seem today to have influenced Gislebertus were actually carved by Gislebertus himself. Whatever the details, Autun is important for its artistic originality and because – unlike other cathedrals – virtually all the stone-carving was done by one person. This makes it clear that the Devil is deprived of a fixed iconography, since the devils in the tympanum are totally different from the devil involved in the death of Judas. In fact, the two devils in the Judas capital itself are different: one has flaming shocks of hair, the other has peppercorn hair (typical of Buddha heads); one has pointed ears, the other rounded ones; and neither is of the emaciated devil type that is found in the tympanum.

A common explanation for the Devil's variety of appearances is that it is the Devil's nature: he takes many forms. Shakespeare's Hamlet knew this. When the ghost of his dead father appears and explains how he was murdered, Hamlet initially believes him; but on reflection (II, ii), in a moment of rationalizing, Hamlet soliloquizes:

> . . . The spirit that I have seen
> May be a devil, and the devil hath power
> T'assume a pleasing shape . . .

However, this notion hardly explains the difference in hairstyles. Furthermore, though in literary sources the Devil sometimes changes his actual form, usually in medieval drama he simply *disguises* himself by wearing a different costume (illus. 50).[154] In paintings and sculptures the Devil is rarely in disguise, certainly not in any of the many examples carved by Gislebertus. The capitals at Autun that display the Temptations of Christ include a fierce devil with flaming hair who has the features and power of Satan. The author of the most thorough modern study of Christian iconography, the German scholar Gertrude Schiller, suggests that as Satan the tempter becomes more monstrous in appearance, his role changes from tempter to adversary.[155] Though Schiller's knowledge of such representations is exceptional, this shift seems doubtful. With a few exceptions, most medieval representations

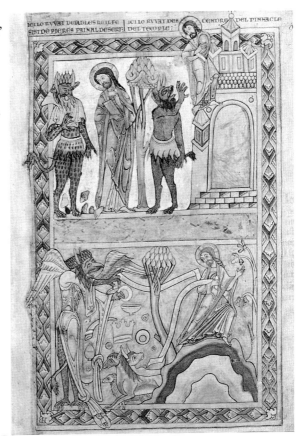

50 'First and Second Temptations of Christ' (upper register) and 'Third Temptation' (lower register), *Winchester Psalter*, 1150. British Library (Cotton Nero MS C iv, fol. 18r), London.

of the Temptations remain at the stage of development of the Winchester Psalter, and this naturally includes works made after Gislebertus. The Autun Satan is not an evolution from something else: it is the distinct product of Gislebertus's own imagination. In a departure from convention, in one capital Gislebertus's Satan, standing on a tower, is higher than Jesus (illus. 51). We know we have found the Devil when we can sense the power of evil. Precisely because Gislebertus, alone of his contemporaries, has created a fiend who is *not* under Christ's control – who is under no one's control – we feel we face Satan.

About a decade after Autun was finished, the Winchester Psalter was completed.[156] Though the Psalter is English work while the cathedral is French, and though a Psalter's painted folios and a tympanum's stone are quite different media, the same odd lack of unified iconography of the Devil makes a comparison instructive. The three Temptations in the Winchester Psalter, *c.* 1150, are on one folio. The first and second are at the top; the third is at the bottom (illus. 50). The

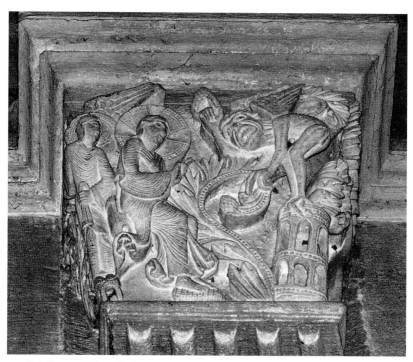

51 Gislebertus, 'The Third Temptation of Christ', *c.* 1130, on a capital in St Lazare, Autun.

Devil sticks out his tongue in the first Temptation; his hands and feet have claws, and he wears the costume of a spotted animal. Over that costume are the shaggy shorts. He has large, but not particularly goat-like, ears, and big horns. Standing next to Jesus, he looks neither at him nor at the stones on the ground, towards which his left hand seems to gesture. There is no emotional or pictorial relation with Jesus except proximity, so that this Devil looks a bit bizarre, but hardly terrifying. An ornamental tree divides the first from the second Temptation, where Jesus stands on the temple in an impossibly awkward way. Jesus is smaller than the Devil, a hopeless attempt by the artist to indicate background and foreground. This second Devil is identical to the first, except that he is naked but for his shaggy shorts, and he has normal ears. One clawed hand is raised threateningly in Jesus's direction. This scene, too, is wooden. The third Temptation has a fantastically dressed Devil. With a beak nose, claws, tail, horns and wings, he offers Jesus the world through odd symbols floating in the air that include a crown, bowls, horns and some bracelet-like objects that resemble those associated with Ahura Mazda of Zoroastrianism. The sleeves and bottom of the Devil's dress are so long that they have been knotted in

the aristocratic fashion of the time. The clothing is parted on the side to reveal that this Devil's body is the same as that of the first one. The Devil's scroll reads 'Worship me and all is yours'; Jesus has his own scroll, which, in response, reads 'You shall not tempt God'. The beak nose, shark teeth and the wings – as well as the dress – make this evil-looking Devil different from the other two.

In the same Psalter's *Last Judgment*, the devils differ even more (illus. 52). In the top register, the damned are tortured by three of them. Two have horns, two have wings; two have the shaggy skirt and all three have wolf-masks; one has hoofs while two have claws. All three have the spotted furry covering of the Devil in the first Temptation, but not one has the viciousness of the savage crowd in the Betrayal or the torturers in the Flagellation. Compare a Devil tempting Christ (see illus. 50) with the image by the same artist, or team, using the same techniques and conventions, showing the men torturing Christ (illus. 53). Which

52 'Tortures of the Damned', *Winchester Psalter*, 1150. British Library (Cotton Nero MS C iv, fol. 38*r*), London.

53 'Christ's Flagellation', *Winchester Psalter*, 1150. British Library (Cotton Nero MS C iv, fol. 21*r*), London.

figure seems foolish and wooden? Which figure embodies cruelty, hate and evil? This juxtaposition is most curious: in the arts the Devil does *not* embody evil; evil is represented strongest through human figures. This situation is not peculiar to the Winchester Psalter; the issue is the same with Giotto's Devil, the clearest example of perhaps the most curious aspect of the Devil in art. The Devil is a marginal figure – pervasive, but marginal. He is not painted or carved in an abstract style or in a symbolic style, but is always particularized, in a specific situation or action. But that action is typically marginal – urging on Pilate, for example. Earlier (in the opening paragraphs of chapter Two) I mentioned that figures in medieval art, through their iconography, are typically treated as a *figura*: a particular person is perceived through an interlocking series of relationships, so that, for example, a prophet of the Old Testament signifies and prefigures an Apostle of the New.[157] Figural realism is a defining characteristic of early Christian art: the Devil's fall prefigures, signifies and contains the fall of Adam.

The curious fact is, though, that most representations of the Devil do *not* lend themselves to figural interpretation. One reason is that though the Devil has a life with different stages, these are not often shown. Samson performs great feats, meets Delilah, is shorn, captured, and finally revenges himself on his tormentors. He has a history that is implied in his representations because these show a variety of particular stages in his life. The most common representations of the Devil, however, are sharply limited to the Devil as microbe, as a snake tempting Eve, as sitting in Hell or fighting with Michael during psychostasy. Peter (in the second-century Acts of Peter, VIII) ticks off

the Devil's marginal evil doings that were to be painted: 'Thou has made Judas . . . do wickedly and betray our Lord Jesus Christ. . . . Thou didst harden the heart of Herod and provoke Pharaoh, making him fight against Moses; thou didst give Caiaphas the boldness to hand over our Lord Jesus Christ to the cruel throng . . .'. Nowhere, in the Acts, does Peter speak about Lucifer, nor about the Devil being the adversary of God and Jesus. Crucial episodes – the creation of the Devil, his sitting beside God, his (and not a dragon's) conflict with God and his angels, and his tempting of Jesus – are rarely shown. The result is that even in the clumsiest and most artificial Byzantine paintings, the Devil is the least convincing figure of all. Neither frightening nor fearful, rather than appearing as a real adversary of God, he seems to be just a pest (illus. 33, 54).

An odd lack of unified iconography of the Devil within the Winchester Psalter, even on the same folio, and also even on capitals

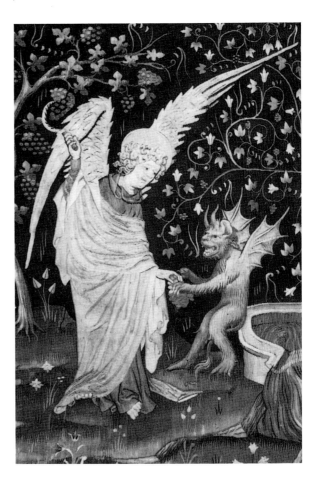

54 Detail of illus. 72: the Devil as a pest, from the Angers Apocalypse Tapestry.

within St Lazare, is characteristic. The confused iconography of the Devil is like a mixture, not a compound, a suspension not a solution, and this is because nobody seems to have been sure about who the Devil was, whether he had sinned from the beginning or not, whether demons were Satans or not, or whether Satans were fallen angels or just large-phallused fauns mounting Manichaean maids. Or, too, whether the Devil was the reason why hundreds of thousands were killed fighting against the Roman Emperor's forcible imposition of the arbitrarily defined orthodoxy that Procopius, the sixth-century Byzantine historian, wrote about.

The three major Gothic Last Judgments are to be found at Notre-Dame in Paris and in the cathedrals at Chartres and Bourges. All three were completed before 1250, and in none of them is Christ depicted within a mandorla womb, that remnant from the Apocalypse. All are roughly similar, with the Parousia and Deësis (the separation and psychostasy) and the Resurrection shown in separate bands, in that order. The most unusual feature of Notre-Dame's *Last Judgment* is the dead rising fully dressed, an idea of Maurice de Sully, the Archbishop of Paris. Heaven and Hell are presented outside the tympanum in the voussoirs. To the right of the sinners being led to Hell are grotesque devil-monsters. Two surround the boiling cauldron in which sinners are tortured; one has a beak, the other a snout quite similar to the one in Dürer's *Harrowing of Hell*, a woodcut of 1510. Notre-Dame's *Last Judgment* is the least interesting of the three: the shifting of Heaven's joys and Hell's torments into the voussoirs weakens the drama. It is hard to judge the original quality because what we see today is a restoration. Fragments of the original indicate quite different styles. The most artistically successful section is the Resurrection of the Dead, but while the angel and figures on the left are marvellously expressive and alive, those on the right are stiffer and 'technically' a hundred years older.

At Chartres, the Virgin and John are as large as Christ; in feeling and structure this Last Judgment stresses the Deësis, the sympathetic intercession of Christ's mother and John. Angels in a band of cloud-waves hover over the damned who, unlike the figures in the work at Bourges, are fully dressed kings, queens and bishops, moving as if in a trance toward the Hell Mouth. The devils have no horns, no wings, no tails. Large grotesque mouths with prominent teeth display the open-mouth threat. Some have furry bodies; others are simply naked. The damned are fearful, and one man looks with puzzled concern at the angels above him. But there is no sense of horror, no agony, not even from the nude courtesan on the back of a devil who, grabbing her, is ready to heave her into Hell Mouth.

55 'The Weighing of Souls', in a detail from the *Last Judgment*, 1250 (restored in the 19th century), on the tympanum of the west front, Cathedral of St Etienne, Bourges.

The restored Bourges' *Last Judgment* (illus. 55) has finely executed nudes, and the devils bear no resemblance to those at Conques or Autun. Satan and his helpers are also nude; most have a human body: no wings, no talons, no fur, although there are phallic snakes where their penises would be. The bestial heads, prominent open mouths, and the prods identify them as they push the damned into a boiling cauldron heated from Hell Mouth's flames. Satan is fully bearded, holding a forked prong as he watches the scales held by a confident Michael. Protective and human as this Michael is, and beastly as the Devil is, the pair yet co-operate in this tableau: the Last Judgment machine is functioning smoothly.

Why Giotto could not paint the Devil

In the seventh bolgia of Dante's 'Inferno', the poet watches usurers attempting to protect themselves from falling flames and burning sands and is reminded of a dog in summer trying to brush off tormenting fleas. Dante cannot recognize a single face but he does recognize the coats of arms on their money-purses:

56 Detail of illus. 61: Giotto, *The Last Judgment*, 1304–13, fresco, Arena Chapel, Padua.

When I came among them, looking about
I saw the head and shape of a lion
in azure on a yellow purse;

Then as I kept looking I spotted
Another purse, red as blood
Displaying a goose whiter than butter,

And one, on whose white money bag
was an azure, pregnant sow
asked me, 'What are you doing in this pit?'

The questioner was Rinaldo Scrovegni, one of the richest usurers in Padua. And the most important Last Judgment of the fourteenth century would not exist without Enrico Scrovegni, the son of the man who questioned Dante in Hell. Second in wealth to none in Padua, Enrico Scrovegni privately commissioned Giotto to decorate the luxurious Arena Chapel he had built in honour of the Virgin (illus. 61). Perhaps this is the first time a private citizen in Italy was a patron for a major artist. Certainly it is the first Last Judgment in which a known

57 Detail of illus. 61: Giotto, *The Last Judgment*.

usurer's wealthy gifts are graciously accepted by the Virgin Mary: in Giotto's *Last Judgment* – in a prominent place – Scrovegni presents a model of his chapel to the Virgin (illus. 56). Much of this work was painted by Giotto's assistants, but the master himself did Scrovegni's face. Surely here was one man who would not join the damned in Hell. Giotto, too, was financially successful: he maintained homes in Florence and Rome, purchased agricultural estates, and hired out looms quite profitably. He painted St Francis; he did not follow him.

In his completely insulated Hell, this conventional Satan is an unreal grotesque eating the damned the way he is supposed to (illus. 57). Unoriginal in major and minor details, this Ruler of Hell is probably a weak copy of the famous mosaic (early fourteenth century) that Giotto knew in Florence's Baptistery (parts, possibly, were by Cimabue, Giotto's teacher). The Devil ingesting his victims first appeared in the Torcello *Last Judgment* and continued for centuries after Giotto. Perhaps the sitting posture of the Devil, the monarch of Leo's cesspool and filth, led to the defecation of sinners, a subject initiated sometime near the end of the twelfth century and which was to appeal strongly to

Bosch. Giotto's devils are furry, bearded old men with talons and tails, possibly derived from costumes for mystery plays, and they are busy tormenting the naked damned. Disembowelled men hang from a tree; a woman is suspended by her hair; a man by his penis.

Behind the tortures of Hell – from the Winchester Psalter to Giotto – is not just theology or perverse imaginings, but the instruments of judicial torture as *actually* designed and used. The bone-vice in the Psalter is an accurate depiction of a real bone-vice (illus. 52). The hand chopped off that lies on the ground is another detail of an actual practice. Giotto shows both the water ordeal and the spine-roller (illus. 56, 57). The grapnel that devils consistently use throughout the centuries is the same instrument used in torture, and flogging criminals naked through the streets was an event artists would have seen or heard about. This curious combination of the real and the unreal, of actual methods of torture in an imaginary scene is a defining element in many depictions of Hell. Few people realize that the tortures in Hell are mostly accurate representations of contemporary practice. This explains why the punishments and suffering seem real even if the devils do not.

Giotto's *Last Judgment* (1304–13) in the Arena Chapel was different, and influential primarily because it simplified. Reducing a scene to monumental essentials is a characteristic of Giotto's greatness; his reduction is normally an enrichment, though not, perhaps, in his *Last Judgment*, a theme hardly calculated to engage his strengths. The main structural change is Giotto's softening of hierarchies to simplify the relation of man to the Divine. The iconography is traditional; its tone is new. The hard mandorla is now a soft, rounded inner-tube, while the Christ within is not the decisive judge but a serious, kindly, patient man. Fully robed, solidly and comfortably seated, Christ's open palms show his stigmata but threaten no-one. No Weighing of Souls, no conflicts. Since Mary is accepting Scrovegni's gifts she cannot, at the same time, be an intercessor (and besides, with the Christ Giotto has painted, her appeals would not seem needed). On either side of Jesus are his Apostles; below, on his right, are the Saints, and below them the elect (each level in descending size, that old symbolism Giotto discarded in those other paintings that embody his real powers).

The resurrected dead crawl out of cracks in the earth: they just manage to be squeezed into the fresco, as if Giotto would have liked to have left out this fixture but felt obliged to put it in. There is no separation of the blessed and damned. The damned do not move toward Hell: they are in it. The blessed do not move either, because the critical act of separation is not shown. Discarding non-essentials,

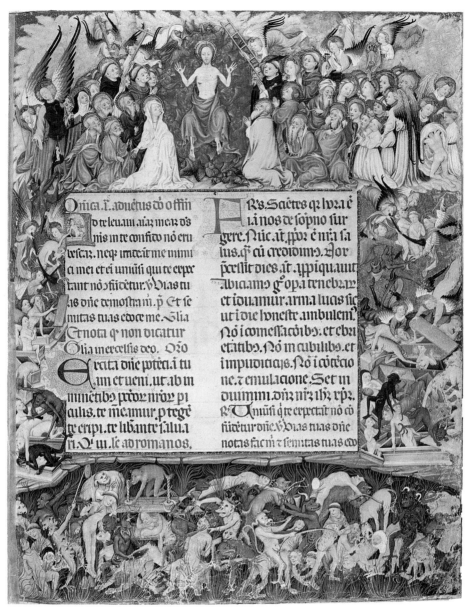

58 Rafael Destorrents, 'The Last Judgment', from the *Missal of S. Eulalia*, 1403. Cathedral Archive (MS S.XV fol. 9*r*), Barcelona.

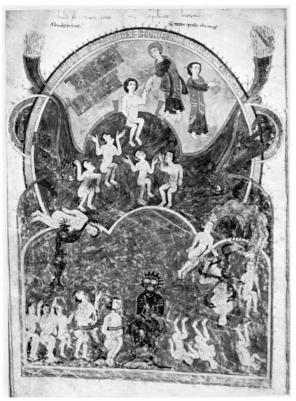

59 Emerterius and Ende, detail from the 'Descent into Hell', *Gerona Beatus*, 975, Gerona Cathedral (MS 7, fol. 16v), Catalunya.

60 Giotto, *Judas Receiving Payment for the Betrayal of Christ*, 1304–13, fresco on the east wall of the Arena Chapel, Padua.

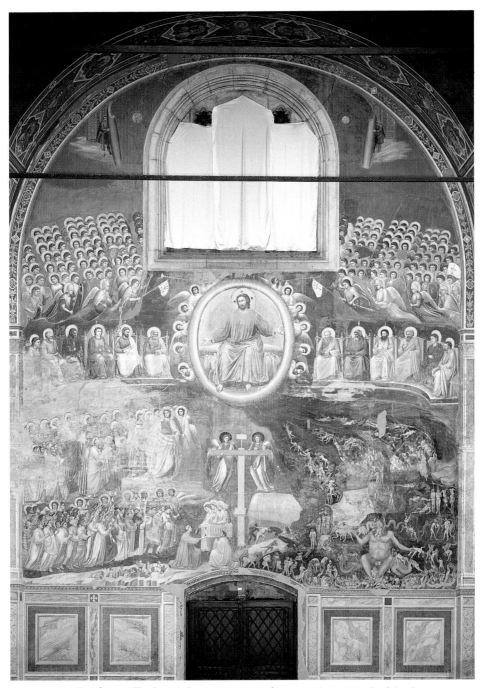

61 Giotto, *The Last Judgment*, 1304–13, fresco on the west wall of the Arena Chapel, Padua.

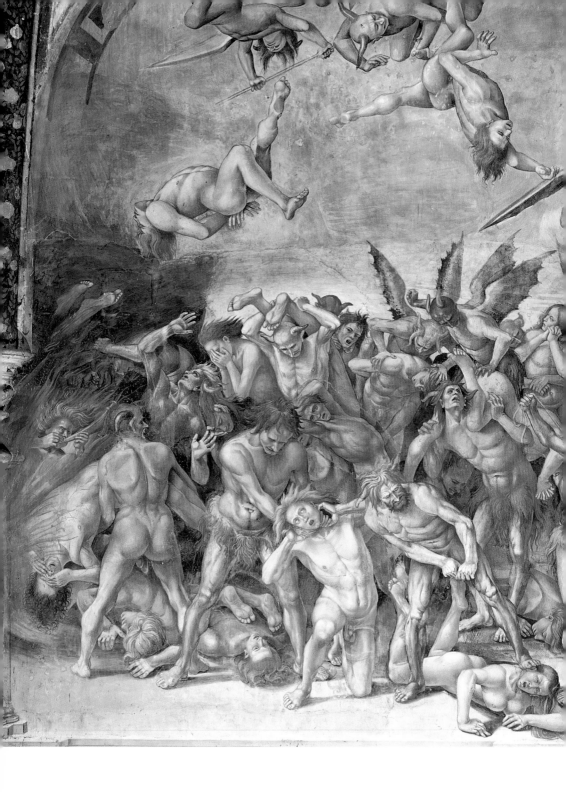

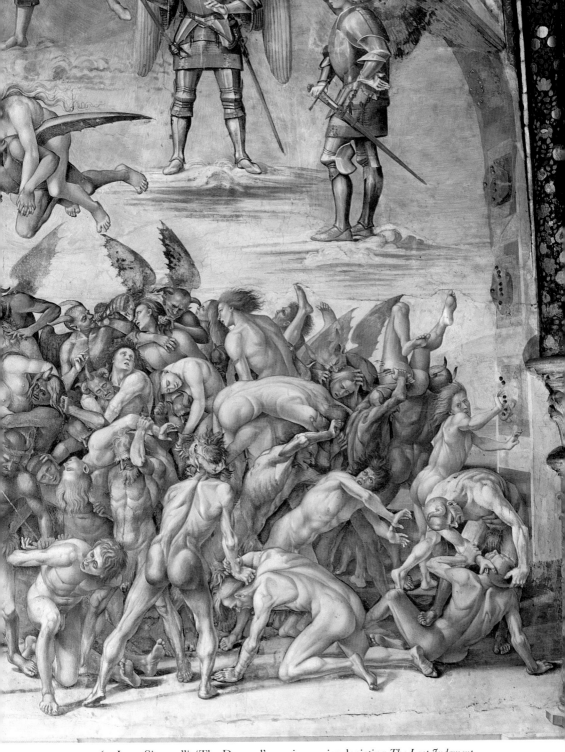

62 Luca Signorelli, 'The Damned', one in a series depicting *The Last Judgment*, *c.* 1503, fresco. Cappella della Madonna di S. Brizio, Orvieto Cathedral.

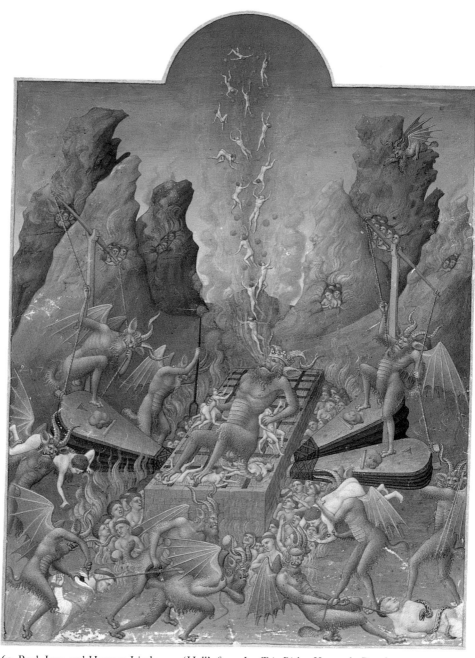

63 Paul, Jean and Herman Limbourg, 'Hell', from *Les Très Riches Heures du Duc de Berri*, 1415. Musée Condé (MS 65/1284, fol. 108*r*), Chantilly.

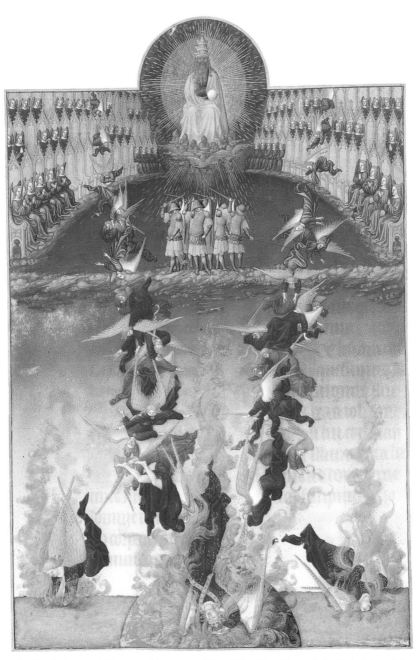

64 Paul, Jean and Herman Limbourg, 'The Fall of Lucifer and the Rebel Angels', with what may be the first beautiful Lucifer, from *Les Très Riches Heures du Duc de Berri*, 1415. Musée Condé (MS 65/1284, fol. 64v), Chantilly.

65 Lorenzo Lotto,
Michael and Lucifer,
1550, oil on canvas.
Museum of the Palazzo
Apostolico, S. Casa,
Loreto.

66 Hans Baldung, *Two
Witches*, 1523, oil on
wood. Städelsches
Kunstinstitut,
Frankfurt.

depicting relations between people rather than between levels, and eliminating movement *between* levels by eliminating the action of separation, were the innovations of Giotto that influenced the two major Last Judgments before Michelangelo's, that of Fra Angelico and, more especially, the one attributed to Hubert van Eyck in the Metropolitan Museum of Art, both painted *c.* 1430. 'Studying nature and not copying other painters, this is what makes a true painter. Giotto not only surpasses all the painters of his time but also all those of centuries past.' This is the judgement of an artist not much given to praising others: Leonardo da Vinci.

Giotto created space through and for the solid volumes of his figures. Their drapery reflects the movement of their limbs in a real world that requires *no* translation (as much Romanesque art, and some Gothic art, does). That is why, as a Giotto specialist, C. Gnudi, has rightly noted, the extra-terrestrial had no special interest for Giotto, because what seemed unreal (as devils did), he sensed as untrue.[158] Giotto's illusion of naturalism – depth and space depicted by means of optical principles – is closer to Pompeian painting than to earlier medieval art. These reasons make Giotto's treatment of the Devil of exceptional interest precisely because his treatment of the Devil was *unexceptional.*

Judas's Betrayal is a scene in the Life of Christ cycle in the same Arena Chapel as the *Last Judgment*, but unlike that large work, this Judas fresco was executed by Giotto alone. Judas holds the bag of silver he has just received; behind him, with a claw-like hand on Judas's right shoulder, is the Devil. Look at the fresco (illus. 60), but forget about iconography, dispense with theology, and ignore the story. The most striking difference is one of technique. All four men, including Judas, are painted in Giotto's characteristic naturalistic style: their robes, their space-filling bodies, their gestures, their faces, their psychological and physical interaction. The Devil, however, could have been painted by a Byzantine artist: he is two-dimensional pictorially and psychologically. He has no real existence. He is *in* the picture but not *of* it. Were the Devil removed from the painting, not only would there be no loss, the painting would be improved, and for two reasons. First, this flat, optically unreal Devil occupies a different level of illusionary reality, a decidedly lower level that harms the panel's spatial unity. Second, the expressive corollary of Giotto's technique is that the deceit, the hesitancy, the evil of Judas are fully expressed in this psychological portrait. The Devil is as redundant as would be a caption on the lines of 'Judas was instigated by the Devil and now belongs to

him'. This venerable Byzantine fiend, an old, black, hairy man, is the best Giotto could do, and it is not much.

If Giotto could not paint the Devil, who could? Giotto could not paint the Devil because evil was viscerally real to him, physically, psychologically, and spiritually; but the Devil was not. The angels who rejected the light, explains Augustine in *The City Of God* (xi, 9), became impure and unclean spirits. 'Evil has no positive nature; what we call evil is merely the lack of something that is good.' This standard theological idea that evil is only the *absence* of something is an insoluble problem for artists, and especially for Giotto, whose solid figures occupied real space. If evil and the Devil are merely the absence of something, how could such a *lack* be painted?

The only major Renaissance painter of the Devil was Giotto; and the only major Renaissance sculptor of the Devil was Donatello. Among Donatello's last works are the bronze reliefs he made for the double pulpit (a Gospel and an Epistle pulpit) for S. Lorenzo in Florence. Compared to the Gospel pulpit, the Epistle pulpit, finished in 1465, is exceptionally original in its composition and spatial freedom. Space is created *in front* of the pulpit, so that its scenes seem to extend beyond it, and one scene is the hoary Descent into Limbo. You have to look hard to find the Devil, an insignificant, tiny figure with small bat-wings, harpy feet, and with a snake wrapped around his legs, who has no function at all. Donatello's Devil is no more needed than the Devil in the Giotto fresco; he was put there reflexively because of traditional iconography. Apparently, the Renaissance sculptor with the most exceptional range and intensity found the Devil of no interest.

'Never trust the artist. Trust the tale', urged Lawrence. Giotto could locate evil in a human actor but not outside one. In his paintings, it is a human shape who embodies evil, and this perception is not limited to Giotto. It is the underlying reason why, before the nineteenth century, there are so few images of the Devil by artists in the West that remain in one's memory. 'Studying nature and not copying other painters, this is what makes a true painter', opined Leonardo. But you cannot paint the Devil by studying nature.

The empty highway

Untouched by Giotto's spirit and form is a *Last Judgment* by the Barcelona divine Rafael Destorrents in the Missal of St Eulalia of 1403 (illus. 58). Crowded, but admirably organized, this *Last Judgment* brings back Michael and his scales (forced into the unusual position on Christ's right because of the text), the Deësis, a very active resurrection

with angels rescuing the blessed from devils and the tortures of the damned. Some devils have talons, bat-wings and horns, but many are grotesque lizards, fantastically beaked birds, demons of a type also found in the Van Eyck and which receive their most powerful expression in the personal visions of Bosch. Where did Destorrents's animal-headed and bird-beaked demons come from? It is hard to say. Some conventions and motifs go back centuries: the folds of Christ's dress on his left knee, for example. Those folds follow the old damp-fold convention of abstract drapery patterns that have no relation to the shape or movement of the limbs covered.

The standing devil in left profile in the lower centre of Destorrents's *Last Judgment* is worth examining. Every time I did I sensed something familiar, as if I had once seen that face somewhere else. Over a year passed before I finally remembered: it is the face of the 'divine bailiff' on a libation beaker from Lagash (a major city in Sumer), made before 2000 BC. That figure stands facing a large snake. The face is in left profile and has the same physiognomy, and, what is particularly startling, it wears the same expression as Destorrents's devil. The resemblance is far too close to be a coincidence, but the transmission is perplexing. It is true that an ivory and ebony inlaid box with relics brought back to Sicily from the Crusades contained an Akkadian cylinder seal dated to before 2000 BC, though whether this was utterly exceptional is hard to say. But if a crusader could bring back to Palermo a second-millennium seal, it at least suggests transmission is a possibility, and our own eyes confirm the fact. Even if we could confirm transmission, the more critical problems are access to and acceptance of such models.

Destorrents most probably knew the famous *Ascension* in the Rabbula Gospels of 585 (Biblioteca Laurentiana, Florence, MS Plut. 1, 56, fol. 13b), which was still being copied in the thirteenth century in Florence. This New Testament codex was written by the monk Rabbula in the monastery of St John of Zagba in Mesopotamia. Christ is in a mandorla supported by angels, a pattern from Hellenized Jewish interpretations of the pagan Victory motif. Directly under him is a tetramorph with winged forms that were typical of seraphim and cherubim and similar to winged sun discs in Assyrian seals of the second millennium BC. Most Romanesque seraphim derive from that same Assyrian form and its later variants, such as winged genii. The painter of the Rabbula *Ascension* did not flip through some illustrated history of art in search of a shape to copy; *how* those genii were transmitted might not be known, but like that figure from Lagash, they were. Even the fish-men in Bosch are found in Assyrian seals, bells and

plaques: they were connected with exorcising disease-causing demons.

Zoomorphs (and sun discs) of Assyria were known and available through the massive Achaemenid palace reliefs and tiles at Susa and Persepolis (particularly the *lamassu*, winged bulls with human heads; figures from Persepolis are found in the Torcello *Last Judgment*). The main source of Persian art forms so common in the Romanesque period were the Sassanians, who inherited Mesopotamian traditions going back to Babylonia. Sassanian silks in particular were found all over Europe, making Persian monster and zoomorphic motifs available for pictorial treatment. Some motifs in Sassanian silks (illus. 49) that are found in French cathedrals from the eighth century go back to Sumerian motifs of the third millennium. Egyptian deities were also familiar: Isis, for example, had been a popular Roman cult. The four zoomorphs of the Evangelists probably derive – at least partially – from Egypt. Horus became John's eagle; Sekhmet became Mark's lion; Ka (soul) became Matthew's angel or man; and Louis Réau, a specialist in Christian iconography, has suggested that Anubis became Luke's bull (though how a jackal becomes a bull is not clear). Persian zoomorphs were also an influence.

If an artist gives Horus with his falcon head a sinister appearance, he creates a beaked devil. In fact, there is a host of Egyptian gods with animal heads, particularly Thoth, normally with an Ibis head, who, as a moon god, sometimes had a dog's head or was a dog-faced ape. Anubis with his jackal head was associated with Hermes as a conductor of the dead to the other world, and sometimes he had a black skin; a few modifications turn him into a devil with a snout. Kom el Shukafa in Alexandria has an Anubis from the early second century AD whose lower body is that of a snake. Another suggestive source is Hellenized Jewish amulets of Yahweh snake forms (including figures with a cock head and two snakes for legs), which are behind the snake-body representations of Anubis. Set, the evil brother that Osiris defeated, has a stiff, forked tail and a curved snout. (If he was transformed into a devil it would be a nice irony, for originally he was not the brother of Osiris at all but was cast out as the Evil One – as Lucifer was – after the Osirian myths were codified and became official dogma.)

In Nubia by the sixth century AD, the level of temple courtyards was raised higher than the surrounding ground by the enormous amount of rubble from the statues of Nubian gods that the Christians had smashed. Temples were changed into churches. Not just in Nubia, but throughout the Empire, Egyptian Christians destroyed centres of Osirian worship, hunting down owners of papyrus scrolls that contained drawings of Osirian gods because those gods were 'devils'.

Christians familiar with Egyptian gods were not students of comparative religion. Tertullian knew more about pagan gods than most Christians, yet he wrote that Anubis had the head of a dog or lion, probably because that is how he perceived Anubis or because he confused Anubis with another deity. So whether the artists knew these gods directly or indirectly, from Egypt or from Rome, hardly matters because, like the classical gods, these gods were demons. 'Many and monstrous', wrote Augustine, 'was the wickedness [of these Egyptian gods]', and behind them are evil demons. Egyptian animal-headed gods, and some Mesopotamian demons, remain the most likely sources of beaked and snouted devils. Nevertheless, to show a similarity (a snouted Set and snouted devils) is no proof that, for example, the beaked devils in the Eulalia Missal derive from some pictorial tradition available in Alexandria. However, it is a fact that the artist of the Soriguerola altarpiece painted the Devil wearing the Egyptian *shenti* (illus. 34). The only reason he did this was because he had in front of him an Egyptian scroll (or copy), which must mean that access to pictures of Egyptian deities continued into the thirteenth century.

Renaissance artists gradually lost interest in the Last Judgment. Hubert van Eyck's and Fra Angelico's works are examples of how the drama has become static. In Van Eyck's *Last Judgment* in the Metropolitan Museum of Art, a beautiful, youthful Michael is the exquisitely armoured, peacock-feathered figure astride Death. Death has an enormous cloak that divides the long narrow panel in half. In the lower half, the damned fall into Hell, where ferocious beasts are splitting lost souls in two, piercing them, biting them, clawing them. But Michael is not fighting Satan, for no Satan is present. Instead of devils are fierce Tyrannosaurus Rex-like monsters. There seems to be neither a psychological nor a pictorial connection between this Hell and the mandorla-less Christ far away and high in the Heavens surrounded by the Saints, the Apostles and the blessed. Van Eyck does connect the two parts of Heaven and Hell through a subtle device. The viewer looks *down into* Hell as if he stood on the same level as Michael (though some distance in front of him) and he looks *up to* Heaven, again from Michael's point of view. Michael's waist, his centre of gravity, is precisely in the middle of the panel. Like Giotto's *Last Judgment*, Hell is completely shut out; there is no movement of separation. Instead of a drama, the Last Judgment has become a static compartmentalization of states. This is also true of perhaps the only Last Judgment that is beautiful: Fra Angelico's two-level altarpiece (illus. 32). There are only two levels (instead of the usual four), but this is a wide, low Last Judgment on a grand scale. In the top curved band is a gentle Christ

surrounded by a mandorla of light and angels; on his right and left are Mary and John with Apostles and Saints. The bottom level is divided into a Garden of Paradise and a variety of devils prodding the damned into the caves of Hell, partitioned for different punishments. At the bottom is the Apocalypse Satan, a Godzilla devouring sinners. The more you regard this big black monster, the closer he seems to a child's stuffed toy. Lawrence's eccentric comment, that 'an artist is usually a damned liar', is perhaps closer to the truth, in this case, than many an interpretation that involves pasting together selections from theological texts to explain what Fra Angelico 'must have meant'.

What has happened to the Resurrection? Dividing the blessed from the damned is a wide highway scattered with rectangular slabs that are the covers for the tombs of the dead. But there is no figure on that empty highway because *the separation has already occurred.* The dead rising from the graves, the struggles between the Devil and the angels simply have no appeal for Giotto, Van Eyck or Fra Angelico. Christ observes. He does not act; he does not judge. The simple fact is that the subject of the Last Judgment did not appeal to the Renaissance any more than did the medieval convention of the mandorla. But before the Last Judgment expired, perhaps the two strangest examples were painted, though strange in quite different ways. Signorelli painted what Vasari called a 'bizarre' Last Judgment, and Christ appears once more as the sun-god in the *Last Judgment* of Michelangelo, which the opportunist Aretino labelled as fit for a brothel.

Sex and the Last Judgment

Luca Signorelli completed one of the few major Last Judgments of the sixteenth century. Although his thinking did not influence Michelangelo, his treatment did. The sexual component and sexual context of his work are distinctive and revealing.

Whereas literature and fantasies about the Devil's sexual powers are common, graphic and carved representations are rare. Erotic art before the last quarter of the fifteenth century is hard to find (with the exception of gargoyles, fantastic creatures, details on column capitals or in the margins of illustrations). There is no example extant by any major artist before the Renaissance, although Edward Lucie-Smith considers the naked sinners suspended by their sexual organs in Giotto's *Last Judgment* to be 'erotic representations'.[159] I suppose it depends on what one means by erotic. Unless there is some *attraction* and sexual awareness present, I would hardly apply the term 'erotic' to a person just because he or she is without clothing. And it is not clear

that the man hanging upside down by his penis is having much fun. Nor is there any subject in Giotto's *oeuvre* that suggests a consciousness of sexual attraction. Georges Bataille seems to have assumed that there were many erotic medieval paintings:

The Middle Ages assigned a place to eroticism in painting: it relegated it to hell! The painters of this time worked for the Church. And for the Church, eroticism was sin. The only way it could figure in painting was as something condemned. Only representations of hell – only repulsive images of sin – could furnish it a Place.[160]

Bataille himself shows up the weakness of his judgement by the three paintings he cites: two from the late fifteenth century, and the third by the sixteenth-century Flemish Mannerist Bartholomeus Spranger, who painted enough erotic works to satiate a satyr. From the early Middle Ages, naked men and women in Hell were sexually uninteresting partly because the early medieval techniques could not evoke (nor were they intended to) a solid, fleshy human body. From the thirteenth century, a few Old Testament subjects were treated with sexual awareness, particularly the voyeuristic David watching Bathsheba bathing.[161] Paintings and tympana up to the end of the fourteenth century were more naturalistic, but the religious context still controlled the scene, and in that scene sexuality usually had no place. In the fifteenth century, a few paintings suggest erotic feeling, such as Fouquet's astonishing *Virgin* (probably a portrait of the royal mistress Agnès Sorel), the Antwerp panel of his dismembered *Melun* diptych. Details of Bosch's *Garden of Delights* (*c.* 1510) are tricky to analyze: though some of the naked figures are attractive, they are within the frame of a category – medieval lust – with the difference that the lust does not fit that abstract category but seems within a private, idiosyncratic world.

 Paintings that are more sexually arousing than those produced for one thousand years suddenly appeared between 1490 and 1530. Classical figures and situations were the ostensible subjects for both painters and engravers. During those decades, Marcantonio Raimondi, Mabuse, Sebald Beham, Hans Baldung and Correggio created erotic art. After a classical statue of Lucretia was found in Rome in the early sixteenth century, the subject of Tarquin ravishing innocent Lucretia and her solitary suicide became the rage.[162] Augustine had resolutely condemned Lucretia and implied that 'she was lured by her own lust'.[163] If Lucas Cranach the Elder knew his Augustine, he probably would have welcomed the suggestion, since he and his workshop did over thirty nude, gently masochistic Lucretias stabbing

themselves. Marcantonio Raimondi, who had worked under Raphael, was imprisoned in 1526 for engravings (after designs by Giulio Romano) that had inspired Aretino to write his famous lewd sonnets. (It was a Marcantonio engraving that Manet borrowed from for his revolutionary *Le Déjeuner sur l'herbe*.) Probably the reason Marcantonio was jailed instead of Giulio was that engravings, like woodcuts, could be printed for mass consumption. Many Renaissance paintings today are known only through Marcantonio's engravings.

Spranger worked in Paris, Vienna and Prague. His *Hercules and Omphale*, *c.* 1575 (Kunsthistorisches Museum, Vienna), seems influenced by Ovid's description of the couple exchanging clothes in a secluded grotto (*Fasti*, II, 305), with crossdressing for its theme – the power of women. What the painting shows, however, is Omphale wearing Hercules's lion-skin and coyly holding his club as she twists her body to display sensuous buttocks to the viewer, suggesting ero-sadistic playfulness. A smirking putto (almost a Spranger trademark) raises a curtain to reveal the scene. *Hercules and Deianira*, a painting of 1517 by Mabuse (Barber Institute of Fine Arts, Birmingham), shows the couple seated with intertwined legs in a classical rotunda, Hercules with a powerful, spiked, phallic club, making the few leaves covering his genitals almost comical. Provocative sexuality is not inherent in Mannerist art, but in practice the first erotic paintings in the Renaissance achieved their effects through virtuoso interminglings of bodies and twisted torsos. Before the end of the fifteenth century it was becoming impossible to decide whether certain nude statues were Eves or Venuses.[164]

In his study of attitudes toward death, Philippe Ariès cites a nineteenth-century novel on the tortures depicted in Baroque art:

As a young girl, Paulina loved above all else, in the churches, the martyrdoms of the saints. She went to church to watch them suffer. . . . [She especially adored a picture of St Catherine of Siena] kneeling and about to swoon. Her hand has been wounded by the stigmata; it lies chastely in the hollow between her thighs. How female she is, the pure image of a woman, this nun, with those wide hips, that soft bosom beneath the veil, those shoulders. . . . The hollow between her thighs signifies love. . . . It is an idea of the devil.[165]

Skeleton Death and a lovely girl, the bony hand on the soft shoulder, occurs again and again. This macabre eroticism is unknown in ancient Mesopotamia, unknown in classical civilizations and – as a leading subject – seems singularly Christian. One arguable exception is a Japanese genre of the late twelfth century that, under the umbrella of a Chinese poetry genre, showed in graphic detail the decomposition, in nine stages, of a beautiful woman. The outstanding example is the

kusōshi scroll (National Museum, Tokyo): in the sixth stage, a black raven tugs at flesh from the dead woman's cheeks; a black dog pulls out her entrails from between her spread legs. The artist seems to have been fascinated by the contrast of erotic beauty and decay.

One artist who often discarded classical cover for his erotic work was Hans Baldung. He studied under Dürer, was rightly famous for some beautiful and moving Virgin Marys, supported Luther, and made woodcuts revealing mystical and erotic interests. An old man, or Death, fondling a young woman was a theme he returned to compulsively. Not only Baldung, but other German Protestant artist-printmakers, including Dürer, Altdorfer and Cranach the Elder, depicted witch and Sabbat scenes. No one can explain these works or why they were done. The Swiss art historian Heinrich Wölfflin concluded that the basic purpose of Dürer's *Four Witches* (1497) was to show beautiful nude women.[166] Even Erwin Panofsky, the erudite author of definitive works on Dürer, could only suggest that 'this prodigious display of female nudity . . . was turned into a warning against sin', admitting that the 'exact nature of the action remains obscure'.[167] This is equally true for Baldung, who did more witch-scenes than the others. In his case, there was some connection with a popular work on demonology.[168]

The most consulted reference work in the fifteenth century for the subject of devils and witches was the *Malleus maleficarum*, written in 1486 by Heinrich Kramer, Dean of Cologne University, and Jakob Spregner, the Dominican Inquisitor-General for Germany. Witches cook children, and collect as many as twenty or thirty penises and place them in a bird's nest; the Devil, however, can restore these members to their owners. If a woman is suspected of being a witch and refuses to confess, she should be tortured until she admits her crimes. In our own time, in 1941, Charles Williams considered this sinister book to be 'an intellectual achievement of the first order', a singular appraisal.[169] Protestants naturally enough opposed the Inquisition since they were often its victims; but, distressingly, they too accepted this irrational treatise. Johann Geiler von Kaisersberg, the cathedral preacher in Baldung's Strasburg, popularized *Malleus*-type demonology and stressed that whatever the Devil did, he did with God's permission. Why, Geiler asked his congregation, do the Devil and witches have power over man? Explanations are many but the real reason is hidden. Geiler's sermons and intense public interest would have affected the awareness of artists who might have been responding to public demand. The relevant fact is that when Geiler's sermons were published in 1516, they included a copy of a witch engraving by Baldung (*Preparations for the Sabbat*). What Baldung's beliefs about

witches were is hard to say. Possibly the reason for his many witch works was that the material provided a non-Christian frame for unleashing the artist's deeper impulses, just as the Sabbat and witches were to do for Goya.

The youth and beauty of his witches are distinctive Baldung characteristics. 'Evil can be seductive' would seem an oversimplification for his message, if there is one. The last cut of a series he did in Freiburg, the *Young Witch with Fire-thrusting Dragon* (1515; Staatliche Kunsthalle, Karlsruhe), is outrageously erotic. A voluptuous young witch, standing, holds on to a flamelike rod; her back faces the dragon from whose horrible mouth a stiff, long tongue-ray slides between her buttocks; two *putti* voyeurs watch. A beautiful nude witch turns her head to watch the viewer in Baldung's *Two Witches* (illus. 66). The second witch sits on a goat; a background of unreal clouds moves as if in response to a spell evoked by the witches. Is there any work that this painting resembles? Is there any literary or pictorial source known? More singular than Bosch, Baldung secularizes some religious motifs and generates mysteries in familiar settings through his own deep feelings for unseen forces, so that some of his canvases are like the gripping irrational dreams Goya was to paint.

Although he was the one artist of his time who could have done justice to the theme, Baldung, unfortunately, never painted the Devil.[170] Or perhaps he did: Adam, in the Madrid *Adam and Eve* (illus. 67). An earlier woodcut (of 1519) on the same theme shows Adam close to Eve, who reacts to him with utter revulsion. In a work of 1525 Eve's response has changed: she smiles while she covers her genitals with the apple as Adam faces down the serpent. The Madrid painting, Baldung's final treatment, is different again. Not without reason did Georges Bataille (an authority on eroticism, according to his admirers) include that painting in his last book, *Les Larmes d'Eros* (1961). Eve holds the apple; Adam cups her breast with one hand and strokes her thigh with the other. In a startling reversal, Baldung makes Adam, not Eve, the seducer. Adam's tousled hair suggests the Devil's horns. (The small serpent in the upper-left corner is barely noticeable.) A sense of sin, shame and guilt are three emotions that have no place in this painting of two people confidently, knowledgeably tied together in their joy of sexual love. In so far as Baldung's Adam is the Devil, this original work suggests Blake's Devil, embodying sexual delight.

Luca Signorelli approaches Baldung neither in imagination nor in technical mastery. Fascinated by buttocks and melodrama, Signorelli was more interested in the theatrical than the theological; his sensibility generated images of sexual sado-masochism and bondage. He was

67 Hans Baldung, *Adam and Eve*, 1531, oil on panel. Fundación Collección Thyssen-Bornemisza, Madrid.

among the first to paint nude scourgers in the Flagellation of Christ, and he adopted one of the scourgers from his predella panel of 1502 in Cortona for his nude *Judith*, painted a year later in Orvieto. The heroine grasps her sword and holds the head of Holofernes. Signorelli takes this archetypal image of castration and – without any known textual basis – makes his the first nude Judith in the history of art.[171] The transformation of a nearly naked scourger into a sword-wielding female nude suggests the directions of Signorelli's imagination.

Signorelli used an amalgam of styles that, in turn, became an identifying feature of his painting. Vasari stressed his 'bizarre inventiveness', but if Signorelli's concepts were occasionally original and often odd, the execution was hardly equal to his ideas. Specifically, his

Last Judgment paintings at Orvieto are a dense mass of crowded, over-developed naked bodies (see illus. 62). Individual figures and groups within the paintings do have force, unconventional iconography and satisfying ironic twists (such as a nude talking with a skeleton). During his training under Piero della Francesca, Signorelli imitated his master's style so well that sometimes the master's work could not be distinguished from that of his pupil. In 1481 Signorelli helped decorate the south wall of the Sistine Chapel, finishing the *Testament of Moses* begun by Perugino. He also frescoed the *Conflict over the Body of Moses* for the Chapel's walls, which was intended to show the Devil and angels fighting over the dead Moses for his soul; unhappily, on Christmas Eve 1522, the supportive moulding over the door collapsed and destroyed the fresco, with the result that we have no idea of what the *Conflict* looked like.

Signorelli then went to Florence where, for Lorenzo the Magnificent, he produced *The Education of Pan* (Berenson thought this work anticipated Poussin and Gauguin). It was destroyed in a Berlin museum by bombing in 1945. In the 1490s Signorelli left Florence and travelled to Umbria, Urbino and Siena. He left Florence, perhaps, because when the Medici fell in 1494 he lost patronage and work. After finishing a fresco cycle in 1498, the *Stories from the Life of St Benedict*, which has some exceptional sections, he was hired to decorate the Chapel of the Madonna of S. Brizio at Orvieto Cathedral, possibly because he was cheaper, faster and more efficient than were the other candidates. There are seven large scenes: *Sermon and Deeds of the Antichrist*; *Destruction of the World*; *Resurrection of the Flesh*; *The Damned*; *The Elect*; *Paradise*; and *Hell*.

The man responsible not only for Signorelli's departure from Florence but for a turning-point in Florence's history was Girolamo Savonarola, who preached fiery sermons against political and personal corruption, captivating crowds that grew until thousands regularly assembled in Florence to hear him. Among those who attended, and felt the influence of his prophecies, were Botticelli and Michelangelo. (Michelangelo could still hear the Friar's voice in his mind decades after the event, according to Condivi.) Following the French invasion of Florence in 1494, Savonarola became virtual dictator of the city. Pope Alexander VI summoned Savonarola to appear before him; Savonarola ignored him, and in 1497 the Pope excommunicated him. Savonarola then denounced the Pope's election as invalid, a denouncement that, even had it been false, would have irritated any pope, but since it was true it infuriated Alexander. Not only did Alexander become pope through bribery, he set new papal levels for children

fathered, gold amassed and nepotism nurtured. Using Franciscans in Florence as a kind of fifth column, and timing his move to coincide with a decline in Savonarola's popularity (the consequence of the Friar's fierce fanaticism), Alexander had him arrested, tried, condemned for heresy, and then executed and burned. This is the historical background that pictorially pervades Signorelli's *Sermon and Deeds of the Antichrist*. Unlike some of his fellow artists, Signorelli had no sympathy with the uncompromising Dominican. Most probably the Christ-like figure (centre foreground) manipulated by a sinister devil and preaching false prophecies represents Savonarola.

What immediately strikes viewers of *The Damned* (illus. 62) is not the iconography, but the panorama of violence. That violence hardly comes from Revelation and *The Golden Legend*, but rather from the riots and lawlessness rampant in Italian cities at the turn of the century. In this fresco Signorelli not only depicted himself but, according to Vasari, several friends, including Paolo and Vitellozzo Vitelli and Gian Paolo Baglioni – all of whom met a violent death. The year Signorelli began work, Paolo, a *condottiere*, was executed for treason; before he had finished, Vitellozzo, also a *condottiere*, was murdered by Cesare Borgia at Senigallia. Baglioni, Lord of Perugia, though still alive when Signorelli painted him, was later executed by Pope Leo X. Even so, personal grief cannot be the only explanation for the endless examples of intense physical cruelty and torture inflicted by devils on their captives. Though most of the devils have horns and a few are winged, all are human, and are either naked or wear the cave-man type of shorts. Cruelty and pain are not exceptional in Last Judgments, but Signorelli seems to have been the first to use the tortures as a frame for sexual and sadistic devil-rape fantasies. The torturing devils are strong and powerful, and their average age looks to be about forty years; their victims, though, are in the prime of life: the men are well-built and handsome; the women are beautiful and sexually attractive, without the nuances of sin that film voluptuous women in analogous medieval settings.

While earlier paintings of lascivious naked women in Hell might have held latent erotic appeal, the poses of Signorelli's women would be suitable for today's market for illustrations of sado-masochistic fetishes. Only ostensibly devils, his wiry, vigorous middle-aged men inflict pain on bound and helpless beauties, most of them passive and accessible (a few are anxious, while only one expresses pain); the young, athletic men seem considerably more frightened. Anatomical exhibitionism infused with homo-eroticism and sexual sadism could be a concise description of this work.[172] Right in the centre is the one devil

that has only one horn (often identified as Signorelli himself). He locks his arms tightly around the waist of an amorous blonde to lift her off her feet as she tries to free herself, her long hair curling over her shoulders and between her breasts. The expression on her face suggests ecstatic pain and masochistic excitement. A companion to this image, made three hundred years later, is the stabbing of the voluptuous slave in the foreground of Delacroix's *The Death of Sardanapalus* (1828) in the Louvre, a memorable canvas with sadistic details. And the closest figure to Delacroix's Satan, which opens the French artist's innovative lithographs to Goethe's *Faust*, is the rather satisfied devil (holding an anxiety-filled blonde nude on his back) flying just above the struggling nude the horned Signorelli is squeezing. The most arresting figures in *The Damned* are not the sweet boy-scout angels watching from above, but the devils and damned souls at the very bottom, breaking out of the panel's frame. One naked devil, standing above a naked man thrown to the ground, grabs the man's hair; to his right, another naked devil is similarly engaged; behind him, a colleague inflicts a tremendous beating. Here, no devil is really a caricature, a sub-human, a creature from another world, a half-animal half-man: the scene is really that of one group of men fiercely and cruelly hurting others. The conditioning and distancing of a theological frame and tone are missing, and the insipid figures in *The Elect* confirm our feelings about which psychic wheels engaged this particular artist's imagination.

Signorelli's work anticipates another fork of Devil themes: a frame for expressing sexual fantasies and sadistic impulses, which are common in modern writings and illustrations of satanism. The viewer is not horrified: he is fascinated. In the late nineteenth century, three artists used the sexual and sadistic sides of the Devil and Hell in their works: in England, Aubrey Beardsley with playful perversity; in Japan, Kawanabe Gyosai with scathing social criticism; and, in Belgium, Félicien Rops with sardonic, blasphemic satanism.

The last Last Judgment

Pope Paul IV was enthusiastic about the Inquisition, imagined that the Jews were behind Protestantism (and therefore he pushed them into ghettos), and decided to destroy Michelangelo's *Last Judgment*, which he saw as a mass of nudes. If the fame of Michelangelo and the influence of his friends had been a bit less, that work would not exist today. But who was painting Last Judgments after 1500? Almost no-one. Why, then, was this theme selected for the Sistine Chapel? Probably the answer is activity in reaction to the Lutheran Refor-

mation, a new, threatening external heresy. With great difficulty on the political and theological levels, with fears of another schism, with the confusing pressures of Charles V, and with the absolute necessity of making some reaction to the Protestant Reformation, Paul III had finally managed to organize the start of the nineteenth Ecumenical Council (the Council of Trent) in 1545, and during its years of preparation this *Last Judgment* was painted. De Campos, a former director of the Vatican Museums, has argued that Michelangelo's *Last Judgment* was a visual manifesto for that Council: the pre-eminence of the Pope, the use of the rosary, the efficacy of good works, and the cult of the Saints are a few specifics.[173] To imagine, though, that a counter-attack against Luther was in Michelangelo's mind would simply be foolish.[174] The serious problems that forced calling the Council of Trent were, however, like meteorological fronts that determined the choice of this theme, a climate that drew Michelangelo's response on many levels. (On the opposite side, Dürer, the committed Lutheran, 'downgraded' Peter in his overwhelming *Four Apostles*, now in the Alte Pinakothek, Munich, a dozen years before Michelangelo gave Peter a more prominent position than in any other Last Judgment.) Exactly when the idea of a Last Judgment began to form in Michelangelo's mind we do not know, because in late 1533, when Clement VII had requested it, Michelangelo was not receptive, and when Clement expired a year later Michelangelo probably assumed the project, too, was dead. Paul III still wanted a work by him, however, and after a year of argument about the proper fresco technique, the wall was prepared, work began (in the summer of 1536), and the *Last Judgment* was revealed on All Saints' Day eve, 1541 (illus. 68).[175]

Michelangelo's friend Vasari went into raptures, claiming that this work was 'directly inspired by God'. Other artists would be 'thrown into confusion by the mere thought of what manner of things all other pictures, past or future, would look like if placed side by side with this masterpiece'. What is directly inspired by God requires special knowledge; and confusion is not surprising. Not God but Michelangelo eliminated the Weighing of Souls by following Dante's use of Minos (borrowed by Dante from the Roman poet Vergil) as the judge to examine the damned and assign them their place in Hell. And it is from Dante (again, from Vergil) that Michelangelo took his idea of Charon, who ferries the damned across the River Styx. Though some figures, like Charon, can easily be identified in Michelangelo's fresco, who most of them are remains speculative. Who, for example, is the giant figure on Christ's right? Vasari said it is Adam. Since when did Adam have a girdle of skin instead of leaves? Condivi, Michelangelo's

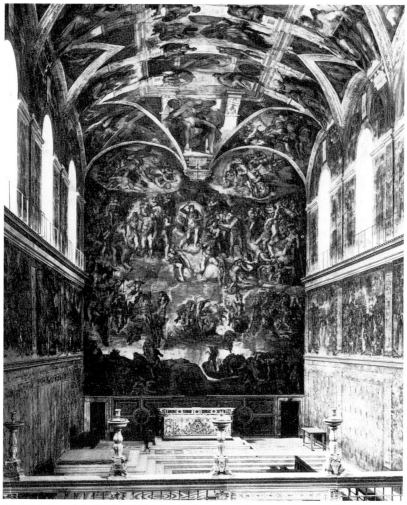

68 Michelangelo's fresco of *The Last Judgment*, 1536–41, on the far wall of the Sistine Chapel, Rome.

pupil, said it is John the Baptist. Since when did the Baptist look so mighty? If Michelangelo's contemporary artist friends could not decide who was who, how can we today? Identifying Christ and the Virgin Mary is not a problem. But instead of the (expected) bearded Christ, Michelangelo painted a Hellenic Christ, an unexpected reversion to the Christ underneath St Peter's basilica who drives Apollo's chariot. (I do not mean that Michelangelo knew Christ as Helios; he did not. From *our* perspective today, though, the similarity between Michelangelo's concept and the early fourth-century mosaic shown in illus. 35 is amazing.)

The rigid bands of Last Judgment iconography and the static compartmentalization are gone. The entire fresco is in motion; as in Gislebertus's work, all action initiates from the unrelenting judge. Jesus's hands keep hundreds of figures circling continuously counterclockwise, the blessed ascending, the damned falling, and horizontally around Jesus is a moving inner band of Saints and Apostles. All the angels are wingless, the demons dark and muscular. But there is no Satan. The demons have neither hoofs nor tails nor pitchforks; there are no tortures of the damned; but the meaning of Hell is clear. Like the unforgettable giant claws around the throat of a lost soul by Gislebertus, three demons trap and determinedly pull down a solitary, cringing lost soul who covers half his face in fear, horror and hopelessness: these horrified souls remain in the mind (illus. 69). What has happened to the separation of the blessed and the damned by the holy angels? Who is blessed? Who is damned? In the Resurrection scene of this *Last Judgment*, no-one knows. And instead of the separation, there are fierce struggles between angels and demons for the new souls. Outcomes are uncertain and seem to depend on the relative force of the contesting angel and demon rather than on the state of the blessed soul. On the left side, the blessed ascend to Heaven by their own efforts or with help (an angel, for example, raises two

69 Michelangelo, a detail from *The Last Judgment*, 1536–41, fresco, in the Sistine Chapel, Rome.

Africans holding onto a rosary). But on the lower-right side are some wild struggles: angels fight to keep demons down; demons drag down the damned. These confusing conflicts derive from Michelangelo's rough ideas for a discarded *Fall of the Rebel Angels*. What is certain is that the separation by the holy angels of the clearly defined blessed and damned is replaced by fierce fights between demons and angels with indeterminate results.

The unexpected iconography of the Sistine Chapel was attacked. Nicolo Sernini, an agent of the Gonzaga of Mantua, contacted Cardinal Ercole Gonzaga about complaints that Christ was shown beardless and looked too young. Charon and Minos were criticized as pagan intrusions. Aretino, the satirical writer called the 'Scourge of Princes', wrote to Michelangelo and raged against the painter's incredible lack of decorum:

I, as one baptized, am ashamed of the license, so harmful to the spirit, which you have adopted. [How could you have shown] impiety of religion in the foremost temple of God? Above the main altar of Jesus? What you have done would be appropriate in a voluptuous whorehouse, not in a supreme choir.[176]

This clever man had seen the light and was fishing for higher honours; these he achieved when Pope Julius III made him a Knight of St Peter. Yet the hypocritical Aretino was far from alone in condemning the work. Ambrogio Polti, a Dominican known as Caterino, made some dangerous implications in his commentary on Paul:

Michelangelo's absolute perfection in the painting of nude bodies with their obscene parts – which even Nature veils in us – is not that of the Apostle, when he denounces and depicts with the living brush of the Spirit the shameful nakedness of heretics.[177]

The nudes, the pudendae, the angels without wings, in fact the entire thrust of this work became too much to bear. In 1566 payments were made to the heirs of Daniele da Volterra, the artist who had been contracted to cover up the genitals, add loincloths and repaint the provocative pose of the nude St Catherine. Even the small serpent biting the penis of Biago de Cessna was obscured.

Michelangelo's contemporary critics do not mention one point of special interest: the Virgin Mary. Mary and John interceding for man, tempering Judgment with pity and mercy, was the important theological, psychological and iconographical complex known as the Deësis. A sketch by Michelangelo of 1534 for his *Last Judgment* shows Christ as if he were about to rise; on his right Mary extends her arms wide open in a direct plea to Christ. Her body, pose and gesture have only one meaning – 'Have mercy!' (illus. 70). But in the finished work Mary

70 Michelangelo, Study for *The Last Judgment*, *c.* 1534, black chalk. Casa Buonarroti, Florence.

faces in the opposite direction to Jesus, while her hands protect only herself; intercession does not come into it. Michelangelo has consciously cast out the Deësis. This is the Last Judgment without pity.

The very three elements that Gislebertus deliberately added in his, the first coherent, powerful Last Judgment – the Weighing of Souls, intercession by Mary, and the separation of the damned and blessed by angels – are the very elements that Michelangelo, four hundred years later, deliberately cast out. And soon after the latter's *Last Judgment* was completed, Lorenzo Lotto finished his interpretation of a theme Michelangelo had dropped: the theme of the rebel angels.

5 The Devil as Rebel Angel

The Rebel Angels

The rebel angels motif derives from the casting out of the dragon and his angels in Revelation. But who, exactly, is cast out? And why? Different people at different times give different answers; sometimes new questions have been asked. In Book One of *Paradise Lost*, Milton's Satan, following the War in Heaven, insists that God does not continue to reign because he is just, but rather because he is

> . . . upheld by old repute,
> Consent or custome, and his Regal State
> Put forth at full, but still his strength conceal'd,
> Which tempted our attempt, and wrought our fall.
> . . . he no less
> At length from us may find, who overcomes
> By force, hath overcome but half his foe.

According to Satan, then, God tempted him by concealing his powers. 'Those who restrain desire', insisted Blake in *The Marriage of Heaven and Hell*, 'do so because theirs is weak enough to be restrained. . . . It indeed appear'd to Reason as if Desire was cast out; but the Devil's account is, that the Messiah fell, & formed a heaven of what he stole from the Abyss'. 'The devil', Freud confidently noted in his essay on 'Character and Anal Erotism' (1908), 'is certainly nothing else than the personification of the repressed unconscious instinctual life'. Worlds apart from medieval perceptions, reinterpretations of Satan stimulated remarkable paintings, powerful literature and unusual ideas. Baudelaire considered that his concept of ideal beauty was exemplified by Milton's Satan.

The first rebel angels are to be found in the oldest Apocalypse extant, the Trier Apocalypse of 800–820 AD (illus. 71). Since the Trier manuscript goes back to a Roman archetype of the sixth century, that would be the first time that the Devil's shape has been painted. On a later folio the dragon we see here becomes Lucifer. Here he is a dragon, but his falling comrades are identical with the holy angels except that they lack haloes. This division points to a near future when

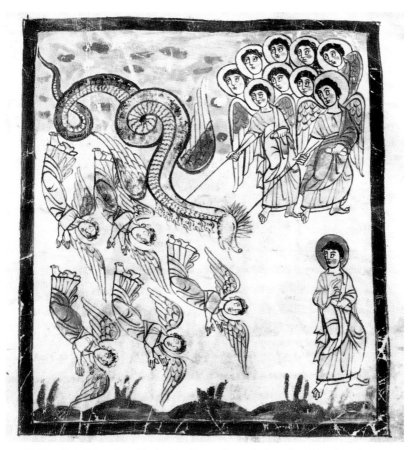

71 'Falling Rebel Angels, with the Devil as a dragon', from the *Trier Apocalypse*, *c.* 800–820. Stadtbibliotek (MS 31 fol. 38*r*), Trier.

the Devil will be symbolized by the seven-headed dragon, and, shaped by Beatus-based designs, becomes Godzilla.

By the late tenth century the rebel angels are polluted spirits thrust out from Heaven (illus. 29). Unlike the Trier treatment, these sad rebel angels are quite different from the holy angels. They are naked, have no sandals, are smaller, and are black with soot. They retain wings and haloes but have the Devil's flaming hair. The middle fallen angel is unusual; unlike his fellows, he looks back with resentment; his is the most individualized face of the six. Perhaps he is Lucifer, though we would then expect him to be larger, or the angel pushing him to be more important. Though technically unimpressive, this is a rare work: the sense of pathos it has makes it the most expressive treatment before the fifteenth century. These polluted spirits are, more accurately, polluting spirits that threaten the social structure. These are the faces

of Marcion and Valentinus, of all Christian leaders that the established Church judged as polluting heretics inspired by the Devil. Of course, these angels are not portraits of specific Arians or Gnostics. However, since heretics were identified with these angels, these angels can be considered 'sociological portraits' of heretics.

In the Greek Menologion of Basil II, dated *c.* 1000, Michael – with large, powerful wings – stands triumphant on a mountain. On each side fall a pair of naked, shrunken bad angels, their wings now vestigial. The angels first to fall are already pitch-black, while their feet have turned to claws. This transformation of an angel to a black, clawed beast is a defining feature of the rebel angels motif. Typically there is no struggle, nothing that implies a threat either before or after. It is not just the technical incompetence but the lack of imaginative exploration that often makes this potential drama a static sign. This mindset for the expulsion scene is the most common until the fifteenth century.

A versatile French Huguenot scholar active in England, François Junius, published in 1655 the first edition of a work now known as the Junius Manuscript (Bodleian Library, Oxford). Originally misattributed to a divinely inspired seventh-century illiterate cowherd called Cædmon, this important manuscript is in fact a tenth-century collection of Anglo-Saxon literature. It includes Exodus, Daniel, Christ and Satan, Genesis A and Genesis B. That last work, a poem, is actually a translation from Old Saxon (Low German), but no-one knows when the original was written. Sometime in the ninth century is the guess of most scholars. Uncertain, too, is why this translation was inserted into the longer main manuscript. Perhaps the compiler appreciated the poem's unusual qualities, or perhaps part of Genesis A was missing and Genesis B filled the gap. Certain it is that Genesis B is the first full literary account of the fall of Lucifer, an account that Milton may have known, since he had met this particular poem's first editor, Junius. If Milton did not know the poem, the resemblances are surprising. Milton's Satan captures the imagination because he is convinced that *he* has been wronged, and his defiance of God is endless. It is precisely this defiance – without which the word *rebel* is weak – that we find in Genesis B.[178]

The closest 'source' of Genesis B is no source at all.[179] It is part of a Latin poetic work by Alcimus Avitus, the sixth-century Bishop of Vienne. Avitus's Satan becomes inflamed with his own evil and, imagining he made himself, he denies his Creator. He is hurled from Heaven, and every terrible act in the world today is the result of the Devil's teaching. When the Devil sees Adam and Eve he is filled with envy and bitterness, and decides to deceive them so they will lose

Paradise. The stereotypal Satan of Avitus belongs to a different world of feeling and thought than the Satan of Genesis B. The Bishop's Satan neither defies God nor believes he is wronged, and his motive for tempting Adam and Eve is jealousy not revenge. Rather than the adversary of God, the Bishop's fiend is the old Satan of the mystery plays, Satan seen through the eyes of the pious. Since no source is known for the original Old Saxon poem it is perhaps more sensible to consider that poem as its own source. Nothing in the corpus of Anglo-Saxon poetry surpasses the imaginative characterizations of Genesis B and its original interpretation of the fall of Satan and Man. Unlike Genesis A, the main work in the Junius manuscript, Genesis B has little moralizing. Instead of instructing, it develops character and purpose, it articulates feelings and thoughts. The fall of Satan is like the attempt by a trusted, capable thane to establish his own independent kingdom and that thane's eventual expulsion by his furious chieftain. It is as if an epic poet had reinterpreted the fall of the rebel angels in his own individual human terms. God ordains ten orders of angels to owe him fealty and work his will. One angel, the highest after God himself, like to the luminous stars, was mighty in mind and muscle. He stirred up strife against the Lord. Thinking he had more might and craft than God, this angel declares 'I need no lord. I can work equal wonders with my own hands, so why must I give homage?' God is enraged and hurls this angel from his throne into Hell, where he turns into the Devil. Assembling the other fallen angels, this Satan insists that God 'has not done right', nor 'can he accuse us of any sin'. And, by making Adam and Eve transgress God's commandment, 'we will revenge and frustrate his will'. God will then, Satan predicts, become furious and cruelly punish them. Satan is defiant, convinced that God has punished him unjustly. He plans vengeance, not repentance. God is easily angered and Satan plans to manipulate that anger to hoist God on His own petard by frustrating His will. Complementing this original concept, the poet has carefully mitigated the disobedience of Adam and Eve. The Devil appeals neither to Eve's pride nor greed but to her obedience to God. The Devil appears as His messenger, and when Eve persuades Adam to eat the apple it is 'out of loyal intent'. Adam and Eve are hardly at fault in Genesis B, and the poet critically comments that 'it is a great wonder God would allow the Devil's ensnaring lies'.

The two other Satans in the same Junius manuscript – a Satan in Genesis A in and the one 'Christ and Satan' – are close relatives of Avitus's Devil. Genesis A is God's version of what happened. The chief angel's perversity came from his pride. Angered, God throws

Satan and his angels down, crushing them. In 'Christ and Satan', Satan admits that because of his pride he can never expect anything better than Hell. His cohorts accuse him of tricking them with lies and call him a criminal. Satan himself confesses: 'I am guilty; my deeds besmirch me'.

None of this in Genesis B. No repentance. There is a sense of loss but no besmirchment. No admission of guilt. No reproaches from the other rebel angels. On the contrary, 'God grew angry with us', explains Satan's chief lieutenant, 'because we refused to bow our heads to him, because we could not accept ministering to him in vassalage'. The Satan in Genesis B insists that God has wronged him. 'He is unjust and I defy him.' This voice, the dramatization of this attitude, is unknown before.

Just as Genesis B has no known source, so, in turn, Genesis B became the source of nothing, unless it was not just the imaginative ancestor of Milton's Satan but – just possibly – a literary stimulus. After Genesis B, Satan speaks countless lines in numerous texts and poems and plays for the next six centuries, but hardly a single line worth reading until Shakespeare's contemporary, Christopher Marlowe, wrote his marvellous tragedy, *Faustus.*

The illustrations undertaken for the Junius manuscript were never completed. The illustrations for Genesis B that do exist are from the early eleventh century, and their spirit is not that of the poem. Crowned Lucifer ascends to his throne in the first register. He has the same human shape and robes as all the other angels; one group offers him crowns and one group seems to hesitate. In the second register Lucifer accepts what may be peacock feathers (possibly signs of pride) from angels at his side, while other angels hold what look to be palms. Lucifer must already have been thrown out of Heaven because the third register shows Christ brandishing three spears, while below, in the last register, Lucifer is in Hell Mouth, tied up like a criminal, his hands and feet changed into claws, his face wizened and ugly, his head covered by black, shaggy hair, while all around him fall the rebel angels, naked except for loincloths. What is interesting is that the knots used to bind Lucifer are identical to those in an illustration from a Trier manuscript. This may be from a pictorial convention, but ultimately derives from how criminals were bound. Lucifer and his rebel angels in this depiction have nothing in common with Satan from the Apocalypse, probably because the most natural source would have been a stage performance.

An Anglo-Saxon illumination (British Library, London, Cotton Claudius MS B iv, 2) of the same century shows God in a mandorla and

his holy angels casting out the falling rebel angels, who are naked except for cave-man skirts. Satan is held in a mandorla that looks like a steel trap gripped by a dragon's jaws. These rebel angels have lost their wings and robes, but they have no bat-wings, no claws, no hoofs. Their forms are human. A fourteenth-century Italian illustration, the Treatise on the Seven Vices (British Library, Add. MS 27659, fol. 1v), seems based on the ninth-century Trier Apocalpyse, with the winged rebel angels falling into a ferocious Hell Mouth. The early fifteenth-century historiated Bible of Guiard des Moulins (Bibliothèque Royale, Brussels, MS 9001, fol. 19) marks a departure in rebel angel iconography. A beautiful angel is transformed into a clawed, bat-winged creature. Other rebel angels can see this: two of them are distressed and two bend down their heads in agony. Perhaps this is the first time since the Benevento Benedictio Fontis angels (illus. 29) that a painter views the emotional conflicts through the eyes of the rebel angels.

For five hundred years there is no example of the rebel angel Lucifer fighting the archangel Michael. Michael as the Devil's antagonist is a motif from the Last Judgment. But that Devil is bestial. At the beginning of the fifteenth century, this old iconography was transformed. The Michael–Satan antagonism is isolated from its Last Judgment context and combined with the Lucifer from the first stage of the rebel angels motif. The artists who created this new prototype were manuscript illuminators, the Limbourg brothers.

The Limbourgs and the road to Baudelaire

In some Late Gothic illuminated manuscripts there is a row of dots under an occasional word or phrase. This was a new scribal practice to indicate that the scribe was aware of an error but preferred not to mar the appearance of the book by making a correction in the text that might well never be read by his client. This new convention points to the fact that though illuminated manuscripts began as a treasured format of God's word for public devotion, they ended as private treasures for displays of personal wealth. Decorated medieval books were called illuminated books (from the Latin *illuminare*, to adorn), and gold leaf was extensively used. The three main types were Bibles and devotional books used for Mass (Sacramentals, Pericopes, Missals and Breviaries), Psalters (an arrangement of Psalms), and Books of Hours (prayer-books). The Bibles and Breviaries were for the clergy and the court; the Psalter was for private devotions and typically for the clergy; but Books of Hours were for aristocrats and merchants who privately commissioned the artists. Initially prohibitively expensive,

these Books of Hours did not primarily communicate the holy word but rather the status of their owners. During the fifteenth century Ghent and Bruges churned out Books of Hours for Europe, and particularly for England. So rationalized was production that modular books were produced; sometimes only single folios were made that could be inserted anywhere in any book. The 'hours' of a Book of Hours are the eight canonical hours of each day; each hour had an office – a prayer or episode related to Mary. Often, there were four other sections: a Calendar with the occupations of the months, the Hours of the Cross, the Office of the Dead, and the Commendation of Souls. One reason for the popularity of these books was that texts could be added that had little to do with Mary. Before long artists were painting almost anything the patron wished, because somewhere a suitable text could always be found. Since a Book of Hours was for a secular audience, artists perhaps felt a greater freedom. What is certain is that *the* decisive transformation in the depiction of Satan occurs in a Book of Hours. And the most remarkable 'Fall of Lucifer' is also in a Book of Hours. Both of these early fifteenth-century books were by the Limbourg brothers, and for the Duke of Berry.

The Duke of Berry was the connoisseur and dilettante *par excellence*.[180] He owned ostriches and dromedaries; he had tapestries and dinner-place settings that beggar description. He moved freely between his seventeen chateaux. He had a famous library of beautiful books, including fifteen outstanding Books of Hours, the world's finest collections of rubies, one of Charlemagne's teeth and drops of the Virgin's milk. He took a laxative mixture of ground gold and pearls. We might infer the Duke liked dogs since he owned 1,500 of them. Along with his tapestries and jewels, he took bears with him in special wagons as he moved from chateau to chateau. The most eminent authority this century on the Limbourg brothers and the Duke of Berry was Millard Meiss. 'The Duke of Berry', explained Meiss, 'created for the youthful illuminators a remarkably stimulating environment'.[181]

Meiss did note that 'there may well have been contemporaries of Jean de Berry who maintained that he cared more for animals and for art than for men'.[182] Well, some people might 'maintain' anything, but you would not guess from Meiss's account of the Duke's life that he was directly involved with the massive fourteenth-century rebellions of the Jacquerie.[183] The Duke so oppressively taxed his subjects that both peasants and merchants rebelled; these uprisings meshed with the Jacquerie of the Tuchins, social bandits who pillaged the rich (and provided the model for Friedrich Schiller's *The Robbers*). After the Tuchin rising of 1383 was brutally suppressed, instead of sentencing

the leaders to death, Berry sold pardons and imposed on the communes an enormous fine of 800,000 gold francs. To call this 'a stimulating environment' is a choice use of words. This pug-nosed Duke who beggared his people selected the Limbourgs and provided for them so they could concentrate on his books, *Les Belles Heures* in 1410 and *Les Très Riches Heures* five years later. These Hours show religious scenes without religious feeling or symbolism, since for the Duke these books were symbols of his status. To say he had 'excellent taste' is not to define that taste any differently than his taste in dogs or gold toothpicks. The Duke's contract with the Limbourgs specified that they could work only for him; this kept his status-objects exclusive.

The culmination of Apocalypse iconography and its most complete depiction is the enormous set of tapestries ordered by the Duke of Anjou, Berry's brother, and produced by the financier Nicolas Bataille *c.* 1375 (illus. 72). We do not know why this ambitious, unscrupulous and nasty man chose such a symbolic and sacred text. But we do know that there was no chateau in all of France in which this work – over 130 metres long – could be shown in its entirety. Louis naturally knew this and displayed different sections at different times for various occasions (much as a museum rotates its holdings). Such partial displays 'attested to the rank, the richness, and the power of the prince who could command and pay for this tapestry'.[184]

Millard Meiss has provided accurate accounts in imposing volumes on French painting during the time of the Duke of Berry. What is hard to explain is why he traced every possible aesthetic influence on the Limbourgs (attributing this finger to Pol and that finger to Herman), but blotted out any suggestion of the relations between their work and the society in which they lived. Although earlier this century the historian Johan Huizinga sought to relate medieval painters to their social world, Meiss deprecated his insightful work: 'As a Dutch republican Huizinga was hostile to all aspects of courtly life . . . [and] his judgments remain more influential than they deserve to be.' Meiss suggests Huizinga's failings were to be expected, for 'the bibliography in [Huizinga's] *The Waning of the Middle Ages* contains few books on art'.[185] Also difficult to understand are Meiss's comments on a contemporary depiction of Berry (in the *Grandes Heures du Duc de Berry*, before 1409, Bibliothèque Nationale, lat. 919, fol. 96). The Elect (including Berry) appear at Heaven's Gate and are met by St Peter. Two are identified by Charles Sterling as the Duke of Bourgogne and the Duke of Orléans. Both were related to Berry; both were long since dead; both, most oddly, seem to depend on Berry's influence for admission.[186] Normally, as Meiss notes, the newcomer to Heaven

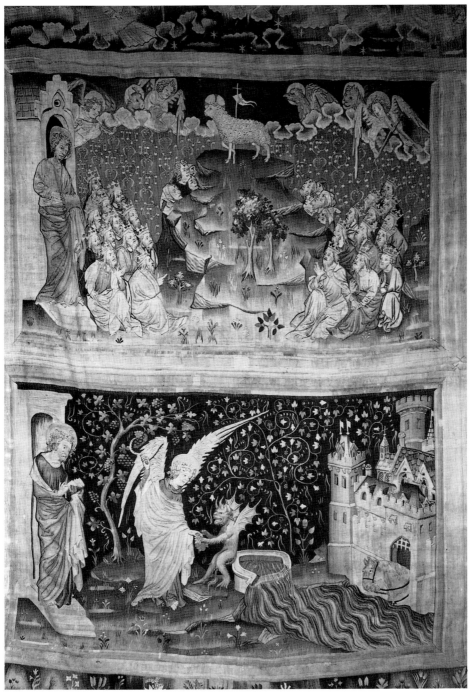

72 An illustration (lower panel) of Revelation, with the Devil as a 'nasty insect', from the Angers Apocalypse Tapestry, *c.* 1375. Chateau d'Angers, Angers.

extends his right hand to Peter, but not in this painting. Instead, Peter must accept Berry's left hand because, with his right, the pug-nosed Duke is fussing with an enormous sapphire encircled by six huge pearls set in a golden collar: an opulent oblation offered to the Keeper of the Pearly Gate. How are we to interpret this gesture – Berry stroking these luxurious jewels? Being neither Dutch nor a republican, Meiss assures us that such jewels could have religious nuances. And he warns: 'Only an enemy would interpret Jean de Berry's action at the Pearly Gate as an attempt to bribe its keeper.' *Only* an enemy?[187]

Meiss begins his life of Berry with the supposition that 'the painters who sat at [his] tables producing the little pictures . . . normally managed, we assume, to keep their minds on their work despite the trouble in the world around them'.[188] But those troubles on a personal, social and political level seeped in, and not just as obvious intrusions, such as depictions of relics from Berry's collection or featuring the Celestine order simply because when the king founded a Celestine monastery, Berry was one of the three who laid the foundation stone. Is not the palette, the vision of the Limbourgs, at least partly a response to the dynamics of their social life? Is not the harmony of the famous, beautiful calendar in *Les Très Riches Heures* also a political statement? Is not one reason Berry pampered his artists was because his aesthetic world was an affirmation of class, perhaps even a psychic barrier against attacks on his class from the likes of the Tuchins? The most prominent subject in the Limbourgs' Hours are the chateaux of Berry. They were not chosen for aesthetic reasons; they were chosen because they are the ground for the vision of these Hours: the view *of* the castle and *from* the castle.

For all their exceptional gifts, the Limbourgs had difficulty with emotional expression. Meiss explains this by saying that 'the execution of paintings of small size exacted, to be sure, certain sacrifices; the minute inflections that compose facial expression, for instance, could less easily be described'.[189] Yet other artists easily did so (an obvious example is the Rohan Master). Perhaps the most deeply felt pictures the Limbourgs painted was the Institution of the Great Litany cycle: scenes from the plague they knew from personal experience of six months in prison during their youth. This cycle's colour, composition and themes suggest places whose centre has been destabilized. Quite unusual is the *Procession of the Flagellants*, an eerie image of the flagellant's emotional and mental world. That such works can be explained by talking about painters sitting on little stools by little tables, making little pictures and thinking only about the contact of their little brushes on vellum, is dubious.

The beauty of *Les Belles Heures* surely pleased the fastidious Duke. The Devil appears in a half-dozen pictures as a minor black bat and irritant. The illustration of Michael defeating Satan is, however, quite different. Though unexceptional in theme, composition, colour and technique, it marks a turning-point in the depiction of Satan and became a much-copied prototype (illus. 75). Satan has talons, light bat-wings and a short tail, but his face and body are human. He expresses agony and anger at being chained. This is the first depiction in which Michael and Satan occupy roughly the same plane of reality. This Satan is no beast: he has a human face because he is a Lucifer after the Fall who contains the spirit of the Lucifer he once had been. The dragon and insect have changed into the new Limbourg Satan, and artists soon accepted this fresh prototype. Naturally, not everyone started painting a Limbourg Satan. The artists of the Rohan Hours, for example, used many figures from the Limbourgs, but not their Satan. The shaggy, black old man, the grotesque mosquito with bat-wings, the marginal instigator and, above all, the dragon, did not disappear, but these models were exhausted and did not fit with Renaissance techniques of showing reality (as Giotto's Byzantine Devil showed). In the middle of the fifteenth century, Antonio Pollaiuolo did a Michael and the Dragon, and never has a more threatening dragon been painted. A simple-minded sign would not do for the man who was among the first to study the human body by actual dissections. When Raphael painted his *Michael and the Dragon* in 1505 (illus. 73), he produced a pure Pollaiuolo-like dragon. Exactly thirteen years later Raphael selected the identical theme, but instead of a dragon he produced a Limbourg Satan who, claimed Vasari, 'reveals all the shades of anger that the Devil's swollen and venomous pride directs against the God who has cast him down' (illus. 74). Technically, Raphael's Satan is not related to that of the Limbourgs at all, but conceptually he is because his Satan has a human form and is pictorially on the same level of existence as the archangel.

These departures from Romanesque concepts and techniques dissipated traditional Christian iconography. In 1473 Ercole de' Roberti painted a Satan and Michael that uses the Limbourg prototype. Oddly, Michael holds the scales while he is stabbing Satan. In earlier Last Judgments Michael holds scales because those scales have a purpose: to weigh the good and bad deeds of the soul. When Michael is fighting Satan, however, the scales look silly; they are there simply because the artist associates the scales with Michael. Tintoretto's *Michael and the Dragon* (S. Giuseppe di Castello, Venice) has the same iconographic confusion. After Raphael, the theme of Michael versus

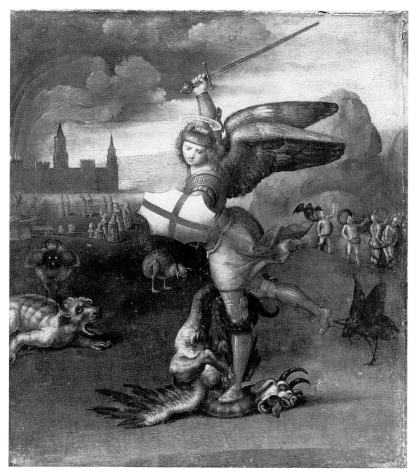

73 Raphael, *St Michael and the Devil* (as a dragon), 1505, oil. Musée du Louvre, Paris.

Lucifer in human form appears in countless paintings with trivial variations. Even Hubert Gerhard's bronze statue in Munich, cast near the end of the sixteenth century, seems hard to imagine without Raphael's painting of 1518. The Limbourgs provided the prototype, and the two paintings of Raphael dramatized the new ways of rendering the Devil.

Equally dramatic as a turning-point are two paintings in *Les Très Riches Heures*, the second Book of Hours made by the Limbourgs for the Duke of Berry. The Hell picture in this book was not part of the original plan; it was added later. Some scholars call it a personal work in which the artists 'showed . . . creative imagination', but pure fire and brimstone seem a more appropriate description (illus. 63). A sabre-

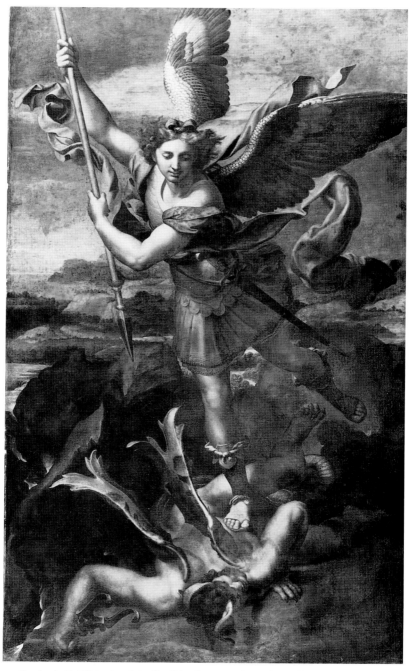

74 Raphael, *St Michael and the Devil* (no longer a dragon), 1518, oil. Musée du Louvre, Paris.

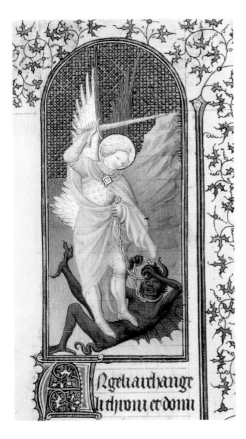

75 Paul, Jean and Herman Limbourg, 'St Michael and the Devil', the latter as a new prototype, 1409, from *Les Belles Heures du Duc de Berri*. The Cloisters Collection (MS 54.1.1 fol. 158r), Metropolitan Museum of Art, New York.

toothed, horned Satan is on a bed of coals and, like some whale playing with a ball at the summit of his spout, this Satan, using flames instead of water, is playing with a score of sinners. Devils pump bellows to intensify the heat, and, in their mystery play costumes, drag sinners to their chief. Derived from the Leviathan tradition, this unoriginal picture is a summary of what Satan and Hell have looked like until then. This depiction was probably influenced by traditions of what Hell looked like, as described in Tundale's Vision, written by an Irish monk in the mid-twelfth century. Enormously popular, this Hibernian pre-Dantean tour of Hell was translated from Gaelic into many languages, including Latin, Old German, Middle English and Anglo-Norman. The nobleman, Tundale, describes the Devil seated on a grate over coal inflamed by bellows worked by demons; the monk informs us that the Devil inhales and then exhales the souls of the damned into different parts of Hell – details quite close to the Limbourg painting.

Someone, however, perhaps an adviser or a friend of Berry's, had clearly imagined Satan differently from the one in the Limbourgs'

earlier Book of Hours (illus. 75). There is no trace of that approach in this later Hell painting, and that same somebody was probably responsible for the insertion of still another extra page: the *Fall of the Rebel Angels* (illus. 64). This painting is of exceptional originality and shows no relevant direct influence (except, possibly, as Meiss implies, a mid-fourteenth-century Sienese painting's arrangement of the stalls in Heaven of the good angels). A few earlier rebel angel depictions had shown these angels in heavenly colours turning into black, besmirched creatures as they fall toward Hell. This is not the case here. Meiss suggests that 'the rebellious angels have all lost the green [of the good ones]; their wings are gold and white, probably a sign of their pretensions and pride'. Perhaps. But the obvious point is the Limbourgs' *departure* from the standard scheme, since their falling angels *remain* beautiful at all levels. Meiss sums up: 'Apparently Pol de Limbourg, rather like Giotto himself, believed evil could be most vividly and significantly conveyed by the portrayal of human beings who have lost control of themselves.'[190] Strange words. Has Giotto's Judas lost control of himself? On the contrary, he has greater control than Jesus. Has the Limbourgs' Lucifer lost control of himself? On the contrary, it has been forcibly wrested from him.

The Limbourgs' Lucifer is the most beautiful example in art – beautiful in composition, in colour, in movement and in conception. Whose idea it was to paint this particular idea and insert it in the book, and what comments were made by the Duke and his friends when they perused it, no-one knows. Though I admiringly described this painting earlier (chapter One, p. 26), if we view the painting from an aesthetic distance, a different approach suggests itself. An intuitive reading by a twentieth-century viewer would see this work as an imaginative leap, a new perspective on the rebel angels. This reading is correct, but it ignores the fourteenth-century context from which the painting arose. The Limbourgs' Hours are ideal examples of how the original religious functions of Books of Hours faded. It could, therefore, be argued that this painting is an impoverishment of its theme because the treatment is aesthetic, empty of religious meaning. It is also empty of ethical meaning: it has no moral content. This is a contradiction since the theme, the conflict of good and evil, demands a treatment that should imply an ethical judgment, but which is not here. Were it really a conflict between a ruler and a rebel, the beautiful Lucifer could have interesting implications if the painting allowed the viewer to consider the possible cruelty of the ruler and the rights of the rebel. Such a theme, if overtly suggested by the Limbourgs, would hardly have resulted in more gifts of diamond rings from a Duke threatened by

rebellions. A naive twentieth-century interpretation might draw such a meaning, but it is unlikely that such a meaning was drawn by the Limbourgs or by Berry. Lotto's mystical interpretation or, later, Romantic interpretations such as Blake's, *do* imply alternative views, emotionally and psychologically. The Limbourgs' fine illuminated folio is only formally a new approach, and though it remains stunning, both visually and imaginatively, it can easily be overrated.

Quite different are Destorrents's grotesques, the sources of which, as I mentioned, are not easy to determine. The same is true of Bosch, a man who lived in a world quite different from that of the Limbourgs. What makes Bosch unique is not technique, for his is often conventional. Combining animal and human parts is not new. Some of the more grotesque scenes in his Vienna *Last Judgment* – blacksmith devils hammering the damned on anvils and limbs sliced from the damned and fried in a pan – derive from popular and populist literary sources, primarily from pre-Dantean visions of Heaven and Hell, particularly the mid-twelfth-century Tundale's Vision, and possibly from the late twelfth-century Monk of Eynsham's Vision and the early thirteenth-century Thurkill's Vision. Unlike other artists, Bosch did not just combine animal and human parts, he fused them to generate a new creature. He combined a head propelled by feet, deleting the body, a sight never seen before; and he fused human and animal parts with inanimate objects, which cannot be found in earlier paintings. An example is that incredible creature in the *Garden of Delights*: a man's head grafted onto a broken eggshell grafted onto two legs, which are tree-trunks rooted in two boats. No-one can forget this image (derived from the gryllus). No-one knows what it means. It was this Tree-man that captured Bosch's imagination, not the Devil. Evil, especially lust, takes countless shapes in Bosch's paintings but, odd though it may seem, the Devil did not much interest him, and this is implied in his treatment of the rebel angels theme. There are a pair of small panels (probably altarpiece-wings) in Rotterdam, one of which was once known as 'The Fall of the Rebel Angels', a moot title. Some of those falling look more like flying-fish or flying mice, and what they are falling to is hardly the expected Hell: instead of flames, two bodiless heads crawl about on their feet, creatures that are definitely Bosch-like and neither in the Bible nor *The Golden Legend*. One 'demon' even plays a lute. The top fifth of the left wing of Bosch's *Last Judgment*, the 'Expulsion of the Rebel Angels', is a bit like a dust-storm in colour, movement and texture. It is a conventional, generalized treatment. The only time Bosch put some effort into this theme is in the *grisaille* border of the Escorial's *Christ Crowned with Thorns*. Though the conflict

between devils and angels is energetic, it was not meant to be noticed much (and it is not), except as a background for the central composition of Christ tormented.

The Devil and his rebel angels did not much interest Bosch because for him there was no *conflict* between good and evil. The difference is absolute and profound but there is no *agon*. The Seven Sins are everywhere, and sinners will be most unpleasantly punished. Bosch's Christ and the saints are in another world, untouched by temptations or evils or tortures. In the Vienna *Last Judgment*, the only members of the heavenly court are the Virgin, John the Baptist, and twelve figures who may be the Apostles; if they are not, then fewer of the elect go to Heaven in Bosch than in any other Last Judgment ever painted. Simply put, in Bosch's vision most men and women are sinners and fools in a carnal world where goodness has no existence, but God sees every sin, and every sin is punished beyond what any sinner can imagine.

A few decades after Signorelli's *Last Judgment*, another painter who veered toward Mannerism, Domenico Beccafumi, painted a large *Michael and the Fallen Angels* (Pinacoteca, Siena). The rebel angels are naked humans without a trace of horns or claws. What engaged the artist is not Michael but the fallen angels, and we can see this since the triumphant Michael is a stolid, stock figure in a stock pose, while on the faces of the rebel angels are pain, fear and suffering. A different world of textures and thoughts than that of either the Limbourgs or Michelangelo is that of Lorenzo Lotto. He was commissioned to help repaint the Vatican *stanze*, but this came to an end when Julius II put Raphael in charge. In Rome Lotto had probably met Beccafumi, and he certainly knew the work of Signorelli. Technically, Lotto's paintings are typically Venetian, but most of his work was done outside of Venice, which he left for good in 1549. Three years later he settled in Loreto, and in 1554 joined the monks at the Sanctuary there as an oblate. But before his religious feelings and mystical strains led him to Loreto, Lotto created a work (illus. 65) that is as original as is the Limbourgs' *Fall of the Rebel Angels*.

Usually, Michael stands over the fallen Lucifer. Or Lucifer falls to Hell. But Michael is always straight: the message lies in the contrast of positions. The stability of Michael's stance indicates the stability of his power. Lotto changed this by placing the longitudinal axis of both Lucifer and Michael at a diagonal and making their axes parallel. That structural parallelism reflects Lotto's mystical rendering. Michael and Lucifer are identical; their bodies are the same; their faces are the same. It is as if we see the two gametes of a zygote. The other face of Lucifer is Michael.

Milton's Satan is indeed the ultimate adversary, strong enough in battle to shake the throne of God. Like his precedessor in Genesis B, Satan refuses to humble himself, refuses to admit he sinned, and remains adamant in his opposition to the Almighty. 'Amateur' readers, fascinated by the early books of *Paradise Lost*, often seem to get Satan wrong, and so are reprimanded by today's professional critics, who are convinced that Milton showed Satan's moral blindness and unpardonable violations. Whatever today's critics may say, the poets and writers of the nineteenth century saw Satan differently. To Coleridge, Byron, Hazlitt and Shelley, for example, the *heroic* Satan was one of Milton's major achievements. For William Blake, Milton wrote in freedom when he wrote about Satan because Milton 'was a true Poet and of the Devil's party without knowing it'. The Devil's party was the party of human freedom fighting against a repressive society. For Shelley, Milton's Devil was morally superior to God:

Milton's Devil as a moral being is as far superior to his God as one who perseveres in some purpose which he has conceived to be excellent, in spite of adversity and torture, is to one who in the cold security of undoubted triumph inflicts the most horrible revenge upon his enemy – not from any mistaken notion of bringing him to repent . . . but with the open and alleged design of exasperating him to deserve new torments.[91]

Some four decades after Shelley wrote those words, Victor Hugo completed *Les Misérables*. In that famous novel Inspector Javert inflicted the 'horrible revenge' of society on those who violated its laws. Hugo compares Javert's feelings to 'the superhuman bestiality of a ferocious archangel' who is a 'monstrous St Michael'. And around the same time that Hugo, self-exiled on the island of Guernsey, imagined a hideous Michael, in Paris Baudelaire was writing up his Journal:

I have found the definition of Beauty, of my Beauty. It is a thing passionate and sad. . . . I cannot imagine Beauty where there is no adversity. . . . It is hard for me not to conclude that the most perfect type of virile Beauty is Satan – in the manner of Milton.

From a perverse polluter and outcast who misled the world into worshipping pagan gods, the fallen Devil had now become charged with beauty and intrinsic power.

Epilogue

The Devil is an extraordinary mixture of confusions. Satan is a creature of theology, of practical ideology and politics, and of oddly connected pictorial traditions. The Ruler of Hell, the Rebel Angel, the counterpart of Michael in the Weighing of Souls, and the Evil Microbe and Provoker barely overlapped pictorially. Without a fixed iconography, the Devil could be Godzilla, or a distorted Pan, or a furry pest with wings or without, with horns or without, with cloven hoofs or without, ferocious or comical. Since the Devil could be a microbe as well as a fallen angel, how could the Devil have a face? He could not because he was not a character, only an abstraction. Not convincingly felt as a 'person', he could not convincingly be shown as an evil force. He was a man with *only* a mask (and not even a man at that).

When Government and Church decrees refer to the Devil, usually they are referring to their opponents. That is why, for example, when the Revd Ian Paisley in November 1985 preached a sermon in Ulster, he described Margaret Thatcher an 'agent' of the Devil. The old lack of iconography is useful because whether it be Thatcher or the Cathars, the Devil has the 'face' of your opponent. The faceless Devil is an effective way to avoid considering the opposition and automatically to place God on one's own side. The Devil is often merely 'the Other'. That formulation makes sense, particularly in the twentieth century. Earlier, perhaps, the Devil was something else, since his image in the arts has curious implications. Through the centuries Christ became more individualized. His face expresses almost every emotion except lust. Christ and the Apostles in Giotto's frescoes might almost have names, as do some of the people who watch the main events. But the Devil is rarely individualized, so we remember Giotto's Judas but not his Devil. Giotto's Judas is a particular person; his Satan is not.

The Devil was not individualized, although heretics, Jews and Saracens were. Yet it is puzzling to discover that there are few sculptures and paintings that show Satan surrounded by heretics, Jews or Saracens. Even in the few known instances, Satan is marginal,

coaching Pilate or some other wicked ruler. And why, both in the few instances where we find devils among the enemies of the Church, and when we find those enemies without devils, are those enemies *not* demonized? Anti-Semitism pervades Christian art. Some illustrations in beautiful Books of Hours are explicitly anti-Semitic, and there are all too many examples in exquisite stained-glass windows and monumental sculptures. Yet these Jews are not shown with horns, fangs, tails or bat-wings.

Heretics in the arts are rare; but when they are depicted, these enemies of the Church are drawn without distortions. I know of only three full paintings before the sixteenth century with heretics as subjects. The most important is a large fresco, in the Spanish Chapel of Florence's S. Maria Novella, painted by Andrea di Bonaiuto (or da Firenze) in the mid-fourteenth century, and entitled *The Church Militant and Triumphant* (illus. 77). Andrea, following instructions by the Dominicans, shows SS. Dominic, Peter Martyr and Aquinas disputing with heretics (illus. 76). The heretic group (on the far right) with Aquinas seems baffled and defeated by his logic; one tears up his books; two Jews he has converted kneel before him. The adjacent group, though, is in vigorous debate. St Peter Martyr's words hardly seem convincing. St Peter is the vicious papal inquisitor who was assassinated by Cathars more than a century earlier. These heretics have highly individualized faces and absolutely nothing, even by indirection, suggests the Devil. This is equally true of two paintings by Pedro Berruguete of *c.* 1500 in the Prado. In those paintings, the Cathars that Dominic debates with and the heretics being led to the ceremonial pyre for burning are normal in all respects: clothing, faces, body and gestures.

Sassetta (Stefano di Giovanni), the most original of the Sienese painters *c.* 1425–50, made the Arte della Lana Chapel altarpiece for the wool merchants' guild. The sun is setting; a priest raises the consecrated host on the right; an excited crowd watches the burning of an intense, bearded man in a dark habit, a heretic (he may be John Hus, betrayed and burned in 1415, or Francesco di Pietro Pocari, burned near Siena in July 1421, or no-one specific). A small bat-devil flies toward him. This work in colour, composition and artistry is the first and easily the best of the three that have heretics as subjects. The heretics and Jews were instigated by the Evil One: they were his agents who did his work, but they were never identified with the Devil in the arts. In fact, except for the Saracens, who accost Charlemagne in a few illustrations of the fourteenth-century Grandes Chroniques de France (illus. 24), I know of no example. (These particular devils were

probably from a drama, as indicated by their human feet, masks and, particularly, by their drums.) Heretics, Saracens and Jews were demonized in writings, but why were they not demonized in the arts? Perhaps because the Church did not want to alienate possible converts. Perhaps to avoid giving the Devil a personality. Perhaps because there were no graphic precedents. Whatever the answer, this unexpected problem suggests that for us to say that the Devil is simply 'the Other' is an oversimplification for the period that lies between 800 and 1600.

I would like to approach this problem from a different angle. A sub-text suggests the crucial reason for the lack of demonization: the Devil works for God. He punishes the sinner: he does God's work, therefore he *cannot* be a Jew or a heretic. *Nowhere* does the Devil suffer in Hell. He looks dismayed during Christ's Descent into Limbo, and helpless before Michael, but in Hell he is content, and many devils seem positively happy. This leads to a curious conclusion: despite the

76 Detail of Andrea di Bonaiuto's 'Dominicans arguing with Heretics' (Peter Martyr is on the left, Aquinas to the right), from illus. 77.

77 (*overleaf*): Andrea di Bonaiuto (or 'da Firenze'), *The Church Militant and Triumphant*, 1355, fresco. Cappellone degli Spagnuoli, S. Maria Novella, Florence.

attempt of many Satanists to imply that the Devil is a symbol of evil, he is not. The most plausible, if apparently perverse, deduction to be made from images of the Devil to be found in the arts from 800 to 1600 is that the Evil One is on God's side. He carries out the garbage. He is so ingrained in our thought and language that it comes, perhaps, as a surprise to learn that some languages have no word for the Devil because there is no concept of the Devil. By *the Devil* I mean the source of evil and the adversary of God. Every civilization seems to have had devils, but there is a difference. Denis Grivot, the Chanoine of Autun who rescued the head of Christ and replaced it where it belongs, in the tympanum of St Lazare, pointed out that 'the Devil is so indispensable in the Life of Christ that without him Jesus Christ would not exist. The sole adversary worthy of Christ is the Devil'.[192]

Earlier, I noticed that Meikira, one of the twelve Divine Buddhist Generals (illus. 23), would be thought a Devil by Westerners though, in fact, this eighth-century stucco figure *opposes* evil. In Japanese mythology, folk-tales and religion there are *oni*, a sort of ogre or demon, red-faced, with horns and often with a club. True, they sometimes spell trouble. Yet some Japanese families claim descent from *oni*, and *oni* help dispel evil spirits for some festivals. In Hell they are often blue or red; like our devils, they are warders and inflict punishment – often horrific – on sinners, but no one imagines them to be adversaries of Buddha or of Emma, the Chinese king who rules Japan's Hell. In Chinese and Japanese hells there are demons fiercer than those found in Western paintings, but those demons are *not* evil. There is a word in Japanese for devil, *akuma*. *Akuma* seems originally to have been used mainly in a few Buddhist texts, but it also appears in some literary works, particularly during the Heian period, and entered common usage when it was selected to translate the Christian *Satan*.[193] There is no equivalent to Satan in Japan, nor was there any equivalent in ancient Greece or Rome, and at least one reason for this was the lack of monotheism. You could hardly have an opponent of 'God' if there are hundreds of deities. The lack of Satan does not imply indifference to evil, even as an active force, although, in a standard work, *Japan: A Cultural History*, G. B. Sansom tells us that the concept of sin in Japan is 'wanting and rudimentary', and that this is because Japanese have an 'incapacity to discern' the problem of Evil. I suppose Sansom is talking about the Christian (i.e., his) notion of sin; fair enough, perhaps, but his notions are rather odd.

Though in Confucianism, evil is typically a negative clog on human nature, in Japan during the Fujiwara and Kamakura periods (twelfth and thirteenth centuries), evil was thought of as a universal force at a

particular historical time. That time was the third stage in human history, *mappō*, which marked the end of Buddhist Law and hope for salvation. Belief in the end of the world, *mappō*, grew in parallel to the transcendental cult of Amida. A keen consciousness of such a world was particularly true from *c.* 1100–1200, the period when the outstanding Hell and Rokudō paintings were created. (It was also during a relatively short period, 1050–1130, that the most deeply felt carvings of the Devil appeared in France, albeit the execution was, typically, crude.) The question is complex, but we can note that though there is no Satan in Japan, in the West there are few (if any) Hell paintings that compare with those created in twelfth- and thirteenth-century Japan, and there is no statue of Satan that compares in power, fierceness and excellence of execution to various demon guardians wrathful against evil from the Tempō to the Kamakura periods.

Another reason the Devil cannot be considered as an image for evil is that since he is a Christian creation whose role the Church defined, he can only represent evil as defined by the Church. Naturally enough, the massacre of the Albigenses or the buying and selling of offices and benefices was not attributed to the Devil by the Church. And naturally enough, Luther considered the Pope an agent of the Devil as he, in turn, was considered one by the Pope. (Protestant artists, such as Lucas Cranach, designed prints that show devils carrying the Pope into Hell's flames.) These simple examples should be enough to undermine any attempt to suggest that the Devil is a symbol for evil. He is not. He is only evil as defined by any Christian sect for its own self-interest. Of course, *after* the sixteenth century, belief in the Devil was not always contingent on belief in orthodox Christian theology. Once the Devil was no longer strictly defined by his opposite, Jesus, he could then become a more general image of evil forces outside standard theological categories. That, however, is a different story and is embodied in the most influential Satanic cult image of all time: the *Sabbatic Goat* by Eliphas Levi of the mid-nineteenth century.[194] Levi was a curious pseudo-scholar who first tried to combine socialism and religion; he finally became an interesting, vacillating occultist with considerable influence. His ritual procedures have been adapted to embrace evil fantasies, usually by people who have an incapacity to distinguish between good and evil. The *Sabbatic Goat* not only influenced films with satanic themes, it became a cult image for alienated spiritualists, members of rock-bands, serial murderers. It is a story beyond our concern.

Nevertheless, some writers talk about present day 'satanism' as if the Satan in rock songs and horror films is merely another manifes-

tation of the same being found on tympana before 1600. An example of what this can lead to is the approach of the demonology specialist Roland Villeneuve. He argues that Satan today appears through the medium of Adolf Hitler, Aleister Crowley and Charles Manson.[195] To present a 'satanist-magician' strolling through Paris (Crowley), a psychopath (Manson) and the leader of a Fascist totalitarian state as different facets of Satan that prove the Devil's reality is to testify to a strong imagination. Though Joseph Conrad's imagination was as powerful as any, he insisted that 'A belief in a supernatural source of evil is not necessary; men alone are quite capable of every wickedness'. As Robert Burns jocularly confided in his address 'To a Painter':

> Dear ——, I'll gie ye some advice,
> You'll tak it no uncivil:
> You shouldna paint at angels, man,
> But try and paint the devil.

> To paint an Angel 's kittle wark,* [*tricky work]
> Wi' Nick, there's little danger:
> You'll easy draw a lang-kent* face, [*well-known]
> But no saw weel a stranger.

Burns was a poet, of course; Conrad a novelist: we accept or reject their insights depending on our personal inclinations. Christopher R. Browning, however, is a historian who has spent over twenty years examining the records of the Holocaust. He particularly studied the detailed accounts of a group that rounded up and shot some 100,000 Jews – the Reserve Police Battalion 101, composed neither of SS members nor of soldiers, but of ordinary middle-aged, lower-middle class family men from Hamburg. Of all the records he perused, says Browning in his *Ordinary Men* (1993), those of this battalion, more than any other 'starkly juxtaposed the monstrous deeds of the Holocaust with the human face of the killings'.[196] The notion that evil is a manifestation of the Devil, the suggestion that there is link between the Devil as he appears on Romanesque capitals and Adolf Hitler seems grotesque, seems a simple Romantic ploy to avoid uncomfortable social facts. 'In every modern society', concludes Browning,

bureaucratization and specialization attenuate the sense of personal responsibility of those implementing official policy. The peer group exerts tremendous pressure on behavior and sets moral norms. If the men of Reserve Police Battalion 101 could become killers under such circumstances, what group of men cannot?[197]

Four hundred and fifty years earlier, Bartolomé de Las Casas, the man whom Gustavo Gutiérrez (the founder of Liberation Theology) considers his precursor, recorded the wholesale destruction of the native population of Spanish America. Though a Catholic priest, Las Casas holds views that are close to Browning's, and, like Browning, he does not blame the Devil:

[Many Christian Spaniards] had become so anaesthetized to human suffering by their own greed and ambition that they had ceased to be men in any meaningful sense of the term and had become, by dint of their own wicked deeds, so totally degenerate . . . that they could not rest content with their past achievements in the realms of treachery and wickedness . . . but were now pestering the Crown [for authority] to devise yet worse atrocities.[198]

The Devil in medieval and Renaissance art, for the most part, remained a sign, never an artistic symbol. Though in the writings of theologians he may be the opponent of God, unless he has the power Milton gave him to shake God's throne, or the anger the Saxon poet gave him against God's injustice, or the uncontrollable fierceness Gislebertus gave Satan facing Jesus, the Devil resembles an impotent insect. We 'read' what the Devil stands for, but we feel nothing because the artists felt nothing: the Devil remains unreal. That does not mean the torments of Hell were unreal, and it certainly does not mean evil has no face. Compare the unconvincing devils torturing the damned in the Winchester Psalter (illus. 52) with the brutal faces of the men flagellating Jesus (illus. 53), or compare Giotto's little nasty bats with the suffocating power of evil in Giotto's *The Kiss of Judas* in the Arena Chapel.

Near the end of Shakespeare's *Othello*, the hero realizes how Iago has maliciously deceived him. The villain is captured and brought before Othello, who now faces his deceiver. Then, speaking as much to himself as to the embassy from Venice, Othello says: 'I look down towards his feet, but that's a fable.' Othello sees no cloven hoofs. The Devil with human feet is the Judas Giotto painted and the flagellators that the artists of the Winchester Psalter drew. Solzhenitsin, in *The Gulag Archipelago*, argues that Iago was 'a little lamb' because he knew he was doing evil. 'Shakespeare's evildoers', he continues, 'stopped short at a dozen corpses. Because they had no *ideology*.' Ideology legitimizes violence, stiffens determination, and makes horrors seem natural. The murdering Spaniards, Las Casas bitterly noted, 'proclaim and record for posterity their conviction that the "victories" they continue to enjoy over an innocent population, by dint of massacring them, come from God'.[199] Solzhenitsin points to other examples of how ideology keeps the minds of determined leaders in fine fettle:

That is how the agents of the Inquisition fortified their wills: by invoking Christianity; the conquerors of foreign lands, by extolling the grandeur of their Motherland; the colonizer, by civilization; the Nazis, by race; and the Jacobins (early and late), by equality, brotherhood, and the happiness of future generations.

Thanks to *ideology*, the twentieth century was fated to experience evildoing on a scale calculated in the millions. This cannot be denied, nor passed over, nor suppressed. How, then, do we dare insist that evildoers do not exist? And who was it that destroyed these millions? (pp. 173–4).

It was not the Devil.

The Devil did, though, justify the crusades of the Christian churches and of the Emperors against Albigenses and Hussites, their murders of critics, such as Arnold of Brescia and the philosopher Giordano Bruno, the burning of Hus, whose personal safety had been guaranteed by the Holy Roman Emperor himself, and the burning of Servetus in Geneva by Calvin, a leader of the Protestant Reformation. This hollow creature, the Devil, enabled a learned Pope, Gregory IX, to write to the King of Germany about heretics who sucked toad tongues, prompted Leo to call Jews and Manichees inhabitants of cesspools, and justified placing a halo around the Emperor Theodosius's promise to execute all heretics because the Emperor is guided by heavenly wisdom.

Origen's belief that the Devil might be saved was mocked by Augustine. Origen's and Abelard's ideas about the Devil did not destroy the Devil as a symbol of evil, but such ideas would have diminished the effectiveness of the Devil as an ideological weapon of the Church, which used the Devil to explain Origen's and Abelard's deviations.

If the Church and Empire used the Devil for their own aims, this does not imply cynical disbelief. On the contrary, belief in the Devil *was* real and *is* real. Pope Paul VI and Pope John Paul II in our time affirm belief in the real Devil. The issue of *Der Spiegel* for 22 December 1986 had a special section on the Devil, and there cited the Vatican's Cardinal Ratzinger, who had explained that 'for Christian believers, the Devil is a mysterious but real, personal and not symbolic presence'. Perhaps Bishop Rudolf Graber speaks the truth when he says that 'if there is no Devil, then there is also no God'. Perhaps belief in the Devil is one way for Christians, and even non-Christians, to avoid facing evils that might otherwise reveal how inadequate theological explanations are. But this issue is not limited to Christian theology. What makes Browning's exhaustive study of the five hundred 'ordinary men' who comprised Police Battalion 101 so extraordinary is that he convincingly

undercuts most theorizing about the mass murders of the Final Solution. Wartime brutalization, bureaucratized killing, the mind-set of 'desk murderers', special selection by higher authorities, or 'self-selection' from psychological predispositions – all such notions are shown to be feeble explanations for the behaviour of Battalion 101.[200] Even the ideology that Solzhenitsin focused on has, in this case, limited relevance. In a Fascist society, however, the individual has no choice; disobedience was no option – surely this was a crucial factor? So I had thought . . . Browning's most startling statement is this:

Quite simply, in the past forty-five years no defense attorney or defendant in any of the hundreds of postwar trials has been able to document a single case in which refusal to obey an order to kill unarmed civilians resulted in the allegedly inevitable dire punishment.[201]

'I look down towards his feet', says Othello, 'but that's a fable'. If so many people today believe, as I had, that one reason for the horrors committed by the Third Reich was that disobedience to orders was not an option, yet that belief turns out to be based more on a desire for it to be true rather than on the facts, it is not, then, surprising that belief in the Devil functioned as an easy way to explain evil. Perhaps that is why so many Christian images of the Devil seem trivial, though the suffering from evil is not.

No other creature in the arts with such a long history is so empty of intrinsic meaning. No other sign or supposed symbol is so flat. And if what the Devil looks like was largely determined by the costume used to impersonate him, this is fitting: the Devil is only a costume, even if it has become inseparable from the skins of those that wear it.

References

1 André Chastel, *A Chronicle of Italian Renaissance Painting*, trans. P. Murray (Ithaca, NY, 1983), p. 101. Professor John Shearman of Princeton, however, does not sense the same problems as Chastel does; as a result, he has difficulties: see his tortured explanation of the Temptations of Christ in 'The Chapel of Sixtus IV', in *The Sistine Chapel*, ed. Carlo Pietrangeli et al. (New York, 1986), pp. 57–62.

2 J. Contreras and G. Henningsen, 'Forty-four thousand cases of the Spanish Inquisition', in *The Inquisition in Early Modern Europe*, ed. G. Henningsen and J. Tedeschi (DeKalb, 1986), p. 119.

3 E. Douglas Van Buren, *Symbols of the Gods in Mesopotamian Art* (Rome, 1945), pp. 68–70.

4 Komatsu Shigemi, *Nihon no Emaki*, VII (Tokyo, 1987); Ienaga Saburō, *Gaki Sōshi, Jigoku Sōshi, Yamai-no Sōshi, Nihon Emakimono Zenshu* (Tokyo, 1979); Shimbo Toru, *Jigoku Gokuraku no E* (Tokyo, 1984); *Nihon no Bijitsu*, no. 271, special Rokudō issue (Tokyo, 1988), summarizes recent scholarship.

5 Takaaki Sawa, *Art in Japanese Esoteric Buddhism* (Tokyo, 1972), p. 17.

6 Roland Villeneuve, *La beauté du Diable* (Paris, 1983).

7 Spinoza's letter to Burgh, 1675, letter LXXIV.

8 Marvin H. Pope, *The Book of Job* (New York, 1965); Peggy L. Day: *An Adversary in Heaven: Satan in the Hebrew Bible* (Atlanta, 1988). Like most biblical matters, the meaning of Satan in the Old Testament is complicated. A critical review of Day's book is in the *Journal of Semitic Studies*, XXXVI/1 (1991).

9 In all the early Fathers; Clement, Exhortation 2:23, 10:74; conclusive summary in Jean Danièlou, *A History of Early Christian Doctrine before the Council of Nicaea* (London, 1973), II, p. 429.

10 Vasari, *Lives of the Artists*, trans. G. Bull (Harmondsworth, 1965), pp. 36–7.

11 Matthew 12:26–8; Mark 3:22, 25 26; Luke 10:17–18, 11:18.

12 *The Chester Mystery Cycle*, ed. R. M. Lumiansky and David Mills (Oxford, 1974).

13 P. B. Shelley, 'Essay on the Devil and Devils' (*c*. 1819), in *Shelley's Prose*, ed. David Lee Clark (New Mexico, 1954), p. 274.

14 Otto Kaiser, *Isaiah 13–39: A Commentary* (London, 1974); *The Interpreter's Bible*, V (New York, 1952).

15 Origen, *Contra Celsum*, trans. H. Chadwick (Cambridge, 1953), IV, 65.

16 Augustine, *The City of God*, trans. Demetrius Zema and Gerald Walsh (Washington DC, 1962), I, 8.

17 Ibid., XI, 15.

18 Cited in Neil Forsyth, *The Old Enemy* (Princeton, 1987), p. 430; Augustine's special pleading is analysed on pp. 427–33.

19 Augustine, op. cit., XI, 13.

20 Aquinas, *Gentiles*, III, cvii, 7.

21 Augustine, op. cit., XIV, 11.

22 J. H. Charlesworth, ed., *The Old Testament Pseudepigrapha: Enoch*, trans. E. Isaac (New York, 1983); *The Apocrypha and Pseudepigrapha of the Old Testament in English*, trans. R. H. Charles, (Oxford, 1913), II.

23 M. A. Knibb, 'The Date of the Parables of Enoch', *New Testament Studies*, XXV (1979), pp. 345–59.

24 Franz Delitzsch, *A New Commentary on Genesis*, trans. S. Taylor (Edinburgh, 1888), pp. 222–33; A. Dillman, *Genesis, Critically and Exegetically Expounded*, trans. W. B. Stevenson (Edinburgh, 1897), I, pp. 232–43.

25 Especially 15:8; 6:10.

26 Justin's second *Apology*, v:2–6.

27 Athenagoras, *Plea*, 24.

28 Clement, *Stromateis*, V, i:10, 1–3; discussed in Danièlou, op. cit., p. 63.

29 Tertullian, *The Apparel of Women*, 2:1.

30 In Danièlou, op. cit., III, pp. 162–3.

31 Augustine, op. cit., XV, 23.

32 W. B. Henning, 'The Book of Giants', *Bulletin of Oriental and African Studies*, XI (1943–6), pp. 52–74, cited in C. L. Mearns, 'Dating the Similitudes of Enoch', *New Testament Studies*, XXV (1979) pp. 360–69.

33 Aquinas, *Gentiles*, III, cvii, cix.

34 Hastings Rashdall, *The Idea of Atonement in Christian Theology* (London, 1920).

35 'To the Ephesians', in *The Apostolic Fathers*, trans. Francis X. Glimm et al. (Washington DC, 1962) p. 94.

36 Henry Bettenson, *Documents of the Christian Church* (Oxford, 1943), p. 31.

37 *Christology of the Later Fathers*, ed. Edward Rochie Hardy (London, 1955), pp. 22–4.

38 *Second Oration on Easter*, xxii.

39 Augustine, *Trinity*, xiii, 4.

40 'Why God Became Man', vii, in *A Scholastic Miscellany: Anselm to Ockham*, ed. Eugene R. Fairweather (London 1956).

41 Daniel Defoe, *Robinson Crusoe* (1719), ed. Angus Ross (Harmondsworth, 1965), p. 220.

42 'Exposition on the Epistle to the Romans', ii, in Fairweather, op. cit.

43 G. G. Coulton, *Five Centuries of Religion* (Cambridge, 1923–7), I, p. 64.

44 Jean Gimpel, *The Cathedral Builders*, trans. from French (New York, 1984), p. 86.

45 R. Lightbown, *Piero della Francesca* (London, 1992), p. 148.

46 Pucelle, 'The Belleville Breviary', in *A Documentary History of Art*, ed. E. G. Holt (Princeton, 1947), I, pp. 130–34.

47 Erwin Panofsky, *Abbot Suger*, 2nd edn (Princeton, 1979), p. 214.

48 Gertrude Schiller, *Ikonographie der Christlichen Kunst* (Gütersloh, 1966), II, pp. 98–176.

49 Contreras and Henningsen, 'Forty-four thousand cases of the Spanish Inquisition', op. cit., p. 104.

50 Ibid., p. 105.

51 Ibid., p. 121.

52 'The Dovecote has opened its eyes', C. Ginsberg in Henningsen, op. cit., p. 193.

53 Coulton, op. cit., p. 465.

54 Arnobius of Sicca, *The Case Against the Pagans*, trans. G. E. McCracken (New York, 1949), I, pp. 36, 40–41.

55 Friedrich Heer, *The Medieval World: Europe 1100–1350*, trans. J. Sondheimer (New York, 1962), pp. 393–4.

56 Erwin Panofsky, *Studies in Iconology* (New York, 1962), pp. 25–9.
57 'Essay on the Devil and Devils', in *Shelley's Prose*, p. 274.
58 François Vogade, *Vézelay* (Bellegarde, 1992), notes to pl. 17.
59 Francis Salet, *La Madeleine de Vézelay* (Melun, 1948), p. 149.
60 Ibid., p. 154.
61 L. F. Kaufmann, *The Noble Savage: Satyrs and Satyr Families in Renaissance Art* (Ann Arbor, 1984), pp. 31–2.
62 C. Gaignebet and J.-D. Lajoux, *Art profane et religion populaire au moyen âge* (Paris, 1985), pp. 120–25.
63 Kaufmann, op. cit., pp. 32–41.
64 Cheikh Anta Diop, 'Origin of the ancient Egyptians', in *A General History of Africa*, II: *Ancient Civilizations*, ed G. Mokhtar (UNESCO 1981), pp. 35–40.
65 Peter Brown in *A History of Private Life*, I: *From Pagan Rome to Byzantium*, ed. P. Veyne (London, 1987), p. 245.
66 Schiller, op. cit., I, pp. 137–52.
67 Leo Steinberg, *The Sexuality of Christ in Renaissance Art and in Modern Oblivion* (New York, 1983).
68 Among the few exceptions are a Weighing of Souls, Canterbury, early twelfth century (Florence, Laurentiana, MS Plut, xii, 17, fol. 1); Sassetta's *St Antony Beaten by Devils* (though the devils' genitals have been defaced!), early fifteenth century (Pinacoteca Nazionale, Siena); and, by indirection, devils in the Bourges *Last Judgment*.
69 G. G. Coulton, *Art and the Reformation*, I: *Medieval Faith and Symbolism* (Cambridge, 1953), pp. 49–50.
70 Gimpel, op. cit., p. 60.
71 R. W. Southern, *The Making of the Middle Ages* (New Haven, 1953), pp. 201–2.
72 Gimpel, op. cit., p. 100; José S. Gil, *La escuela de traductores de Toledo y sus colaboradores judios* (Toledo, 1985).
73 John Harvey, 'The Development of Architecture', in *The Flowering of the Middle Ages*, ed. Joan Evans (London, 1966), pp. 90–91.
74 G. Sarton, *A History of Science: Hellenistic Science and Culture in the Last Three Centuries BC* (New York, 1959), II, ch. 1–2.
75 Socrates, *Church History from AD 305–439*, XVII, 13–15.
76 Sermon, XVI, iv.
77 Other examples from the Utrecht Psalter include: fol. IV (Ps. 1; 3r (Ps. 5), 3v (Ps. 6); 16v (Ps. 29); 17r (Ps. 30); 59r (Ps. 102); 64r (Ps. 108); 77v (Ps. 137); 78r (Ps. 138).
78 Typical examples are illus. 16, 33, 50.
79 François Garnier, *Le langage de l'image au moyen âge* (Paris, 1982), ch. 13.
80 Jeffrey Burton Russell, *Lucifer* (Ithaca, NY, 1984), p. 132.
81 Of course there are exceptions, though few. Perhaps the Jaki is the most relevant. The four kings guarding Buddhist temples from the four directions are called, in Japanese, the Shi-Tennō. These four benevolent Devas sometimes trample evil spirits below their feet. In the ante-chamber of cave 427 of Tun Huang, in a large coloured stucco work, three divine defenders stand on Jaki with thick tufts of flaming hair identical to that of the Conques devil in the Golden Calf capital and to that of the Autun devil watching Judas's suicide. In this particular instance, their appearance and facial expressions are so close to their Christian counterparts that they would hardly, I think, be noticed as Chinese were they placed in a medieval Church grotto. (See *Mogao Grottoes of Dunhuang*, Tokyo, 1980–82, II, pl. 46) That cave dates from the Sui Dynasty (turn of the sixth century); later, more accessible examples include the creatures under the feet of the Shi-Tennō at Todaiji and Hōryūji, both in Nara but both have lost the tufted flaming hair either because

the later Chinese models used did not have them or the Japanese made their own changes (my guess is the former reason). We can, then, find some evil creatures in the East with flaming hair but (a) they are infrequent: the creature underfoot typically does not have such hair; and (b) more pertinently, flaming hair remains a key identifying characteristic of figures fighting evil.

82 Villeneuve, op. cit., p. 36.

83 And not only human figures. Perhaps the best example is the unprecedented Great Cock of Hell that dominates the frame within which he is painted. Rather than anger against evil, this creature suggests a great malignant spirit. His comb changes into flames, his neck-feathers and ruff curve into flames; he kicks those that have abused beasts; his face embodies more frightful evil than most European devils could even if packed together. See Jigoku-Sōshi, II, iv (Tokyo National Museum).

84 Jurgis Baltrusaitis, *Le Moyen Age fantastique* (Paris, 1981), pp. 144–50.

85 Steinberg, op. cit., p. 132.

86 R. J. M. Olson, 'Giotto's Portrait of Halley's Comet', *Scientific American* (May 1979), pp. 134–42.

87 Two artists who created a modern Satan both use angelic feathered wings. In the opening plate of Delacroix's engravings for Goethe's *Faust*, Satan flies about the city with feathered wings, as does the fierce, implacable Satan who is sowing evil in the world in Rops's illustrations. Perhaps this is hardly curious since both artists were interpreting Satan 'positively', as an alternative to their bourgeois settings.

88 Russell, op. cit., p. 29 n. 2, p. 129.

89 Ibid., pp. 129–30.

90 Coulton, *Five Centuries of Religion*, I, pp. 38–44.

91 Baltrusaitis, op. cit.

92 Schiller, op. cit., I, p. 154.

93 *The Refutation and Overthrow of Knowledge Falsely so-called*, trans. E. R. Hardy, in *Early Christian Fathers* (London, 1953), p. 21.

94 *Prescriptions*, 40.

95 Arnaldo Momigliano, *Essays in Ancient and Modern Historiography* (Oxford, 1977), p. 116.

96 Heresies up to the sixth century and the Church's response: E. I. Watkin, *The Church in Council* (London, 1960); W. H. C. Frend, *The Early Church* (London, 1973); F. Kempf, et al., *History of the Church: The Church in the Age of Feudalism* (New York, 1980), ch. 41; *The New Catholic Encyclopedia*; *The Writings of St Paul*, ed. W. A. Meeks (London, 1972), Part III; and writings of the early Fathers.

97 Tertullian, *Prescriptions*, 37.

98 Giovanni Filoramo, *A History of Gnosticism*, trans. A. Alcock (London, 1990), p. 82.

99 Montague Rhodes James, *The Apocryphal New Testament* (Oxford, 1924), pp. 187–9; the same idea is also in Acts of John (xcviii) in E. Hennecke, *New Testament Apocrypha*, trans. R. M. Wilson et al. (London, 1963).

100 Lecture, II, 4 in *Cyril of Jerusalem and Nemesius of Emesa*, ed. William Tefler (London, 1955).

101 'Essay on the Devil and Devils', in *Shelley's Prose*, pp. 269–70.

102 J. Stevenson, *A New Eusebius* (London, 1957), p. 281.

103 Ibid., p. 283.

104 Augustine, *The City of God*, XVIII, 51.

105 Filoramo, op. cit., p. 168.

106 Pereginus, *The Commonitory*, p. 430.

107 B. J. Kidd, *Documents Illustrative of the History of the Church* (London, 1932–3),
 II, doc. 69.

108 Ibid., p. 216.

109 Kempf, op. cit., ch. 13; Jaime Vincens Vives, *Approaches to the History of Spain*,
 2nd edn, trans. J. C. Ullman (Berkeley, 1970), ch. 4–7; John Williams, *Early
 Spanish Manuscript Illumination* (London, 1977).

110 Commentary by Richard Laufner and Peter K. Klein, *Trierer Apokalypse:
 Facsimile of Codex 31 of the Trier Municipal Library* (Graz, 1975), pp. 112–15,
 134–5.

111 Peter Klein, 'The Apocalypse in Medieval Art', *The Apocalypse in the Middle
 Ages*, ed. R. K. Emmerson and B. McGinn (Ithaca, NY, 1992) p. 187.

112 Philippe Sénac, *L'image de l'autre, histoire de l'occident médiéval face à l'islam*
 (Paris, 1983), pp. 1, 33–5.

113 John Williams, 'The Apocalypse Commentary of Beatus of Liebana', *The
 Apocalypse in the Middle Ages*, ed. R. K. Emmerson and B. McGinn (Ithaca, NY,
 1992), p. 227, notes 40, 42.

114 Sénac, op. cit., ch. 2–3.

115 Williams, op. cit., p. 220.

116 Klein, op. cit., p. 194.

117 Philippe Ariès, *The Hour of our Death*, trans. H. Weaver (New York, 1981),
 p. 99.

118 Cited in Alexander Heidel, *The Babylonian Genesis* (Chicago, 1942), p. 107.

119 Dominique Collon, *First Impressions: Cylinder Seals in the Ancient Near East*
 (Chicago, 1988), p. 178, fig. 840.

120 Letter CLXXV.

121 *Imperial Lives and Letters of the Eleventh Century*, trans. Theodor E. Mommsen
 and Karl F. Morrison, with an historical introduction by Morrison (New York,
 1962), pp. 3–18.

122 R. I. Moore, *The Origins of European Dissent* (London, 1985); Hans-Georg
 Beck et al., *History of the Church: From the High Middle Ages to the Eve of the
 Reformation* (New York, 1980) ch. 21–22, 28, 32–33; Alan C. Kors and
 Edward Peters, *Witchcraft in Europe, 1100–1700* (London, 1972); Friedrich
 Heer, *The Medieval World: Europe 1100–1350*, trans. Janet Sondheimer (New
 York, 1962), ch. 9; G. G. Coulton, *Five Centuries of Religion*, II: *The Friars and
 the Dead Weight of Tradition, 1200–1400* (Cambridge, 1927); M. D. Lambert,
 Medieval Heresy (London, 1977).

123 Peters, op. cit., pp. 178, 208.

124 R. I. Moore, op. cit., p. 169.

125 Confirmed by modern historians: G. Gonnet, 'Recent European
 Historiography on the Medieval Inquisition', *in The Inquisition in Early Modern
 Europe*, p. 201.

126 Ibid., p. 202.

127 Athenagoras, *Plea* 1.3; LCC, I, p. 303.

128 Tertullian, *Apology*, 7.1, 8.6.

129 Translated in Stephen Benko, *Pagan Rome and the Early Christians*
 (Bloomington, IN, 1948), pp. 65–6.

130 Brian Pullan, *Sources for the History of Medieval Europe* (Oxford, 1966), Part II,
 doc. 17.

131 Peters, op. cit., p. 196.

132 Ibid. pp. 48–9.

133 Jaime Vincens Vives, *Approaches to the History of Spain*, 2nd edn, trans. J. C.
 Ullman (Berkeley, 1970), p. 66.

134 Richard Fletcher, *Moorish Spain* (London, 1993); José S. Gil, op. cit.

135 Lynn Thorndike, *A History of Magic and Experimental Science* (London, 1923),
 II, p. 315.
136 R. W. Southern believed Chartres' importance is exaggerated: see his 'School
 of Paris and School of Chartres', *Renaissance and Revival in the Twelfth Century*,
 ed. R. L. Benson and G. Constable (Oxford, 1982).
137 Heer, op. cit., p. 262.
138 M. F. Hearn, *Romanesque Sculpture* (Ithaca, NY, 1981), p. 139.
139 For example, the distinguished scholar Jeffrey Burton Russell in his *Satan*
 (Ithaca, NY, 1981), pp. 24, 129.
140 Garnier, op. cit., ch. 10.
141 James, op. cit., p. xiii.
142 Carlo Ginzberg, *Ecstasies*, trans. R. Rosenthal (London, 1992), p. 70.
143 S. G. F. Brandon, *The Judgement of the Dead* (London, 1967).
144 V. I. Atroschenko and J. Collins, *Origins of Romanesque Art* (London, 1985),
 p. 80.
145 Ariès, op. cit., p. 100.
146 Jacques Le Goff, *La naissance de Purgatoire* (Paris, 1981).
147 Ariès, op. cit., p. 102.
148 Denis Grivot and George Zarnecki, *Gislebertus: Sculpteur d'Autun* (Paris, 1960).
149 James Snyder, *Medieval Art* (New York, 1989), p. 287.
150 Coulton, op. cit., I, pp. 111, 113.
151 Ginzberg, op. cit., p. 35.
152 Henry Kraus, *The Living Theatre of Medieval Art* (Bloomington, IN, 1967), pp.
 141–3.
153 Hearn, op. cit., pp. 179–80.
154 *The Wisdom Play*, in *Macro Plays*, ed. Mark Eccles (London, 1969), is an
 excellent example from medieval drama.
155 Schiller, op. cit., I, 154.
156 Francis Wormald, *The Winchester Psalter* (London 1973).
157 Erich Auerbach, *Mimesis* (Princeton, 1953), pp. 64–66, 136–41, 170–76.
158 Cited in A. Chastel and E. Baccheschi, *Tout l'oeuvres peint de Giotto* (Paris,
 1982), p. 109.
159 Edward Lucie-Smith, *Sexuality in Western Art* (London, 1991), p. 34.
160 Georges Bataille, *The Tears of Eros*, trans. P. Conner (San Francisco,
 1989), p. 82; the paintings Bataille cites are by Van der Weiden, Bouts and
 Spranger!
161 Charles Sterling, *La peintre médiévale à Paris* (Paris, 1987), I, p. 39, shows
 scenes from the *Bible en images du cardinal Maciejowski*, dated *c.* 1255;
 discussing the scenes of David and Bathsheba, Sterling notes the delicate
 modelling of the body and the sensual tactility, particularly of David fondling
 Bathsheba in bed.
162 A. K. Wheelock and G. Keyes, *Rembrandt's Lucretias* (National Gallery of Art,
 Washington DC, 1991), p. 3.
163 Augustine, *The City of God*, I, 19.
164 C. Seymour Jr., *Sculpture in Italy, 1400–1500* (Harmondsworth, 1966), pl. 147.
165 Ariès, *The Hour of our Death*, p. 373.
166 Heinrich Wölfflin, *Die Kunst Albrecht Dürers* (Munich, 1984), p. 110.
167 Erwin Panofsky, *The Life and Art of Albrecht Dürer* (Princeton, 1943), p. 71.
168 *Die Renaissance im Deutchen Südwesten* (Badisches Landesmuseum Karlsruhe,
 Eine Ausstellung des Landes Baden-Württemberg, 1986), pp. 317–18, 380.
169 Charles Williams, *Witchcraft* (London, 1941), p. 124; most readers would (I
 hope) agree with the medieval scholar Russell Hope Robbins, who calls it 'the
 most important and sinister work on demonology ever written [which] opened

the floodgates of the inquisitorial hysteria': *Encyclopedia of Witchcraft and Demonology* (New York, 1959), p. 337.

170 One of his earliest works is a stained-glass window at Grossgründlach, *c.* 1505, of Satan tempting Jesus. Satan is hairy, has cloven hoofs, harpy-hen hands, with angel (not bat-) wings, and a threatening, horned rooster's head.

171 C. Gilbert, 'Signorelli and Young Raphael', in *Raphael Before Rome*, ed. J. Beck (Washington DC, 1986), p. 121.

172 During the Kamakura period, a new iconography from southern China, the Ten Kings of Hell theme, became popular. Compared to earlier hell-theme scrolls, dismemberment, cannibalism and sadism are intensified. One such Jūōzu (private collection; Kaneko, p. 130) shows two burly demons (*oni*) sawing a spread-eagled nude beauty in half, and, another standard theme, a half-nude temptress on top of a tree whose trunk has sharp sword-like thorns; when the sinner, after great pain, finally reaches the top, the temptress appears at the bottom. In the earlier remarkable Gaki-Sōshi (Tokyo National Museum), *Shi-ben gaki* (scrawny, old belly-bloated black scavenger 'ghosts') gather round and watch a beautiful lady squat and defecate; they wait to devour her faeces, a grotesque, voyeuristic theme (third section of scroll).

173 D. Redig De Campos, 'The Sistine Chapel', in *Art Treasures of the Vatican* (New York, 1947), p. 174.

174 P. de Vecchi, 'Michelangelo's Last Judgment', in *The Sistine Chapel* (New York, 1987), pp. 200–1 summarizes various interpretations.

175 A recent authoritative account is P. de Vecchi, op. cit.

176 André Chastel, *A Chronicle of Italian Renaissance Painting*, p. 202.

177 Chastel, op. cit., p. 281.

178 'The Junius Manuscript', in *Anglo-Saxon Poetic Records*, I, ed. George Philip Krapp (New York, 1931); translations mine.

179 Michael J. B. Allen and Daniel G. Calder, *Sources and Analogues of Old English Poetry* (Rowman and Littlefield, 1976), pp. 3–5.

180 Millard Meiss, *French Painting in the Time of Jean de Berry* (London, 1967), pp. 30–32; Barbara Tuchman, *A Distant Mirror* (New York, 1977), p. 47.

181 Millard Meiss and Elizabeth H. Beatson, *Les Belles Heures de Jean, Duc de Berry* (London, 1974), p. 9.

182 Meiss, *French Painting*, p. 32.

183 Rodney Hilton, *Bondmen Made Free* (London, 1973), pp. 112–15, 132.

184 *La tenture de l'Apocalypse d'Angers*, Cahiers de l'Inventaire Général (Paris, 1987), p. 12.

185 Millard Meiss, *The Limbourgs and their Contemporaries* (London, 1974), p. 5.

186 Sterling, op. cit., p. 253.

187 Sterling (ibid.) dismisses Meiss's conjecture and strongly argues for the gesture's vulgar profaneness.

188 Meiss, op. cit., p. 30.

189 Ibid., p. 12.

190 Ibid., p. 175.

191 Shelley, 'Essay on the Devil and Devils', op. cit., p. 267.

192 Denis Grivot, *Images d'anges et des démons* (Saint-Léger-Vauban, 1953), p. 121.

193 A complete account of the meanings of *akuma* would require a separate section; before its use as the Japanese for *satan*, the word and its cognates are found mainly in Buddhist texts. Other examples are found in the long, tenth-century narrative *Utsubo Monogatari*, the late twelfth-century collection of poems and songs *Ryōjin Hishō*, and the early thirteenth-century collections of Buddhist sermons *Hosshin Shū*; an interesting example from a mid-nineteenth-century Kabuki play about a Robin Hood of Edo (Tokyo's original name), *Nezumi Komon Harunoshingata*, is the line 'Futte waita kono gonangi wa, kon-

nichi no akuma de gozansho.' This implies an evil, disaster-causing spirit who leads a good man down the wrong path, an implication so similar to the Christian notion that I would suspect the idea does, in fact, derive from Christian influences.

194 Levi's illustration of this goat-headed creature appeared in his *Dogme de la Haute Magic* (1855), and is in A. E. Waite's translation, *Transcendental Magic* (London, 1923).
195 Villeneuve, op. cit., p. 14.
196 C. R. Browning, *Ordinary Men* (New York, 1993), p. xvi.
197 Ibid., p. 189.
198 Bartolomé de Las Casas, *A Short Account of the Destruction of the Indies, 1542*, trans. N. Griffin (London, 1992), p. 3.
199 Las Casas, op. cit., p. 70.
200 Browning, op. cit., pp. 162–9.
201 Ibid., p. 170.

Select Bibliography

The Apocalypse in the Middle Ages, ed. R. K. Emmerson and B. McGinn (Ithaca, 1992)

The Apostolic Fathers, trans. Francis X. Glimm, Joseph M. F. Marique and Gerald G. Walsh (Washington DC, 1962)

Phillipe Ariès, *Images de l'homme devant la mort* (Paris, 1983)

Arnobius of Sicca, *The Case Against the Pagans*, 2 vols, trans. George E. McCracken (New York, 1949)

Erich Auerbach, *Mimesis* (Princeton, NJ, 1953)

Augustine, *The City of God*, 3 vols. trans. Demetrius Zema and Gerald Walsh (Washington DC, 1962)

E. Baccheschi, ed., *Tout l'oeuvre peint de Giotto* (Paris, 1982)

Jurgis Baltrusaitis, *Le Moyen Age fantastique* (Paris, 1981)

Henry Bettenson, *Documents of the Christian Church* (Oxford, 1943)

S. G. F. Brandon, *The Judgement of the Dead* (London, 1967)

Gérard De Champeaux, *Le monde des symboles* (St-Léger-Vauban, 1980)

J. H. Charlesworth, ed., *The Old Testament Pseudepigrapha* (New York, 1983)

André Chastel, *A Chronicle of Italian Renaissance Painting*, trans. P. Murray (Ithaca, NY)

The Chester Mystery Cycle, ed. R. M. Lumiansky and David Mills (Oxford, 1974)

Clement of Alexandria, *Exhortation to the Greeks*, trans. G.W. Butterworth, Loeb Classical Library (Cambridge, MA, 1919)

Dominique Collon, *First Impressions: Cylinder Seals in the Ancient Near East* (Chicago, 1988)

G. G. Coulton, *Five Centuries of Religion*: I: *St Bernard, his Predecessors and Successors, 1000–1200*; II: *The Friars and the Dead Weight of Tradition, 1200–1400* (Cambridge, 1923, 1927)

Jean Danièlou, *A History of Early Christian Doctrine before the Council of Nicaea*, II: *Gospel Message and Hellenistic Culture*; III: *The Origins of Latin Christianity* (London, 1973, 1977)

Mary Douglas, *Purity and Danger* (London, 1966)

Giovanni Filoramo, *A History of Gnosticism*, trans. A. Alcock (London, 1990)

Michel Foucault, *Surveiller et punir: Naissance de la prison* (Paris, 1975)

W. H. C. Frend, *The Early Church* (London, 1973)

C. Gaignebet and J.-D. Lajoux, *Art profane et religion populaire au moyen âge* (Paris, 1985)

François Garnier, *Le langage de l'image au moyen âge* (Paris, 1982)

José S. Gil, *La escuela de traductores de Toledo y sus colaboradores judios* (Toledo, 1985)

Jean Gimpel, *Les Bâtisseurs de Cathédrales* (Paris, 1980)

Erwin R. Goodenough, *Jewish Symbols in the Greco-Roman Period*, II: *The Archeological Evidence from the Diaspora*; III: *Illustrations for Volume I and II*; IX/X: *Symbolism in the Dura Synagogue* (New York, 1953–64)

Denis Grivot, *Images d'anges et des démons* (St-Léger-Vauban, 1981)

—— and George Zarnecki, *Gislebertus: Sculpteur d'Autun* (Paris, 1960)

Arnold Hauser, *The Social History of Art* (London, 1951)

Friedrich Heer, *The Medieval World: Europe 1100–1350*, trans. from German by Janet Sondheimer (New York, 1962)

G. Henningsen and J. Tedeschi, eds., *The Inquisition in Early Modern Europe* (De Kalb, IL, 1986)

Rodney Hilton, *Bondmen Made Free* (London, 1973)

The Junius Manuscript, ed. George Philip Krapp, *Anglo-Saxon Poetic Records*, I (New York, 1931)

The Writings of Justin Martyr: The First Apology, The Second Apology, Dialogue with Trypho, trans. Thomas B. Falls (Washington DC, 1948)

L. F. Kaufmann, *The Noble Savage: Satyrs and Satyr Families in Renaissance Art* (Ann Arbor, 1984)

B. J. Kidd, *Documents Illustrative of the History of the Church*, 2 vols (London, 1932–3)

M. A. Knibb, 'The Date of the Parables of Enoch', *New Testament Studies*, XXV (1979), pp. 345–59

Komatsu Shigemi, *Nihon no Emaki*, VII (Tokyo, 1987)

Alan C. Kors and Edward Peters, *Witchcraft in Europe, 1100–1700* (London, 1972)

Henry Kraus, *The Living Theatre of Medieval Art* (Bloomington, IN, 1967)

M. D. Lambert, *Medieval Heresy* (London, 1977)

Jean Lassus, *The Early Christian and Byzantine World* (New York, 1967)

Jacques Le Goff, *La naissance de Purgatoire* (Paris, 1981)

Emmanuel Le Roy Ladurie, *Montaillou: village occitan de 1294 à 1324* (Paris, 1978)

Library of Christian Classics (London, 1953–7):
 I: *Early Christian Fathers* (Justin, Athenagoras, Irenaes), ed. Cyril Richardson
 II: *Alexandrian Christianity* (Origen, Clement, etc.), ed. Henry Chadwick and J. E. L. Oulton
 III: *Christology of the Later Fathers*, ed. Edward Rochie Hardy
 IV: *Cyril of Jerusalem and Nemesius of Emesa*, ed. William Tefler
 V: *Early Latin Theology* (Tertullian, Cyprian, Ambrose, Jerome), ed. S. L. Greenslade
 VIII: *Augustine: Later Works*, ed. John Burnaby
 IX: *Early Medieval Theology*, ed. George E. McCracken
 X: *A Scholastic Miscellany: Anselm to Ockham*, ed. Eugene R. Fairweather

Emile Mâle, *L'art religieux du XIIe au XVIIe siècle* (Paris, 1945)

C. L. Mearns, 'Dating the Similitudes of Enoch', *New Testament Studies*, XXV (1979), pp. 360–69

Millard Meiss, *French Painting in the Time of Jean de Berry* (London, 1967)

——, *The Limbourgs and their Contemporaries* (London, 1974)

—— and Elizabeth H. Beatson, *Les Belles Heures de Jean, Duc de Berry* (London, 1974)

Arnaldo Momigliano, *Essays in Ancient and Modern Historiography* (Oxford, 1977)

Theodor E. Mommsen and Karl F. Morrison, trans., *Imperial Lives and Letters of the Eleventh Century* (New York, 1962)

R. I. Moore, *The Origins of European Dissent* (Oxford, 1985)

New Catholic Encyclopedia, 15 vols (Washington, DC, 1969)

Origen, *Contra Celsum*, trans. Henry Chadwick (Cambridge, 1953)

Otaka Yorio and Fukui Hideka, eds, *Apocalypse*, Bibliothèque Nationale, Fonds Français, 403 (Osaka, 1981)

——, *Apocalypse Anglo-Normande*, Cambridge Trinity College MS R. 16.2 (Osaka, 1977)

Phillip M. Palmer and Robert P. More, *Sources of the Faust Tradition* (New York, 1966)

Erwin Panofsky, *Studies in Iconology* (New York, 1962)

Edward Peters, ed., *Heresy and Authority in Medieval Europe* (Philadelphia, 1980)

Marvin H. Pope, *The Book of Job* (New York, 1965)

Mario Praz, *The Romantic Agony* (Oxford, 1933)

Hastings Rashdall, *The Idea of Atonement in Christian Theology* (London, 1920)

Louis Réau, *L'iconographie de l'art chrétien*, 3 vols (Paris, 1955)

Die Renaissance im Deutschen Südwesten, Badisches Landesmuseum Karlsruhe, Eine Ausstellung des Landes Baden-Württemberg (1986)

Revue des Sciences Humaines (Lille), issue no. 234 on 'Les Arts du Diable' (1994)

Russell Hope Robbins, *Encyclopedia of Witchcraft and Demonology* (New York, 1959)

Jeffrey Burton Russell, *The Devil* (Ithaca, 1977)

——, *Satan* (Ithaca, 1981)

——, *Lucifer* (Ithaca, 1984)

Claude Schaefer, *The Hours of Etienne Chevalier* (London, 1972)

Gertrude Schiller, *Ikonographie der Christlichen Kunst*, 4 vols (Gütersloh, 1966)

Philippe Sénac, *L'image de l'autre, histoire de l'occident médiéval face á l'islam* (Paris, 1983)

The Seven Ecumenical Councils, Nicene and Post-Nicene Fathers, XIV, ed. Phillip Schaff and Henry Wace (Grand Rapids, 1956)

P. B. Shelley, 'Essay on the Devil and Devils', in *Shelley's Prose*, ed. David Lee Clark (New Mexico, 1954)

Shimbo Toru, *Jigoku Gokuraku no E* (Tokyo, 1984)

Socrates, *Church History from A.D. 305–439*, II: *Nicene and Post-Nicene Fathers*, revd trans. by A. C. Zenos (Grand Rapids, 1952)

R. W. Southern, *The Making of the Middle Ages* (New Haven, 1953)

Leo Steinberg, *The Sexuality of Christ in Renaissance Art and in Modern Oblivion* (New York, 1983)

J. Stevens, *A New Eusebius* (London, 1957)

La tenture de l'Apocalypse d'Angers, Cahiers de l'Inventaire Général (Paris, 1987)

Marcel Thomas, *Rohan Book of Hours* (London, 1973)

Barbara Tuchman, *A Distant Mirror* (New York, 1977)

G. Vasari, *Lives of the Artists*, trans. G. Bull (Harmondsworth, 1965)

P. Veyne, ed., *A History of Private Life*, I: *From Pagan Rome to Byzantium* (London, 1987)

J. Vivaud, 'Egyptian Mythology', in *New Larousse Encyclopedia of Mythology* (London, 1959)

E. I. Watkin, *The Church in Council* (London, 1960)

Glynne Wickham, *Early English Stages*, 3 vols (New York, 1981)

John Williams, *Early Spanish Manuscript Illumination* (London, 1977)

Francis Wormald, *The Winchester Psalter* (London, 1973)

Photographic Acknowledgements

The author and publishers wish to express their thanks to the following sources of illustrative material and/or permission to reproduce it:

Agence Photographique de la Réunion des Musées Nationaux: nos. 73, 74; Fratelli Alinari: nos. 41, 76, 77; Arch. Phot. Paris/SPADEM/Agence Photographique Caisse Nationale des Monuments Historiques et des Sites: nos. 54, 72; Artothek: no. 66; Arxiu Mas: no. 58; Osvaldo Böhm: no. 42; Joan Broderick/Studio Lux: no. 13; Cambridge University Library: no. 16; Luciano Fincato: nos. 48, 56, 57, 60, 61; Photographie Giraudon: nos. 3, 40, 63, 64; Institut de Recherche sur l'Histoire des Textes, Moulins: no. 33; Luther J. Link: nos. 4, 10, 11, 12, 19, 30, 45, 46, 47, 51; Foto Marburg: no. 14; Musei Civici di Padova: no. 57; Photo © Pierpont Morgan Library, New York, 1994: no. 38; Donato Pineider: no. 36; Scala Fotografico: nos. 1, 2, 6, 32, 62; Seitz-Grey-Foto: no. 27; Musées de Sens: no. 49; Fotografia della Soprintendenza Archeologica della Province di Napoli e Caserta, Naples: nos. 9, 17; Staatliche Museen zu Berlin, Bildarchiv Preußischer Kulturbesitz, photo Jörg P. Anders: no. 5; Courtesy of Mr T. Tada: no. 23; François Thomas: no. 55; Photo © The Board of Trustees of the Victoria & Albert Museum: no. 15; Photo Zodiaque: no. 20.

Index

italic numerals refer to illustrations